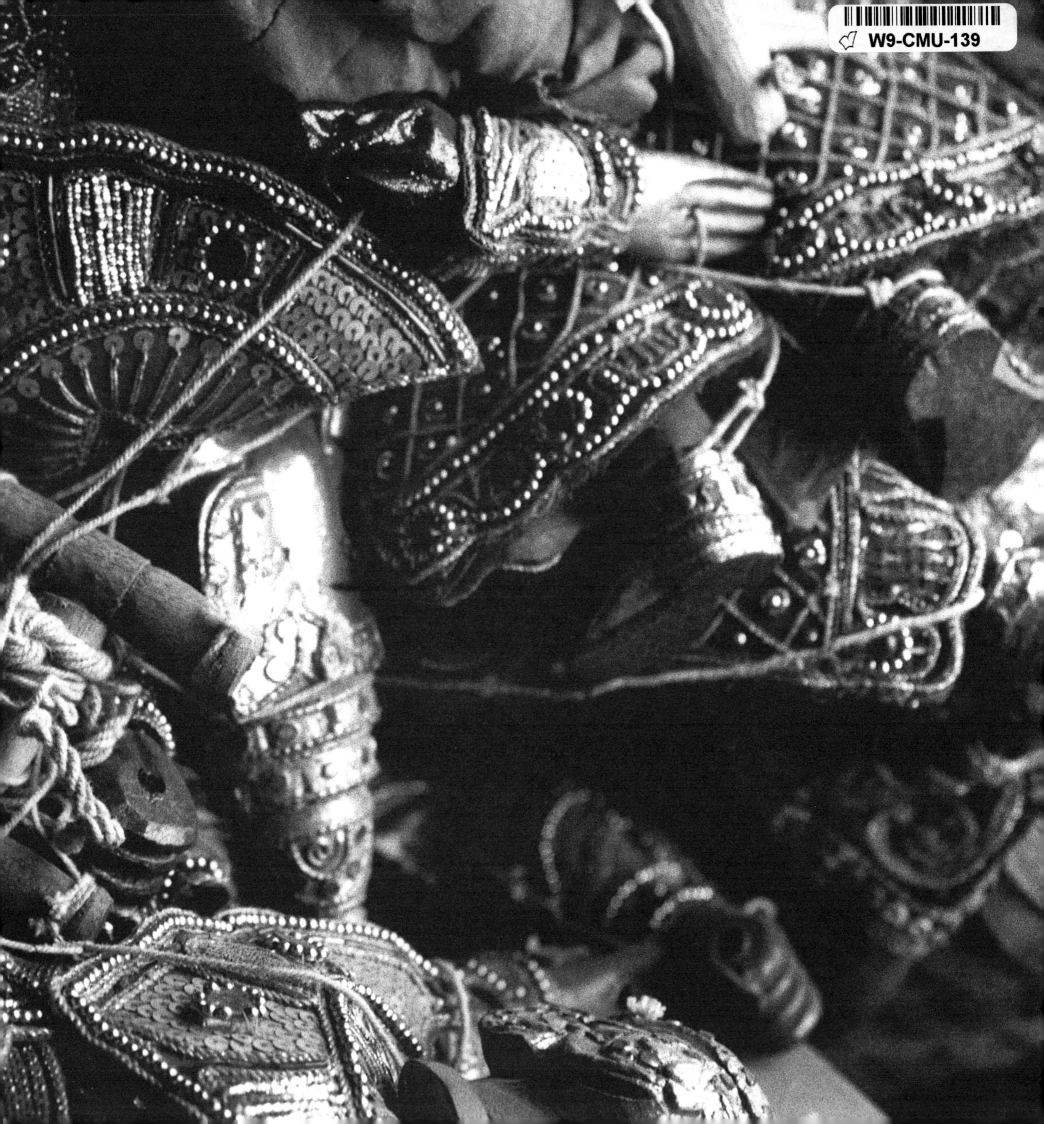

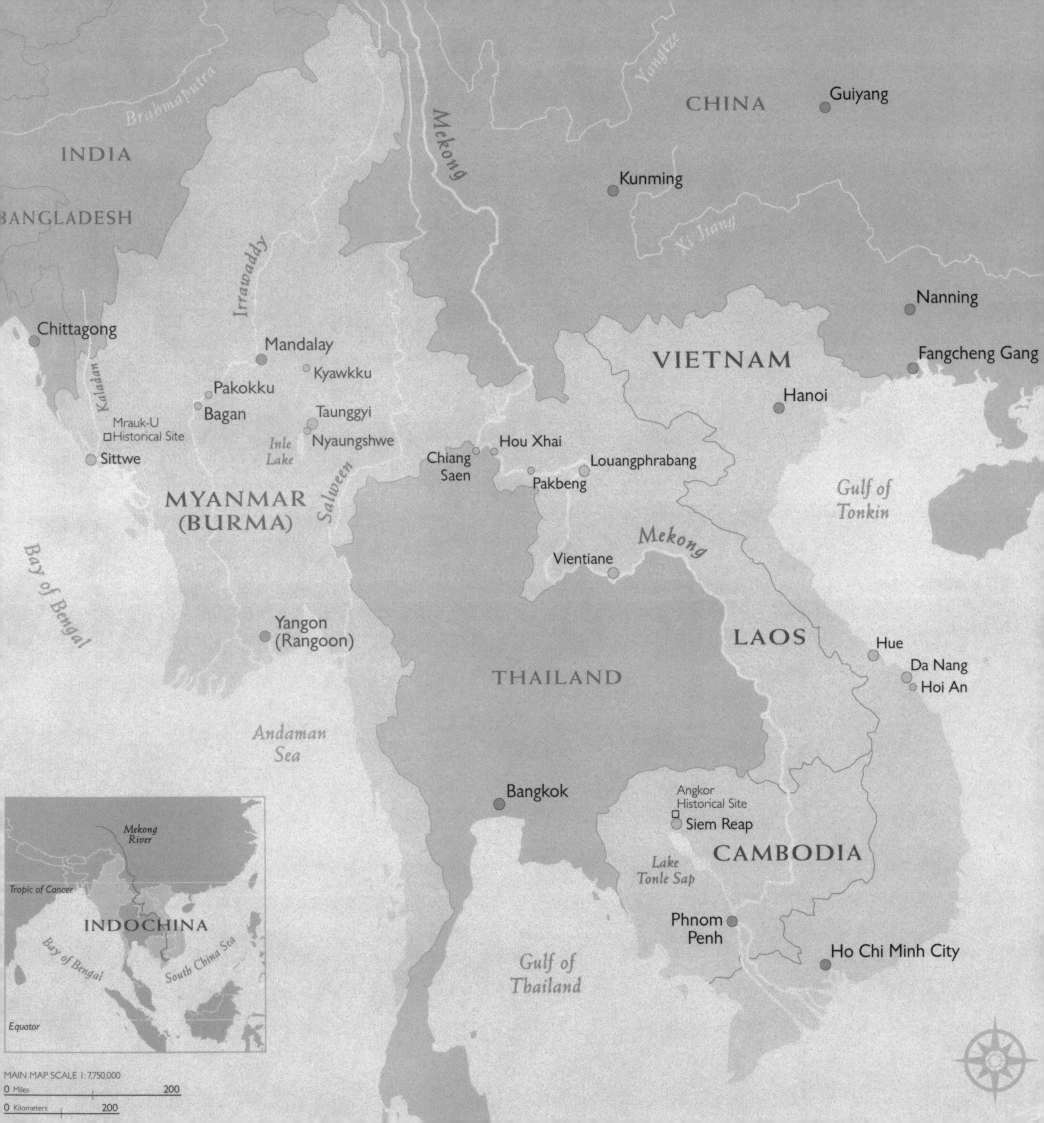

TOUCHING THE MEKONG

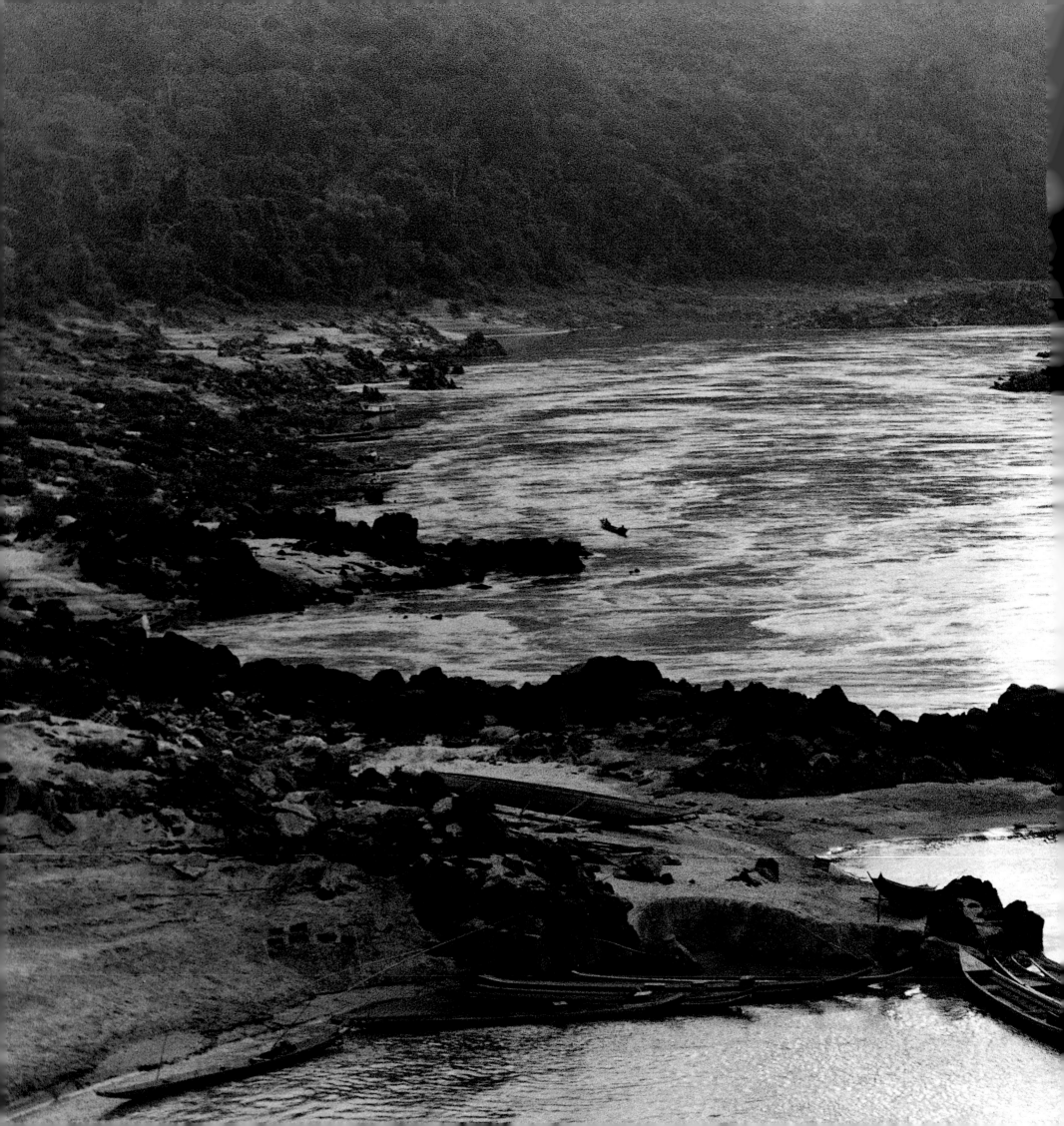

TOUCHING THE MEKONG

PHOTOGRAPHS BY

ANDREA BALDECK

UNIVERSITY OF PENNSYLVANIA MUSEUM OF ARCHAEOLOGY AND ANTHROPOLOGY
PHILADELPHIA

For Emily and Mark
Love from Gram
Christmas 2016

First Edition

The University of Pennsylvania Museum
of Archaeology and Anthropology
Philadelphia, Pennsylvania 19104

Library of Congress Cataloging-in-Publication Data
Baldeck, Andrea.
Touching the Mekong / photographs by Andrea Baldeck. – 1st ed.
p. cm.
ISBN 1-931707-55-3 (acid-free)
1. Mekong River Valley – Pictorial works. I. Title.
DS535.B35 2003
959.7–dc21 2003005646

Printed in USA on acid-free paper

Other Books by Andrea Baldeck:

The Heart of Haiti, 1996

Rudolf Staffel: Searching for Light, 1996

Hollis: Sonata Sonnets & Las Espinas, 1998

Breon O'Casey: In Honor of His Seventieth Birthday, 1998

Talismanic, 1998

Venice a Personal View, 1999

Designed by Veronica Miller

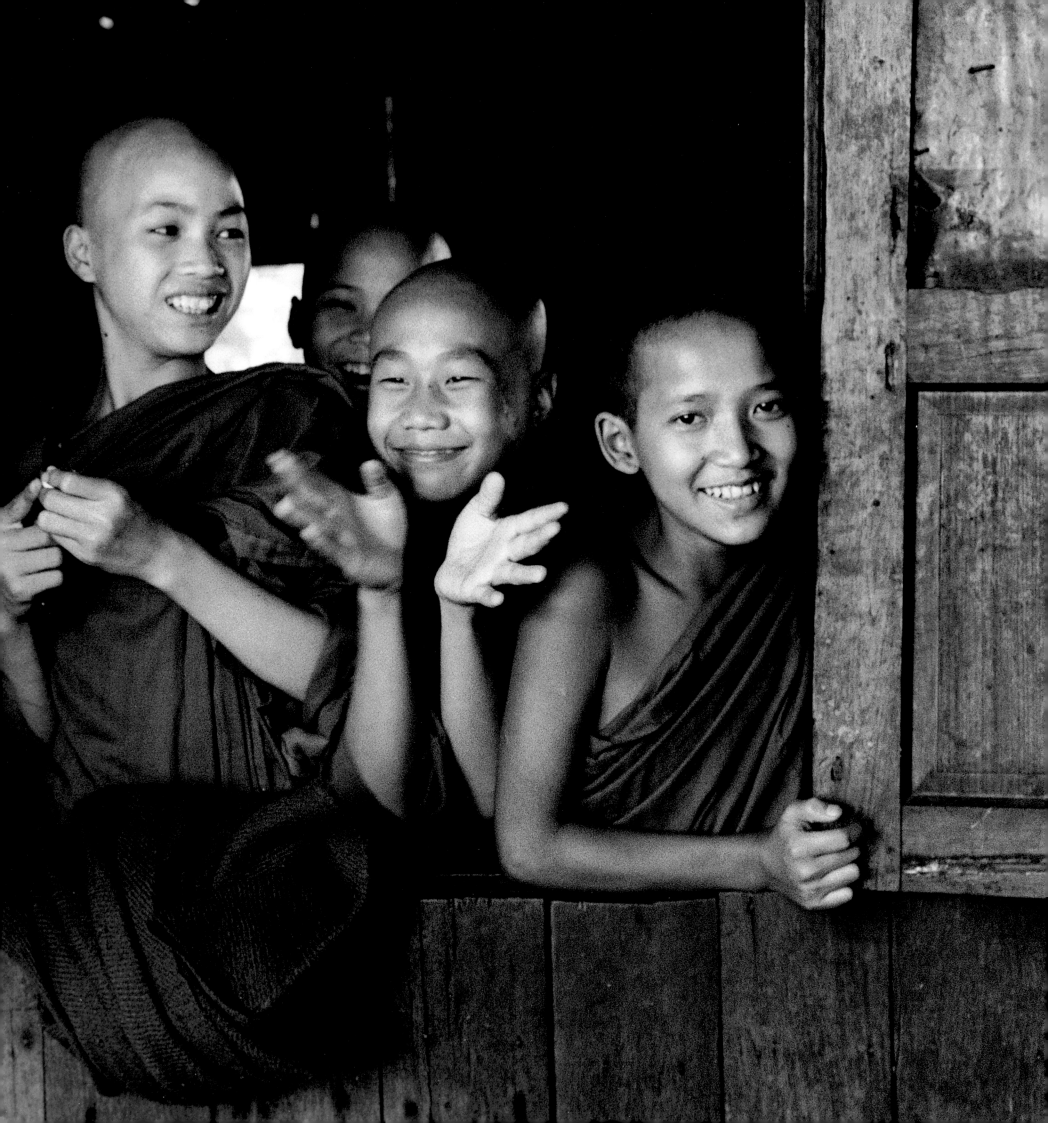

To travel in Southeast Asia is to be humbled by its layers of history and humanity, and by the realization that in a lifetime one could barely scratch the surface of understanding. But what a rich and tantalizing surface! Its sheer visual bounty prompted the photographs which follow. In no way do they constitute a compendium or travelogue; many such volumes already serve this purpose well. The images captured here are very much a personal account of textured, nuanced, enigmatic moments in a fascinating world. Using light and shadow, contrast and composition, I have sought to fix fragments of the surface for the viewer, with hopes of revealing a bit of what lies beneath.

Snowmelt in Tibet gives rise to the Mekong, the major riverine artery of Southeast Asia. Coursing from high plateaus, through mountain gorges and floodplains to the South China Sea, it touches and traverses many countries, including Myanmar (formerly Burma), Thailand, Laos, Cambodia, and Vietnam. With its smaller sister rivers, the Irrawaddy, the Salween, the Chao Phraya, and the Red, it drains the vast wedge of land between India and China which has come to be called Indochina.

Into this region, overland from the North and West and by sea from the South and East, have flowed waves of migration, creating a rich carpet of cultures, languages, and lifestyles. With them came belief systems ranging from indigenous animism, Chinese Confucianism, Indian Hinduism and Buddhism (now the predominant faith), and later Islam.

Along the coasts and river basins grew up trading ports, city-states, and wealthy kingdoms, best known of them being the Khmer civilization and its capital at Angkor, near the Mekong in what is now Cambodia. Warfare, invasion, and changing political fortunes saw empires rise and fall, their ruins reclaimed by jungle.

Western awareness of these distant and fabled lands stretches back to the Roman Empire, but it was not until the Age of Exploration in the 16th century that European traders — Portuguese, Dutch, and later, British — established trading posts in these lands. Navigation of the rivers soon followed, as fortune-seekers and missionaries probed inland into territory unknown to Europeans.

Commerce and converts were not enough, however, as powerful nation-states such as England and France appropriated territories in the global land rush of colonization. They were players in the "great game," superpowers competing for strategic geography, riches, and world supremacy. The French, seeking a river road to China, sent expeditions up the Mekong and claimed governance over Indochina (now Vietnam, Cambodia, and Laos). While treacherous rapids in the river were to thwart their plans for a trade link with China, the adventure uncovered the ruins of Angkor to the amazement of the Western world. England, firmly established in India, warily eyed French expansionism and moved to protect its eastern flank by annexing Burma. Thailand was the one country of the region never to have been colonized by the West.

European colonizers and Southeast Asian people maintained their uneasy, unequal coexistence well into the 20th century, amid the rising currents of nationalism and self-determination. The upheaval of World War II added impetus to these movements, and the postwar world saw empires dissolve and independence arrive in Burma, Laos, Cambodia, and

Vietnam. Transition to statehood in the Cold War era led the new superpowers (China, the Soviet Union, the United States) to compete for influence in this strategic region, unleashing again the forces of political repression, war, migration, and genocide. While wholesale conflict ceased in 1975, it has taken another two decades for a measure of peace, reconstruction, and development to come to the area. Its reintegration into the global community has revived tourism to destinations long inaccessible. Place names on the map that evoke scenes of past exploration and conflict can now be visited by those armed only with guidebooks and cameras.

Thus equipped, and with a headful of visions ranging from the *Ramayana* to the *National Geographic* to the newscast war footage of my college years, I spent two long sojourns in lands touched by the Mekong. Mandalay, Hanoi, Luang Prabang, Da Nang, Angkor. These sites, which by name alone stir the imagination, presented a complex swirl of populations and cultures. Terrains of seductive beauty and variety provoked awe and delight: the jungled mountains of the upper Mekong, the meanders of the Irrawaddy, the placid expanse of the Tonle Sap, the shoreline of the Bay of Bengal. In this highly varied landscape live equally diverse peoples, a cultural patchwork vividly evident at open-air markets and religious festivals, yet also subject to shifting political and economic pressures in a region changing more quickly than can be captured by the camera.

ANDREA BALDECK

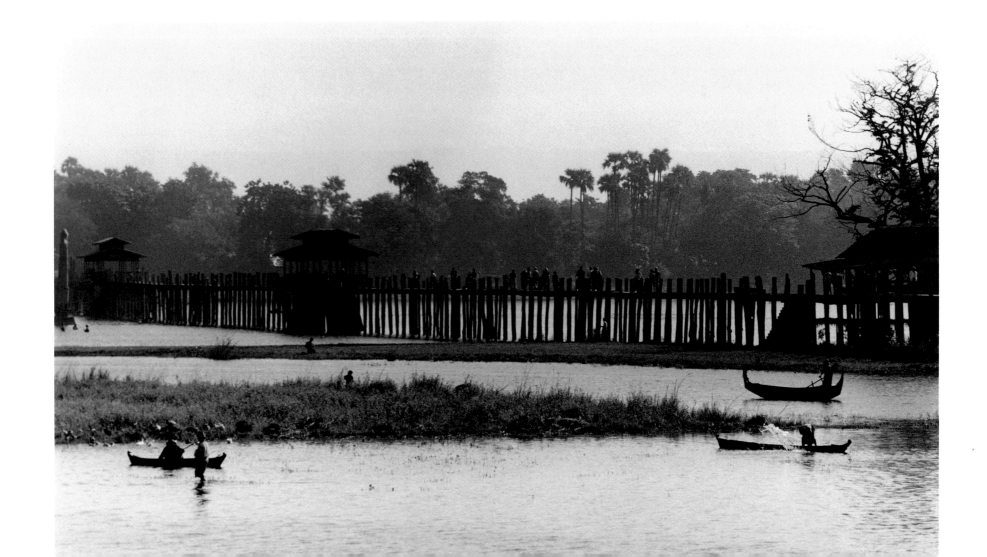

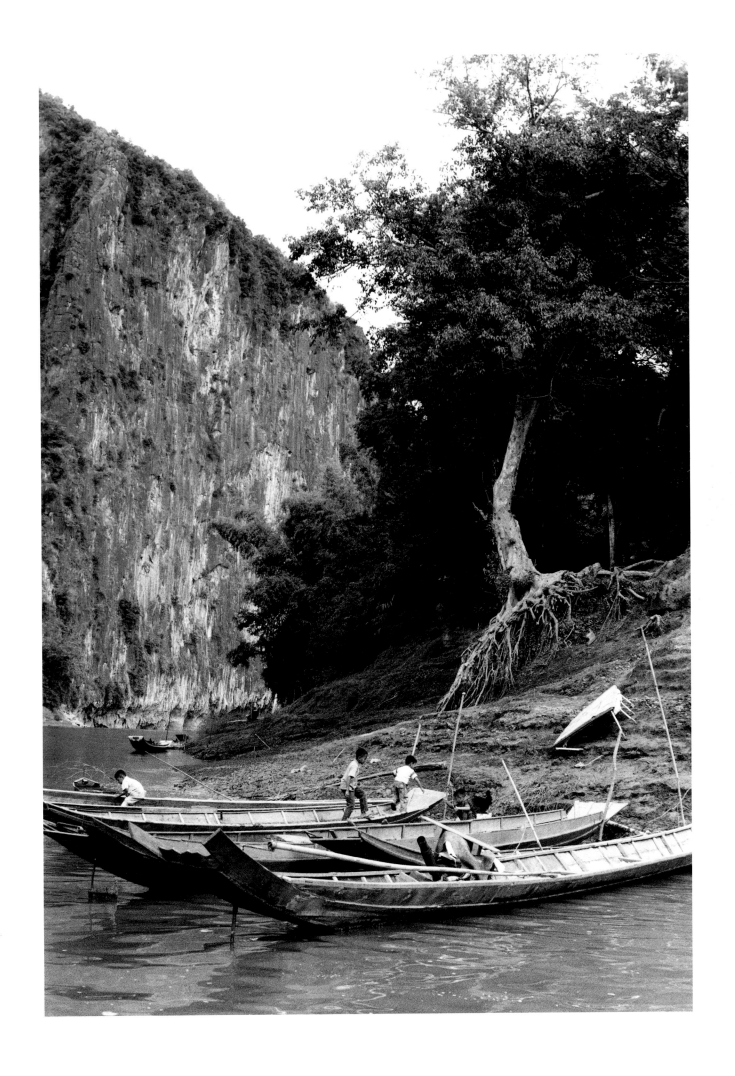

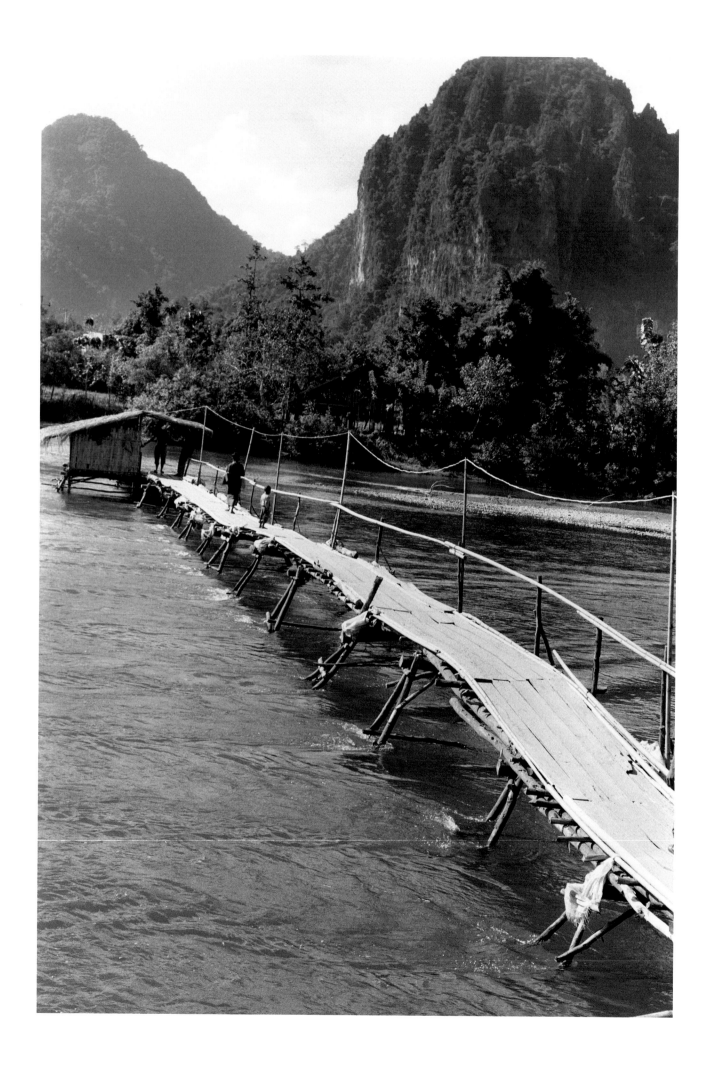

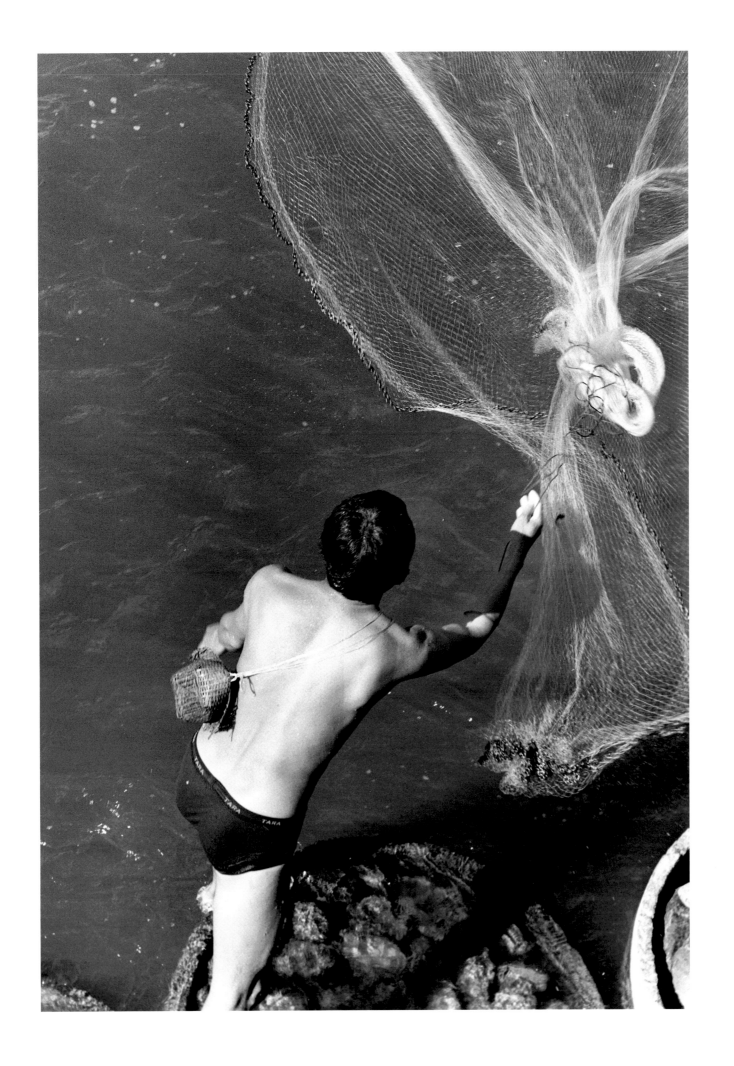

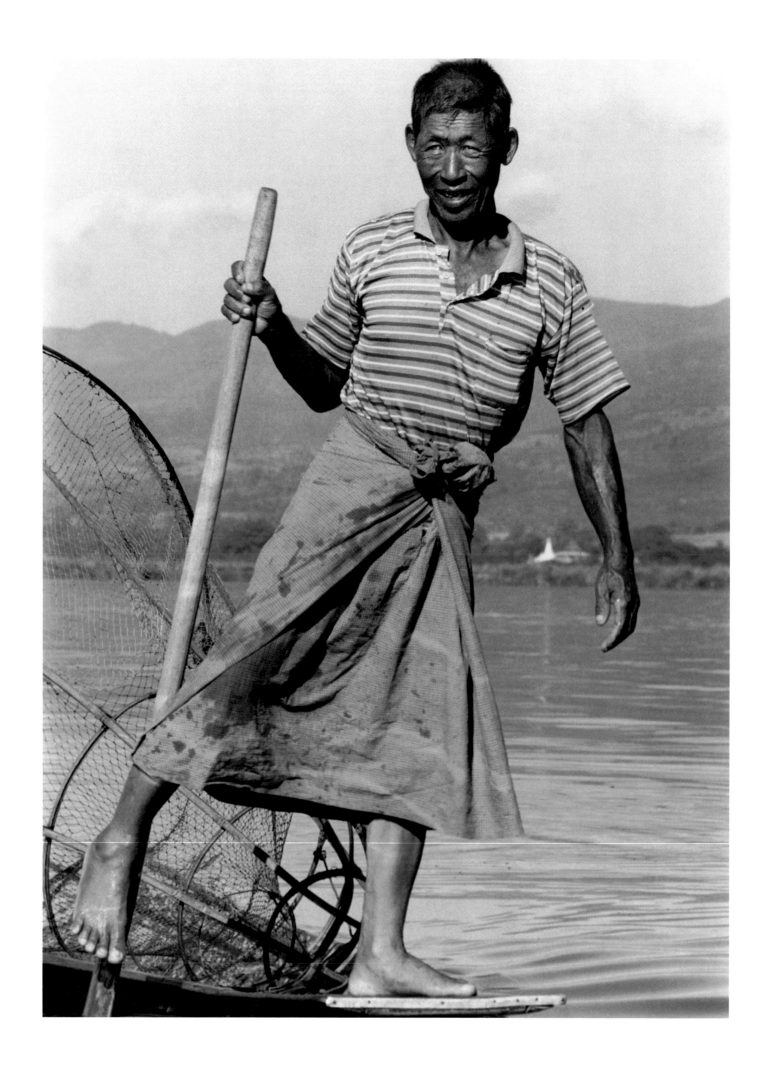

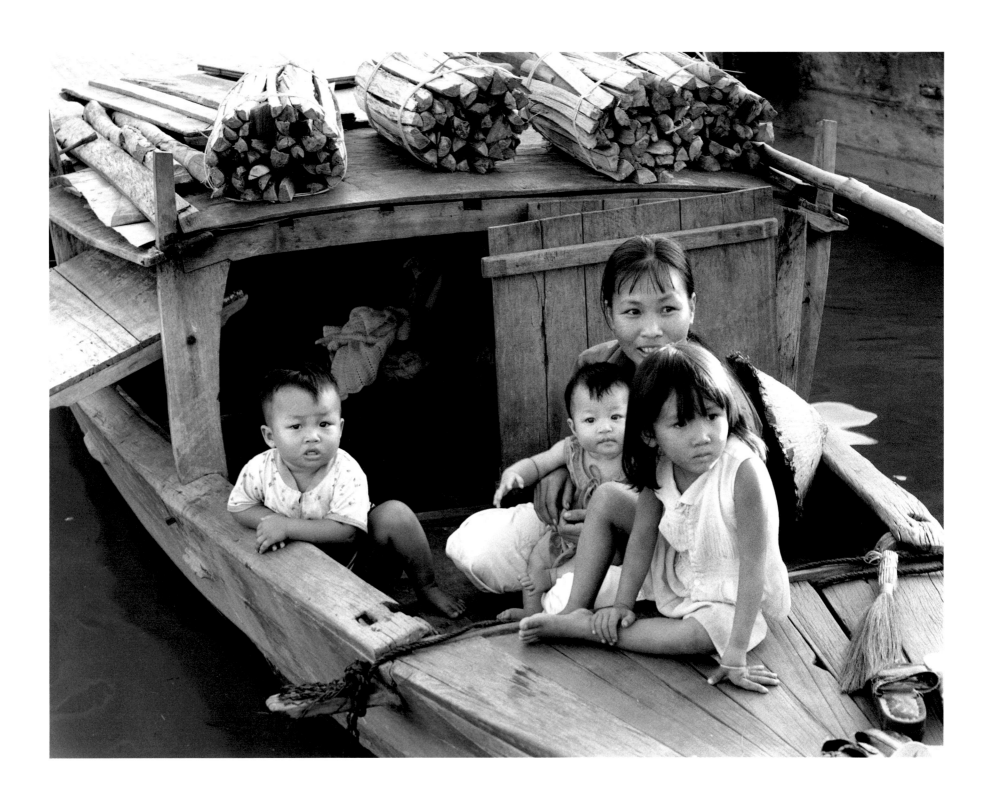

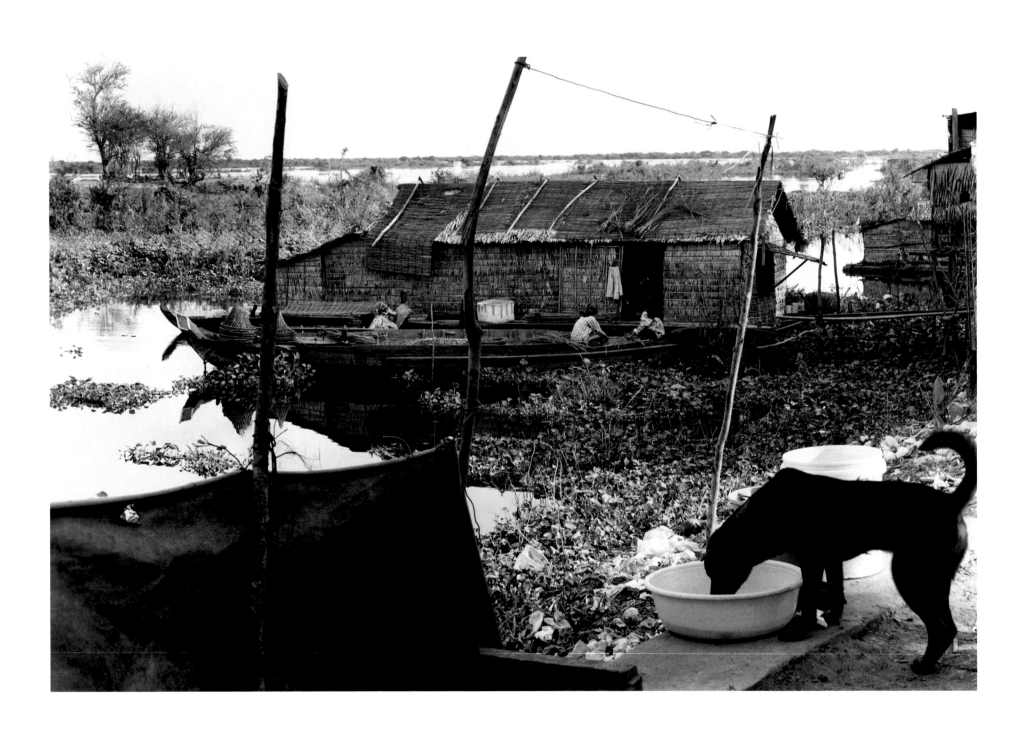

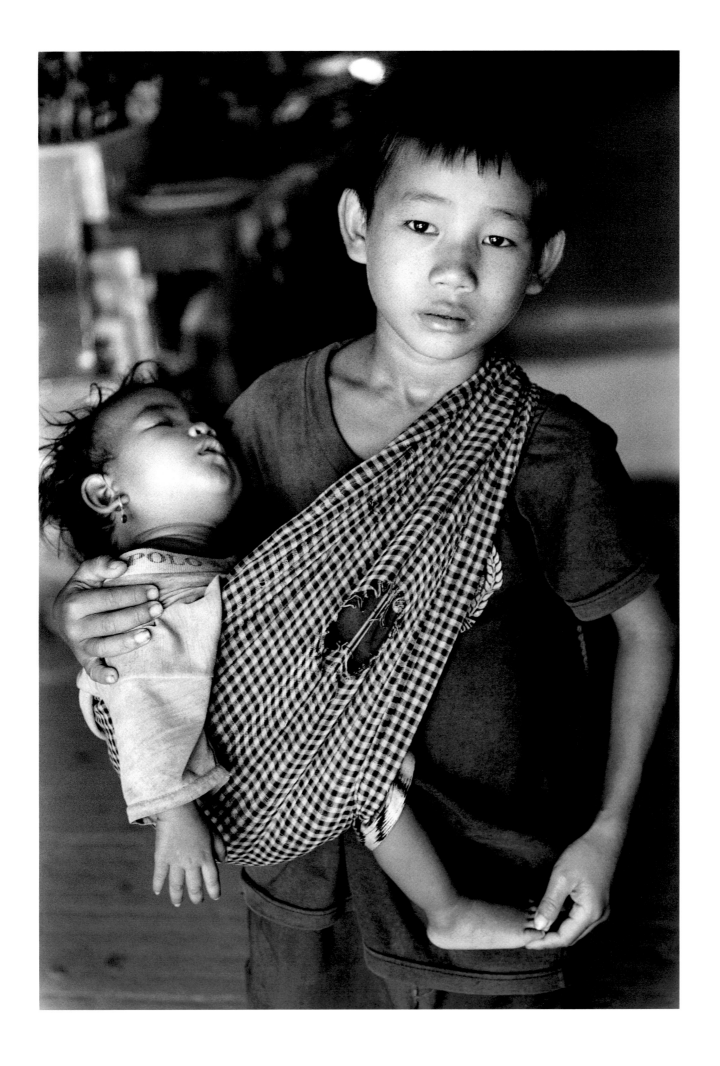

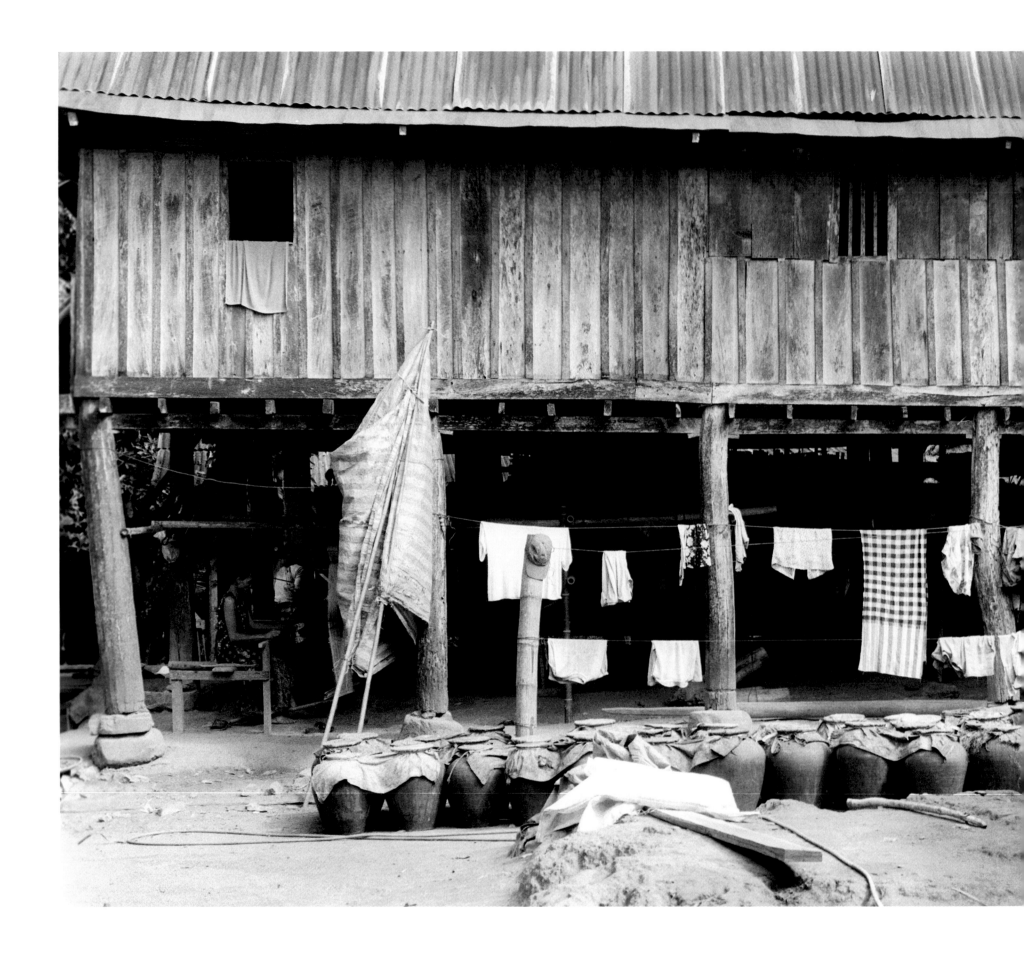

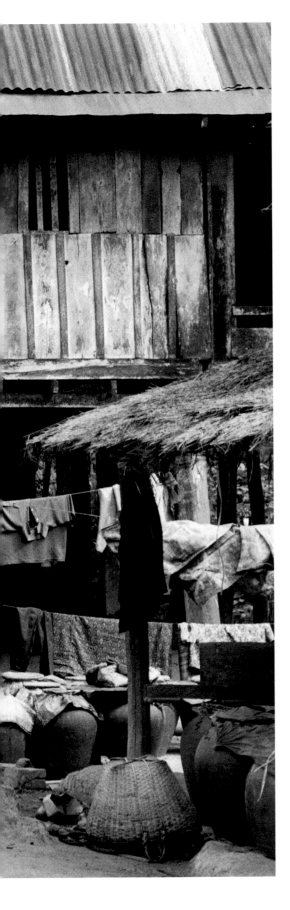

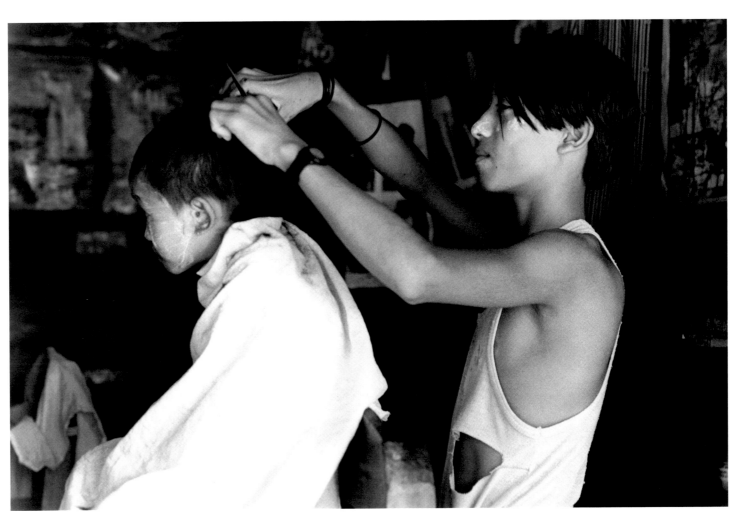

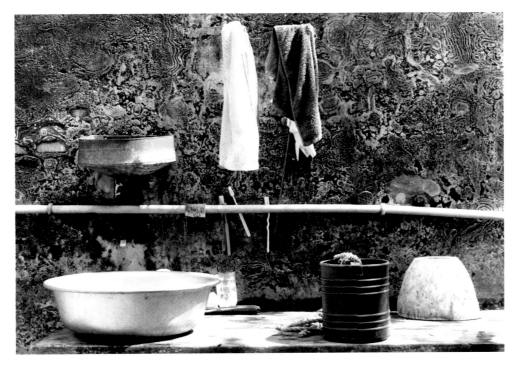

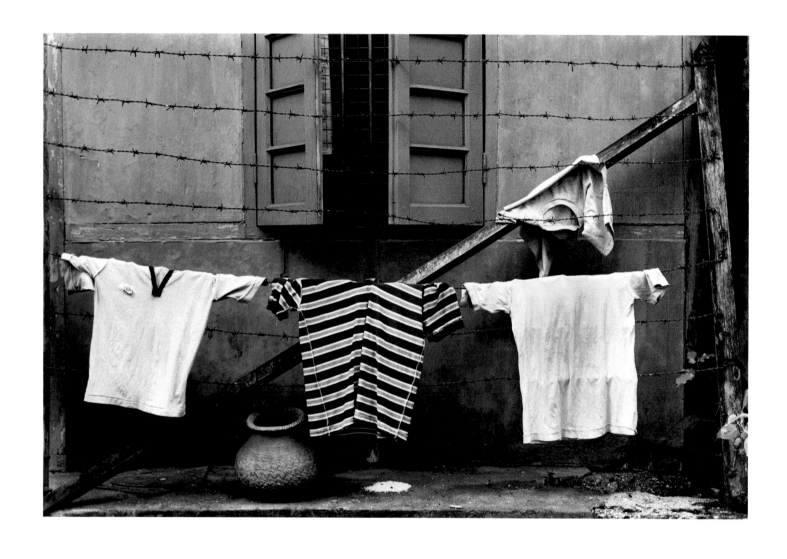

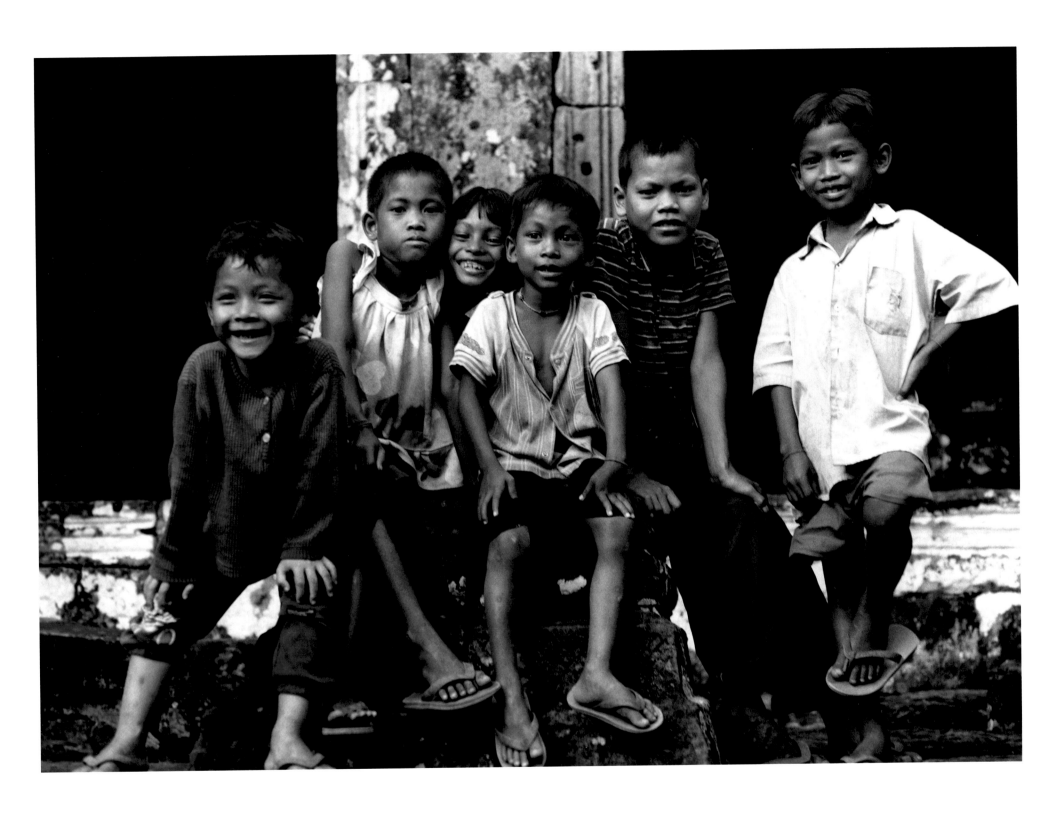

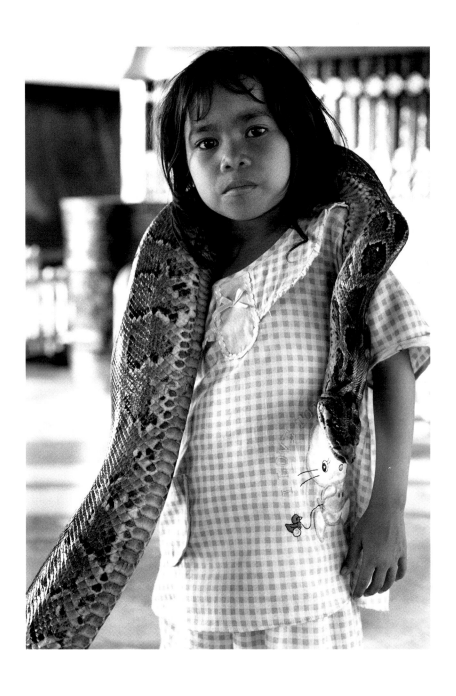

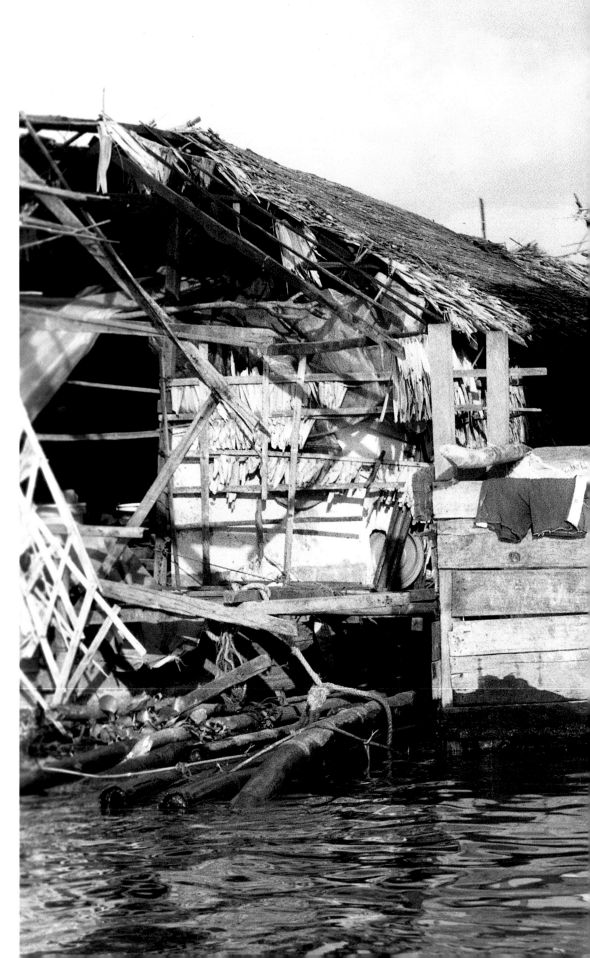

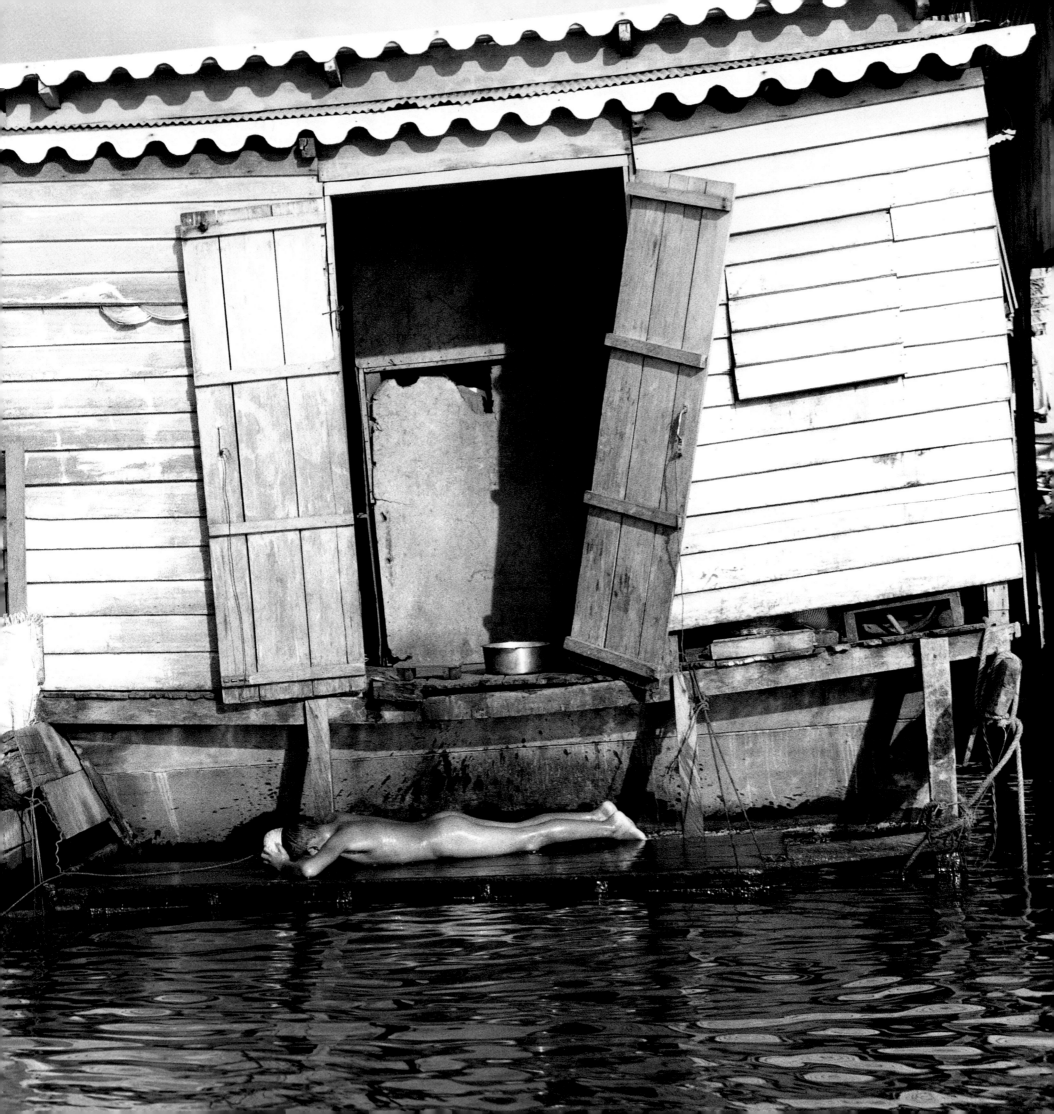

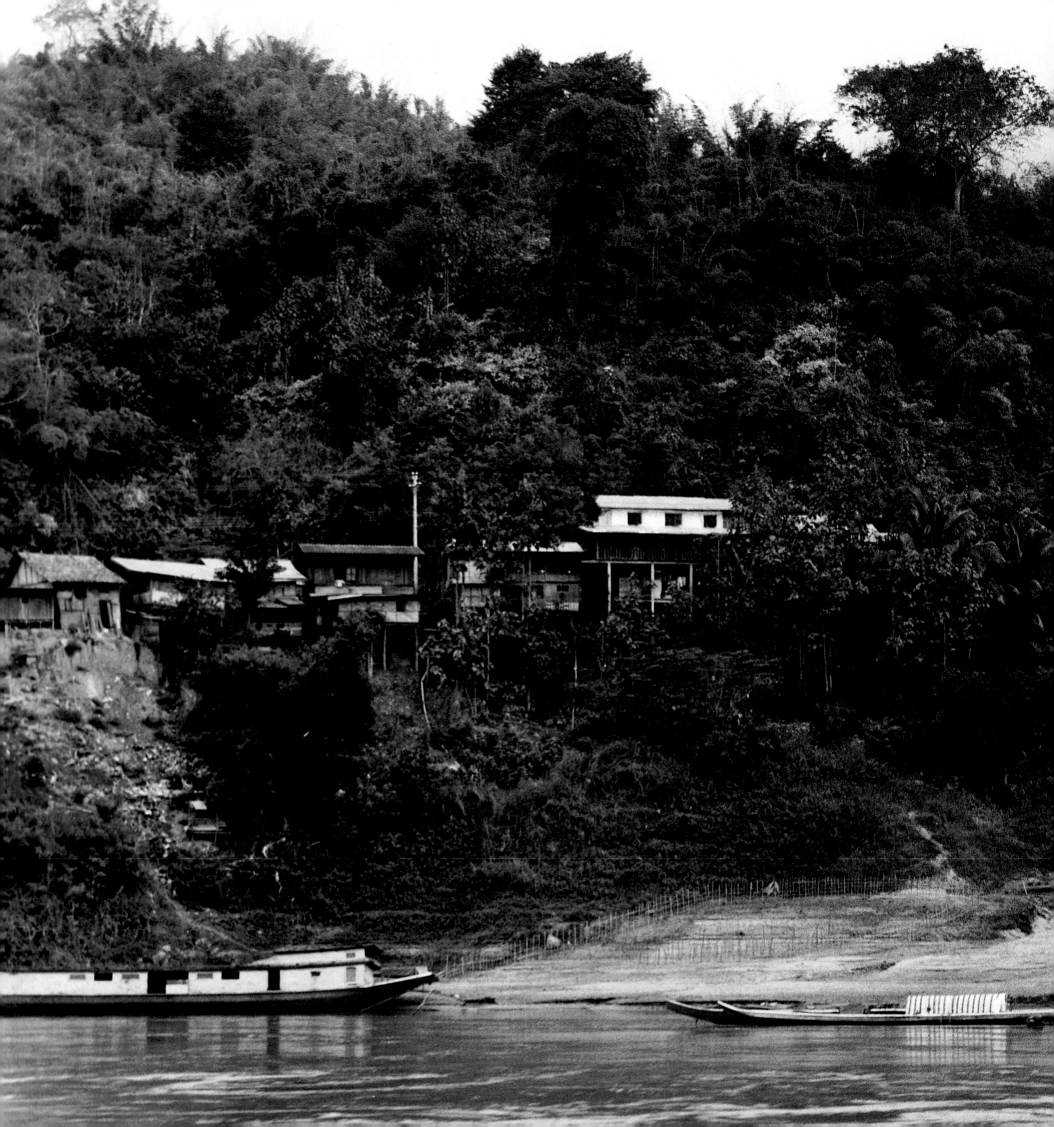

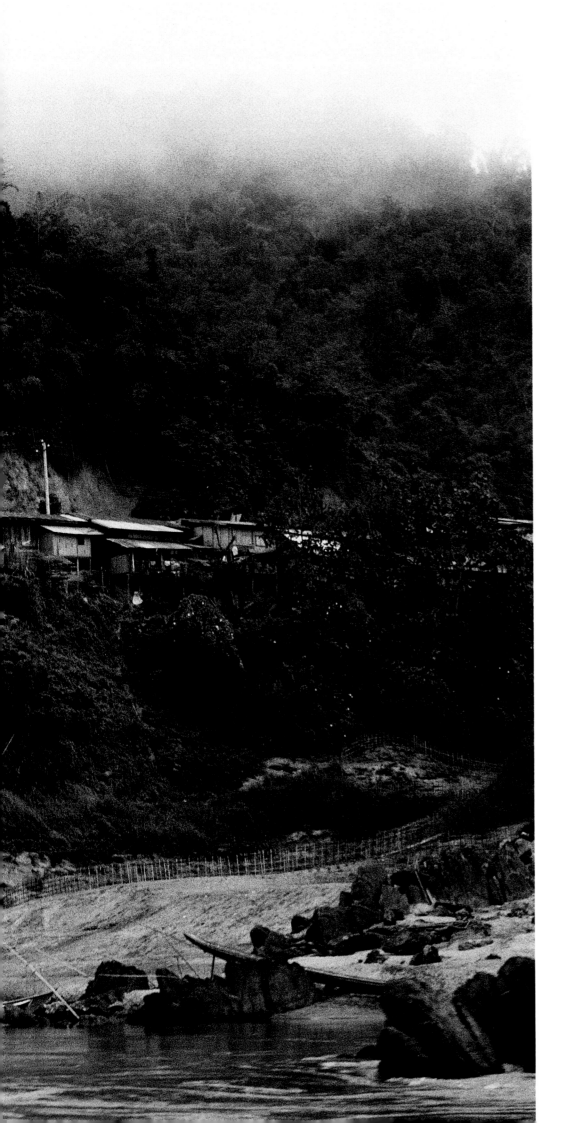

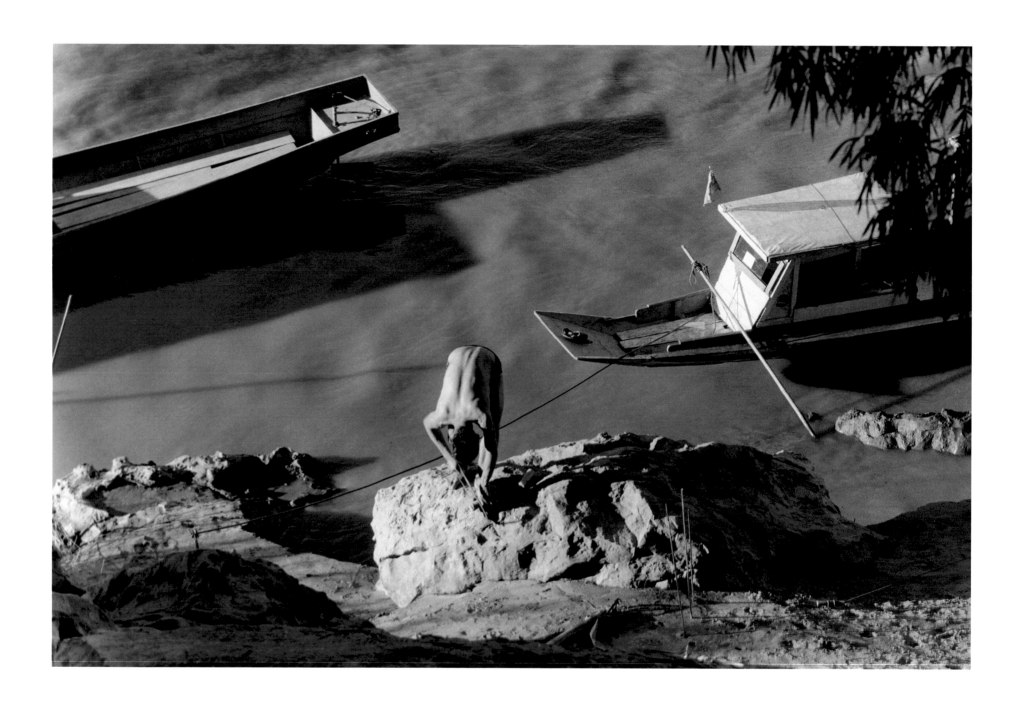

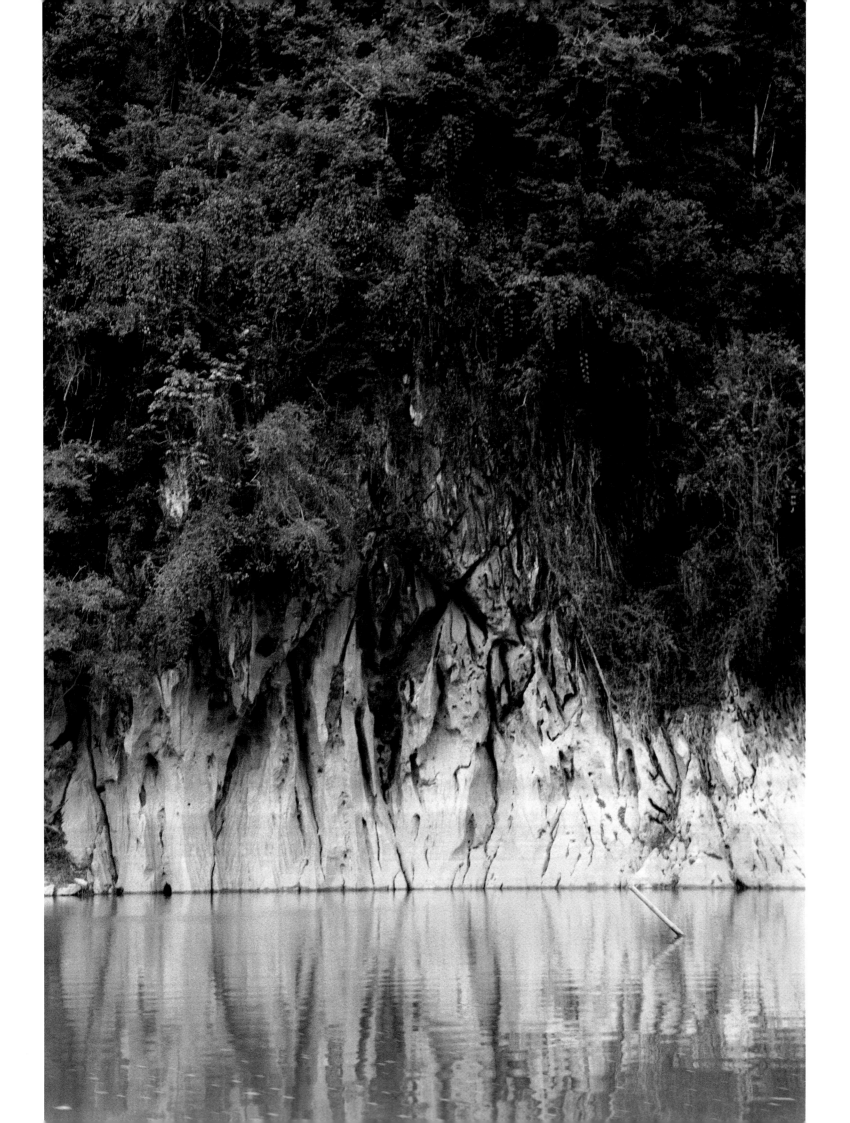

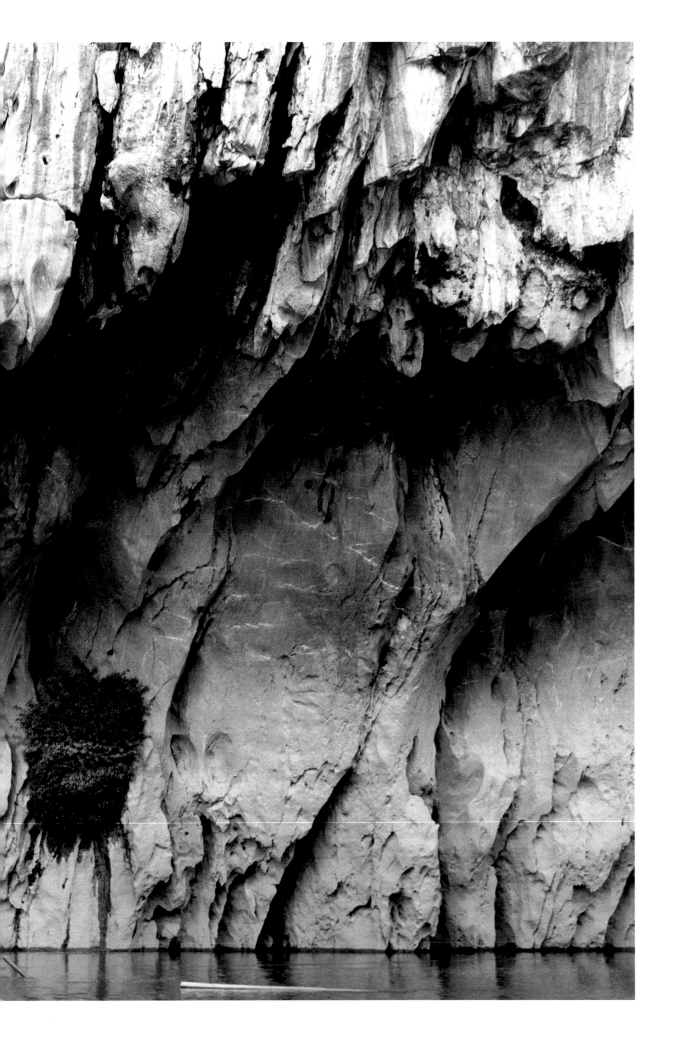
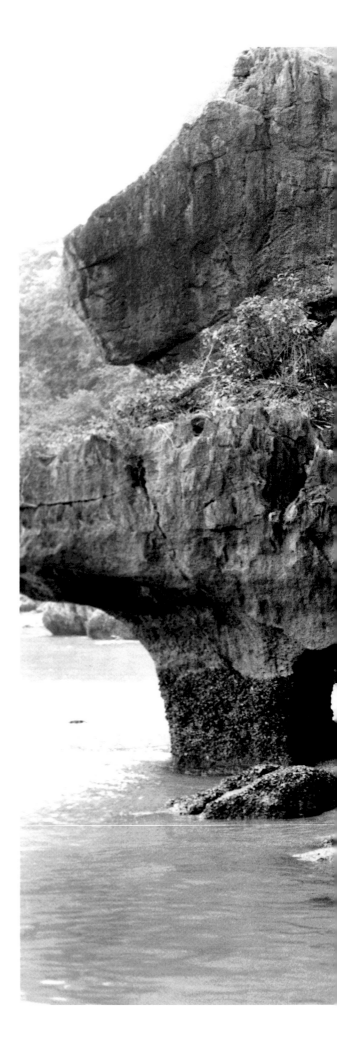

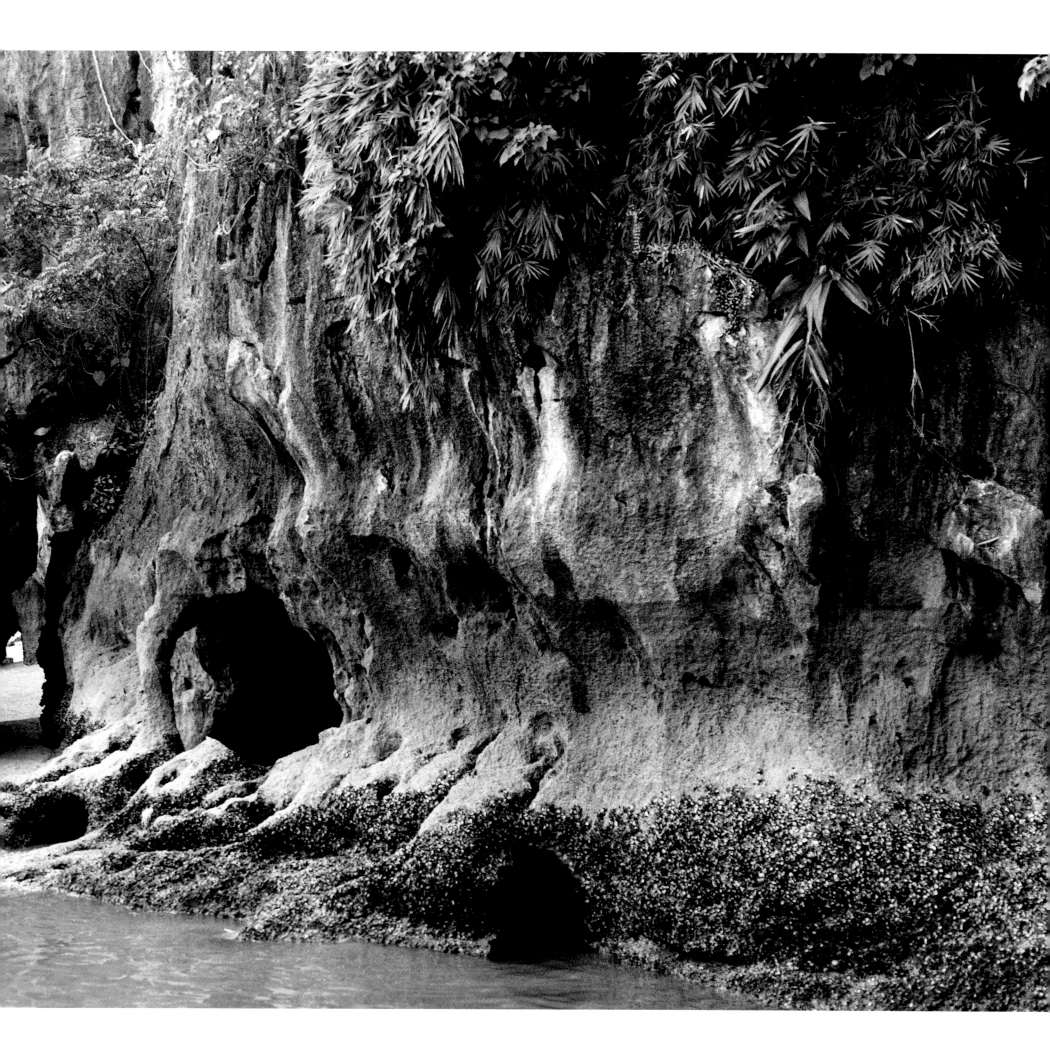

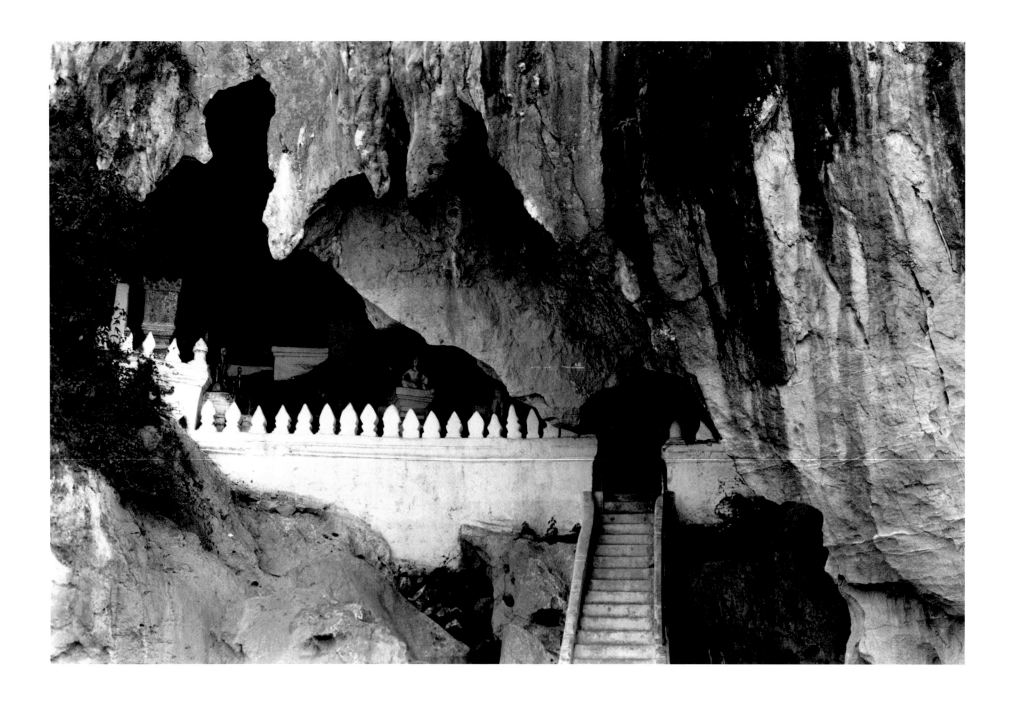

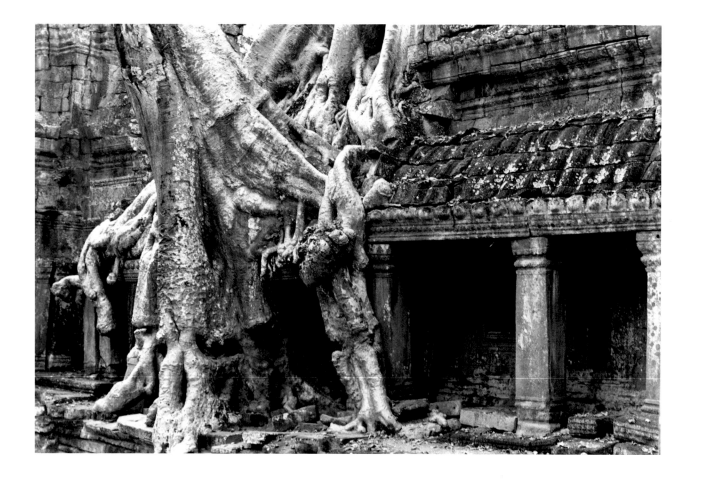

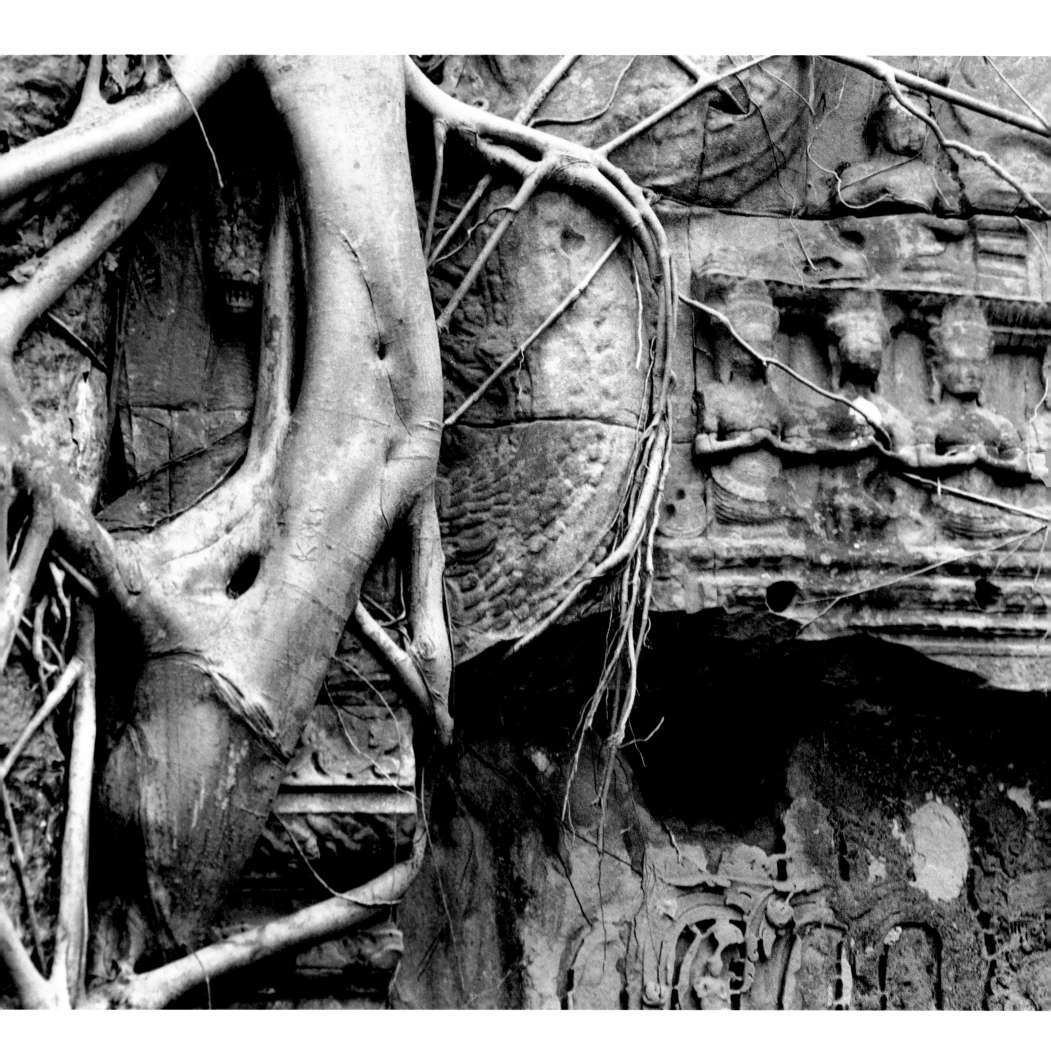

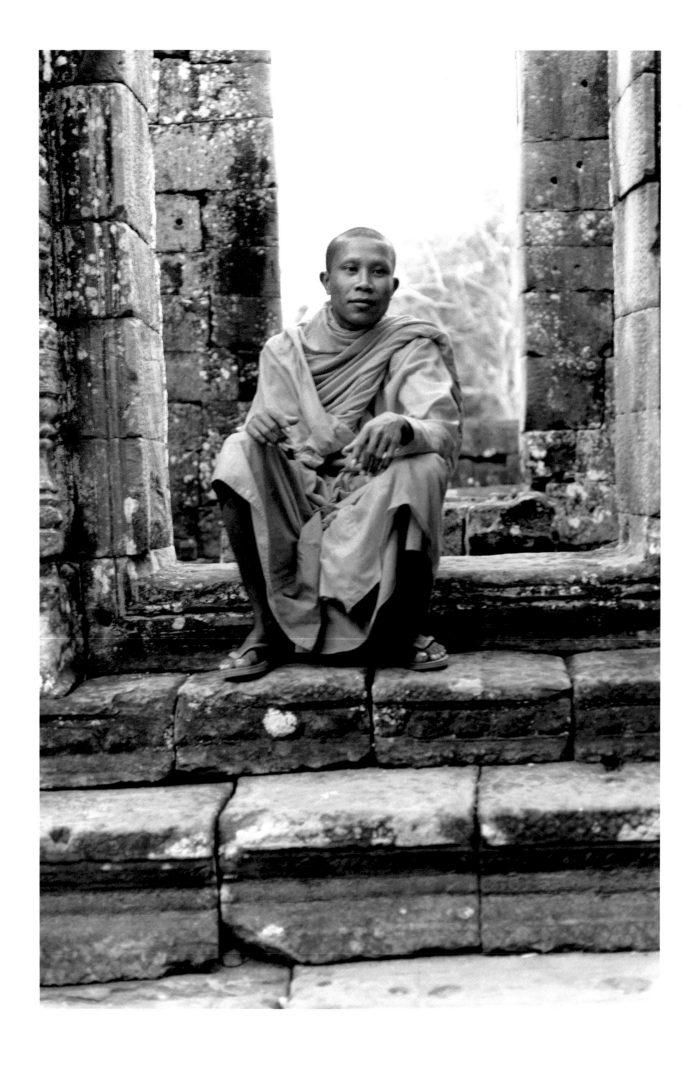

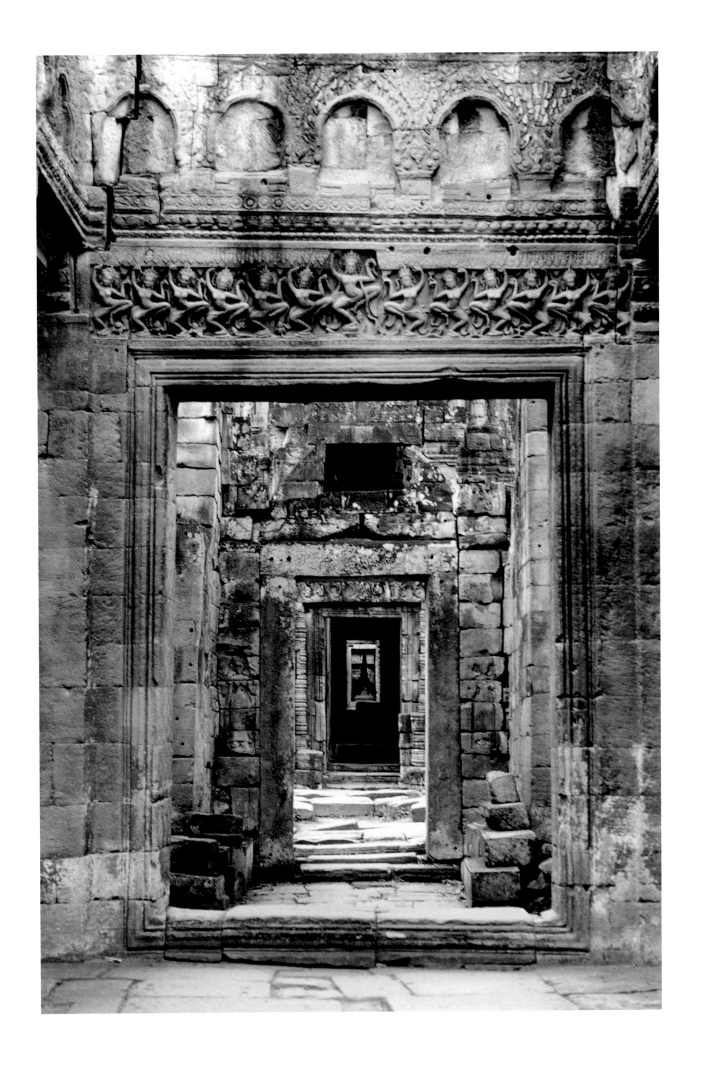

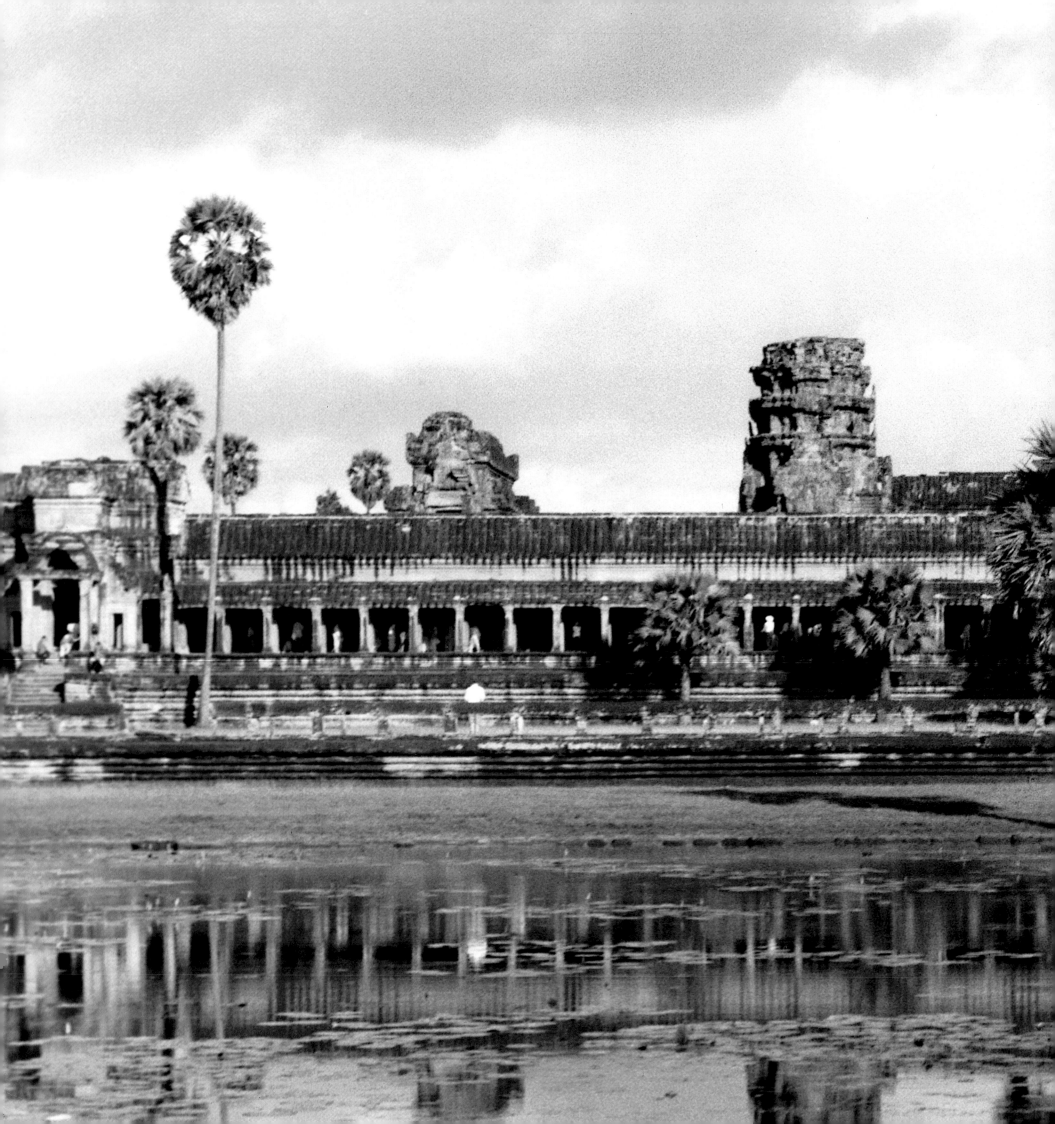

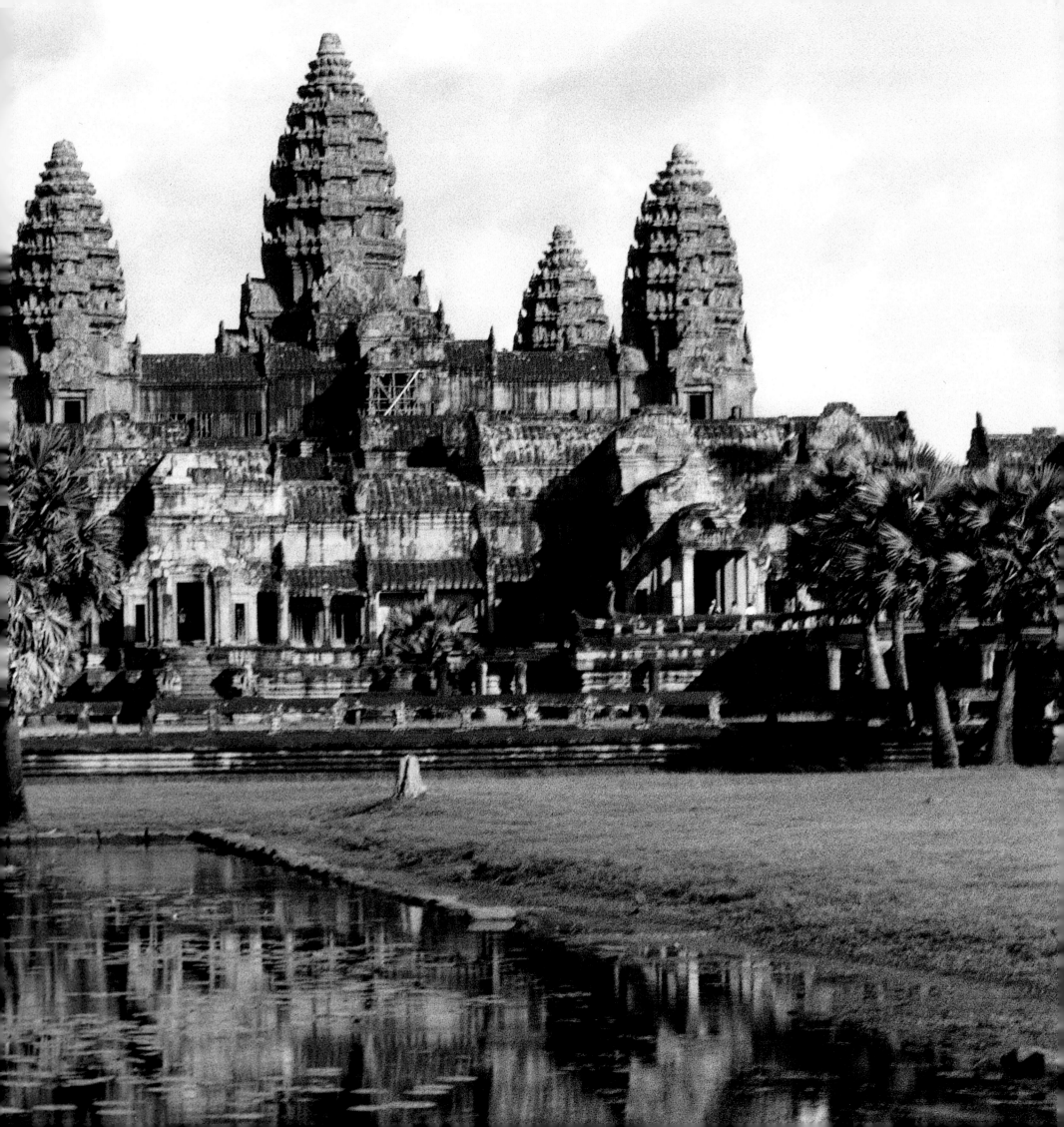

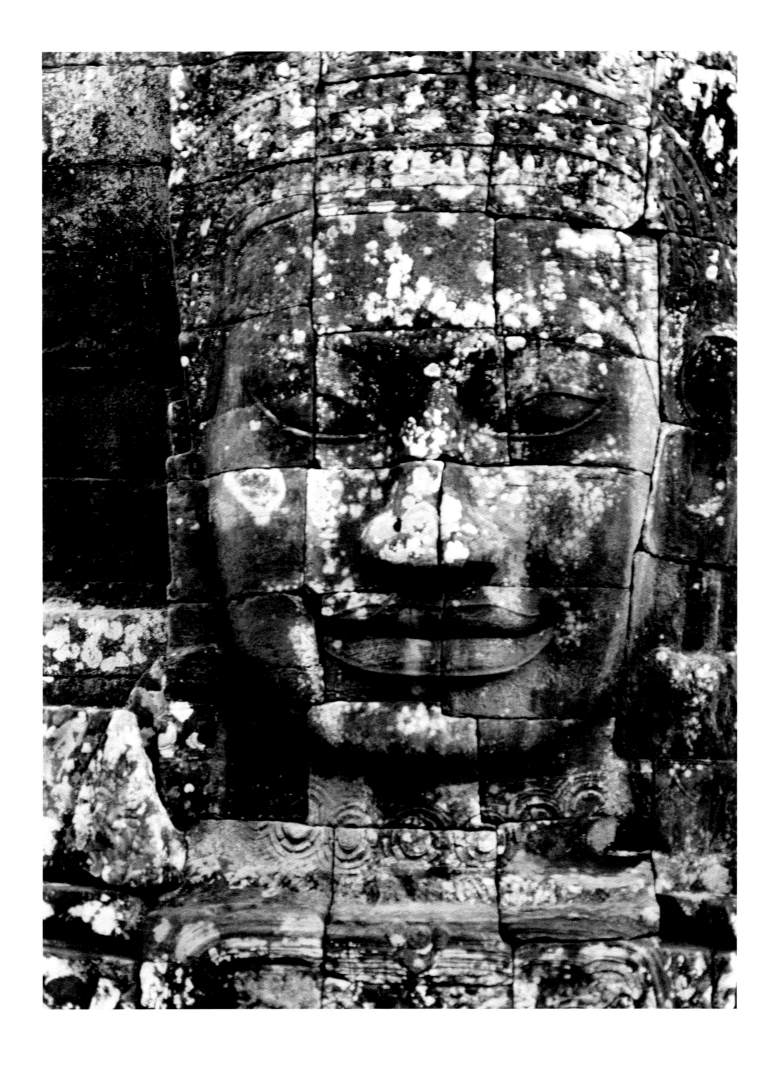

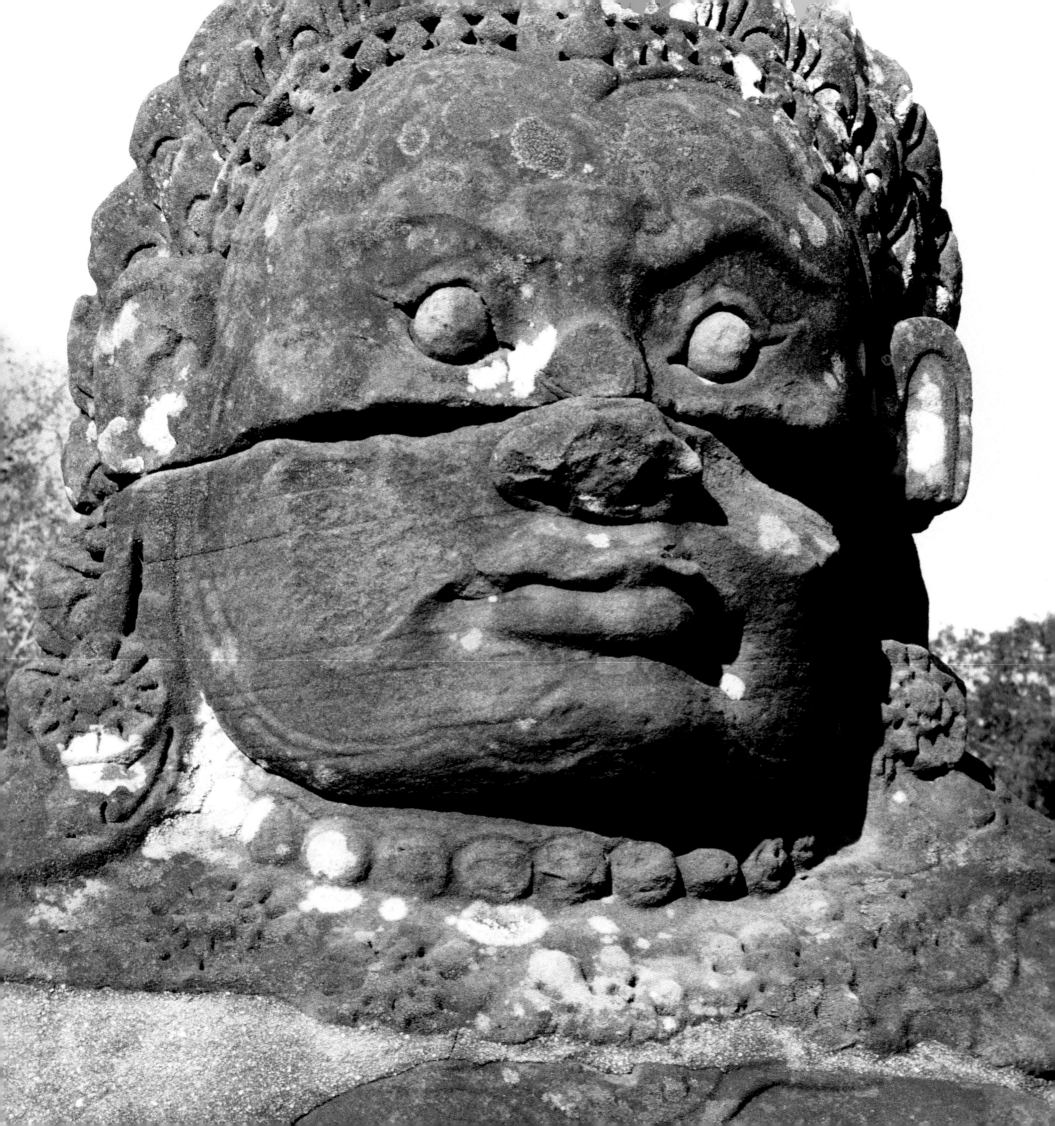

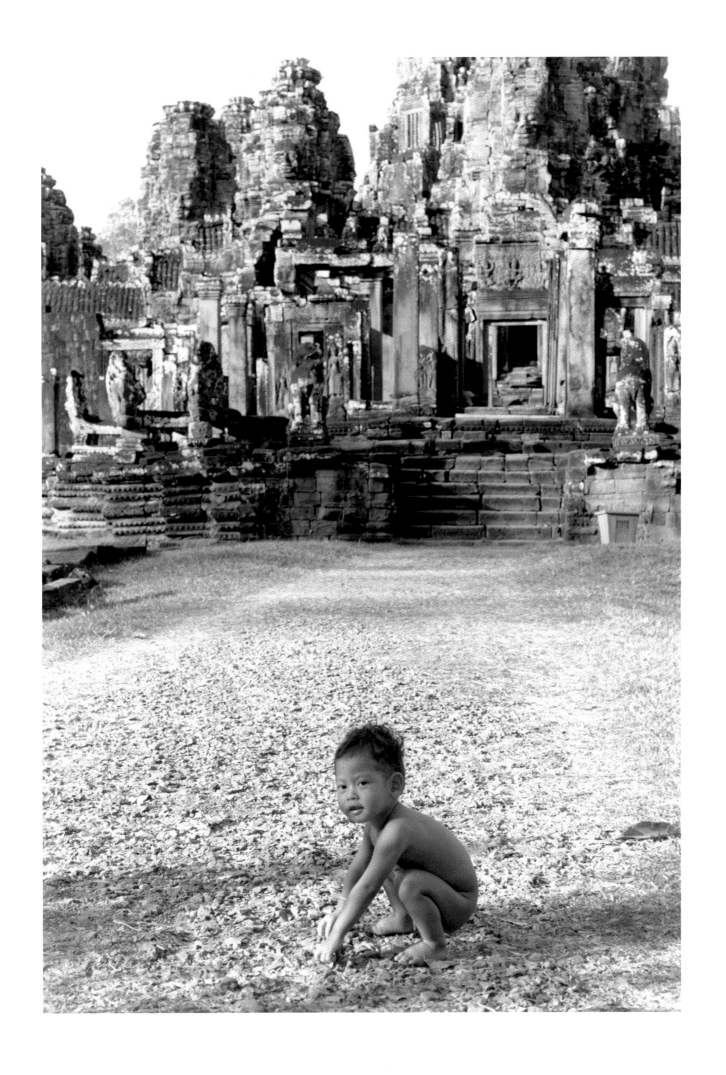

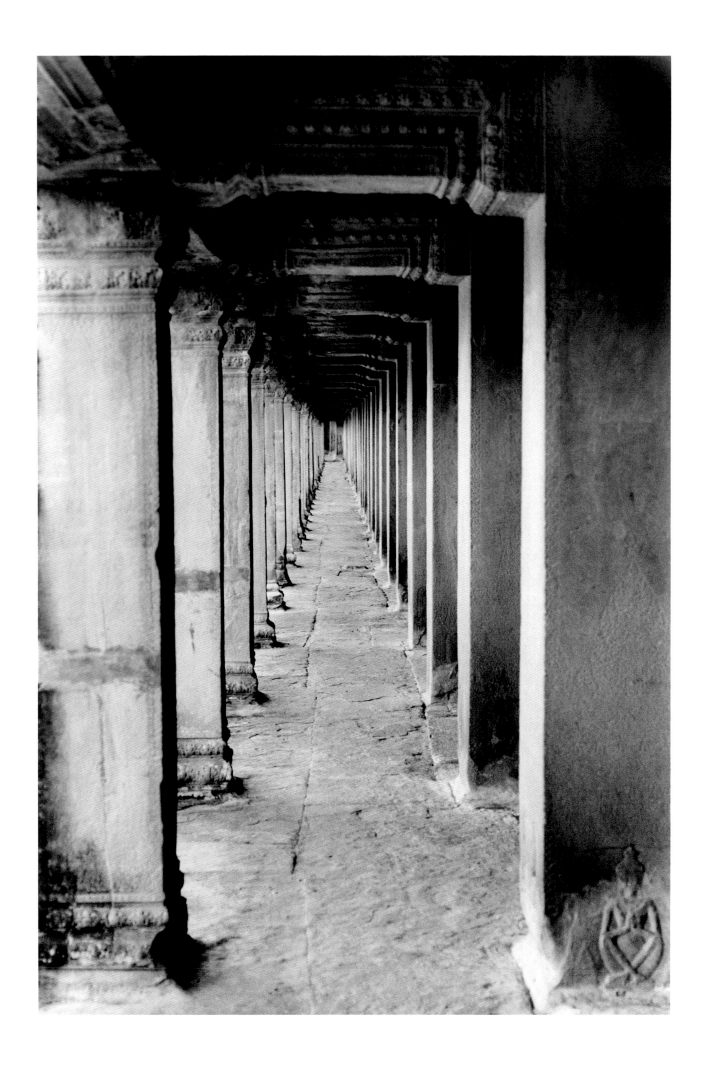

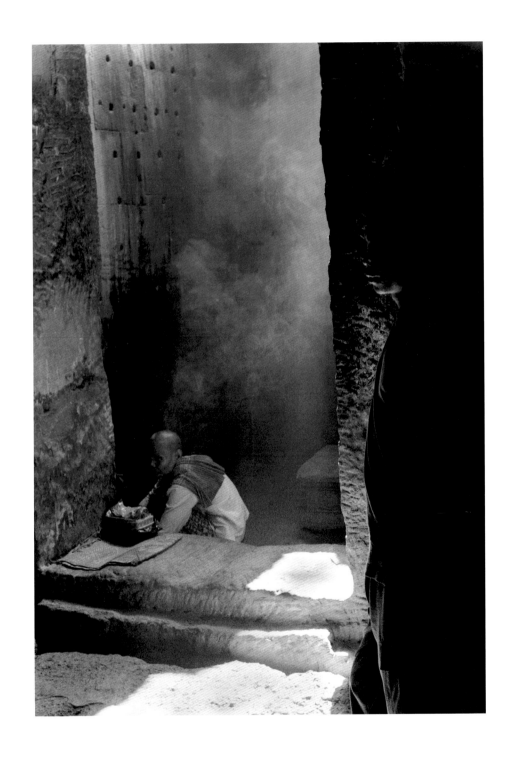

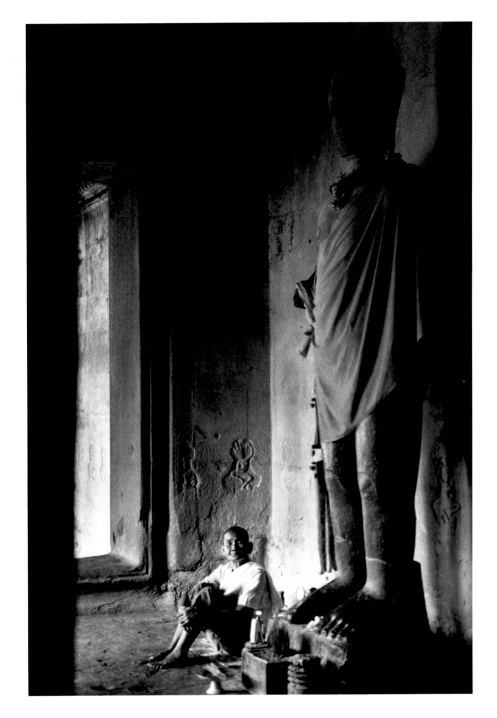

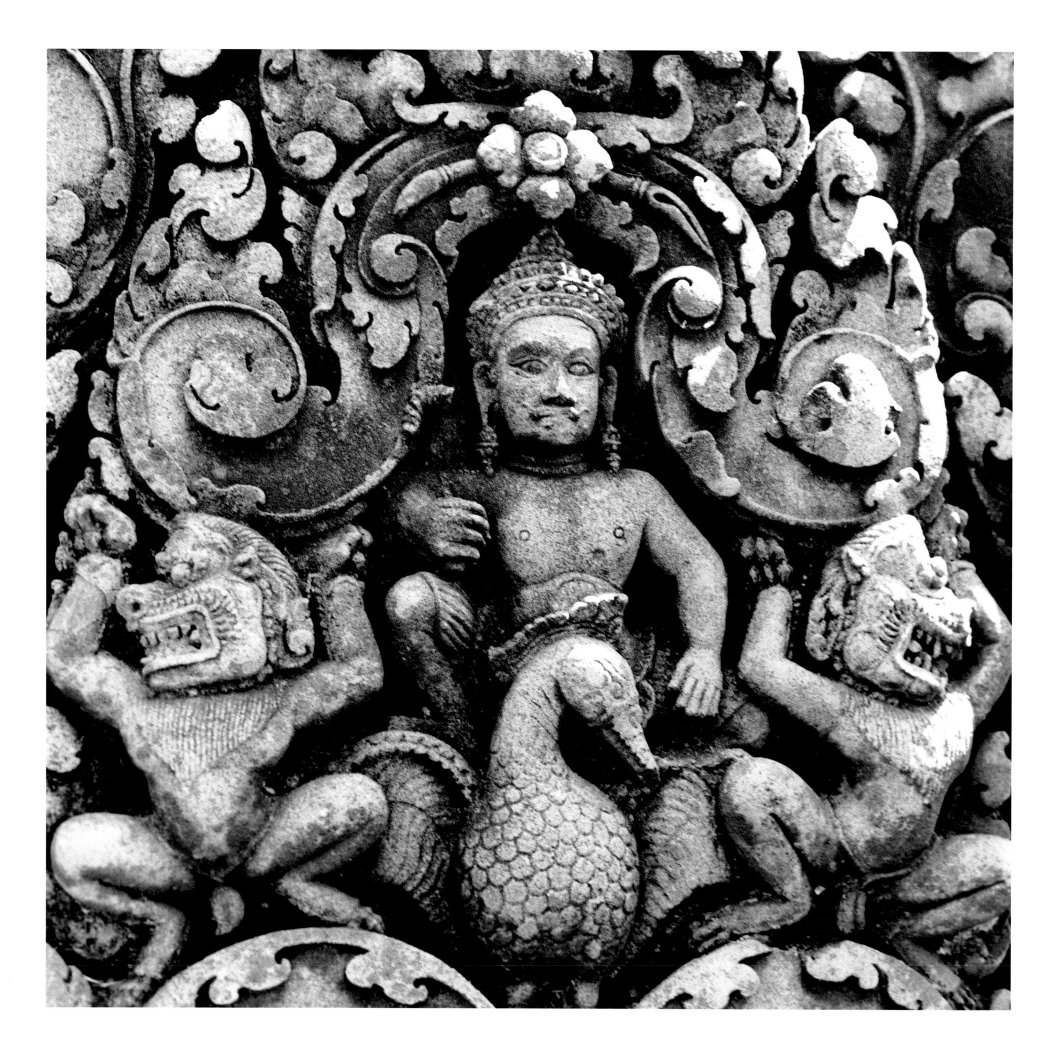

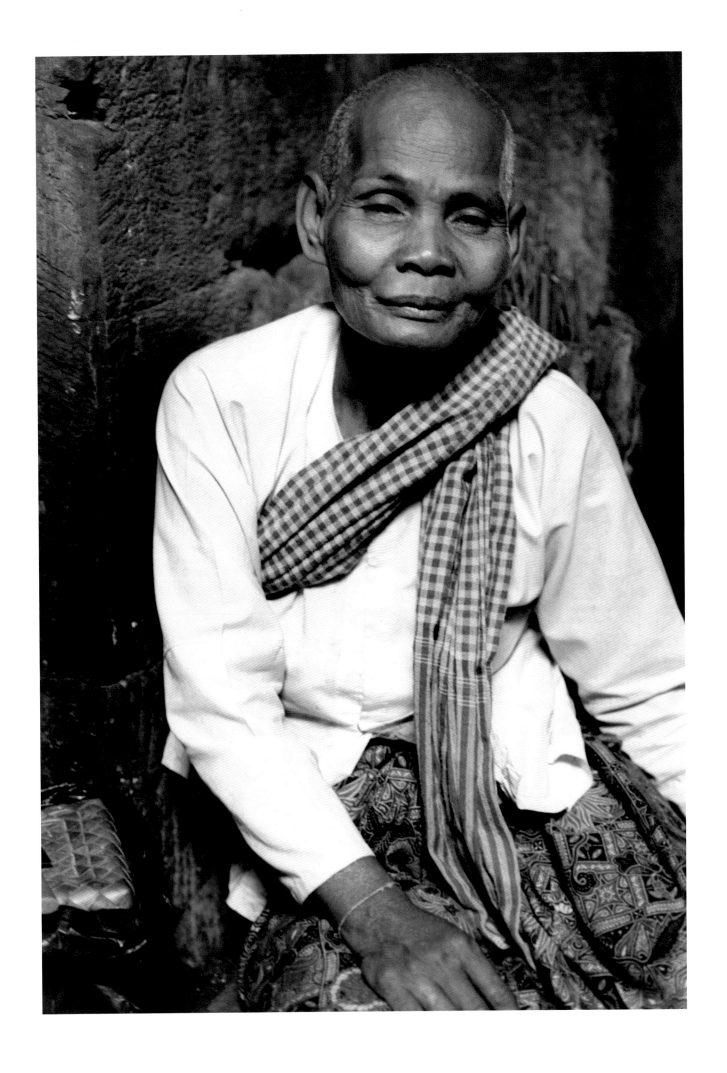

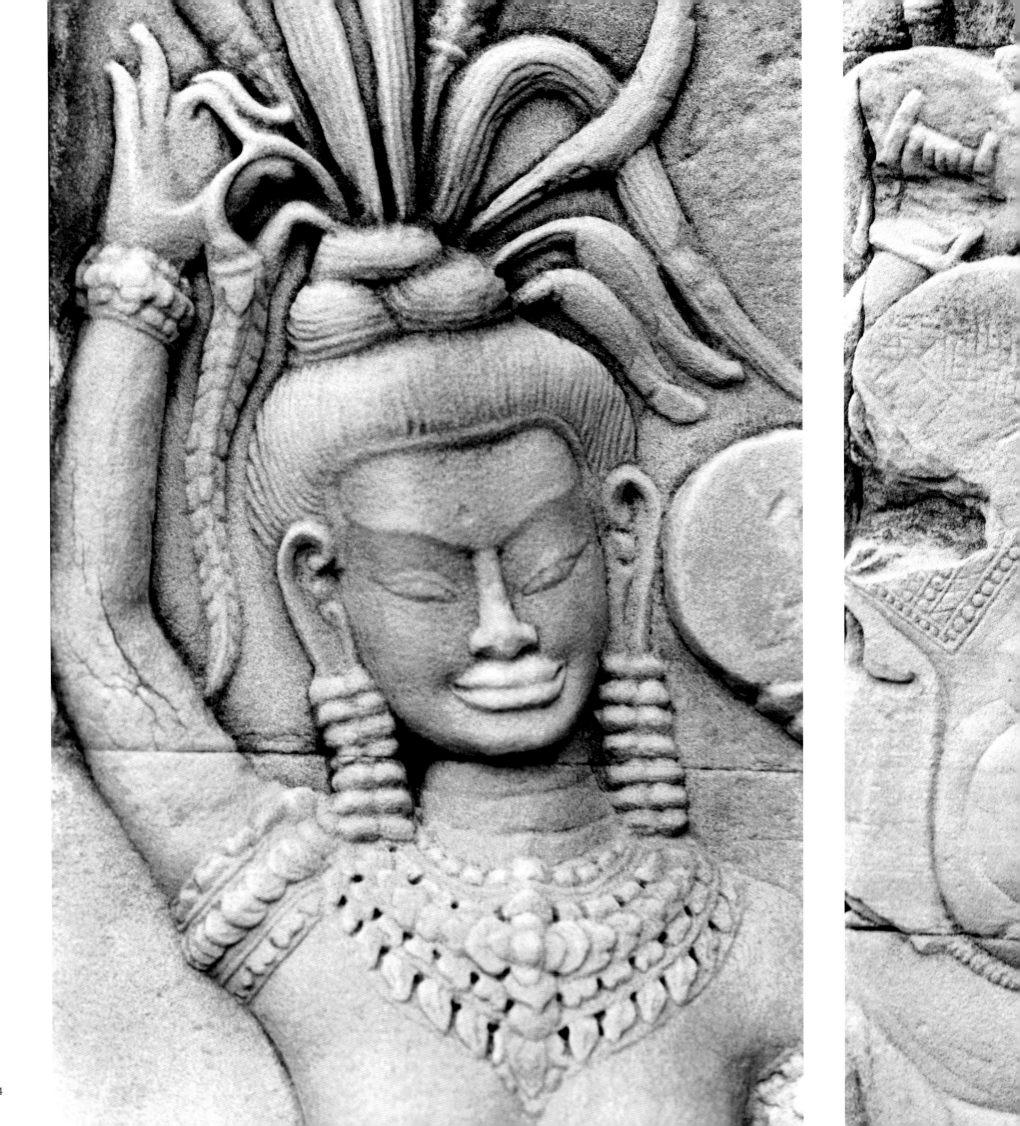

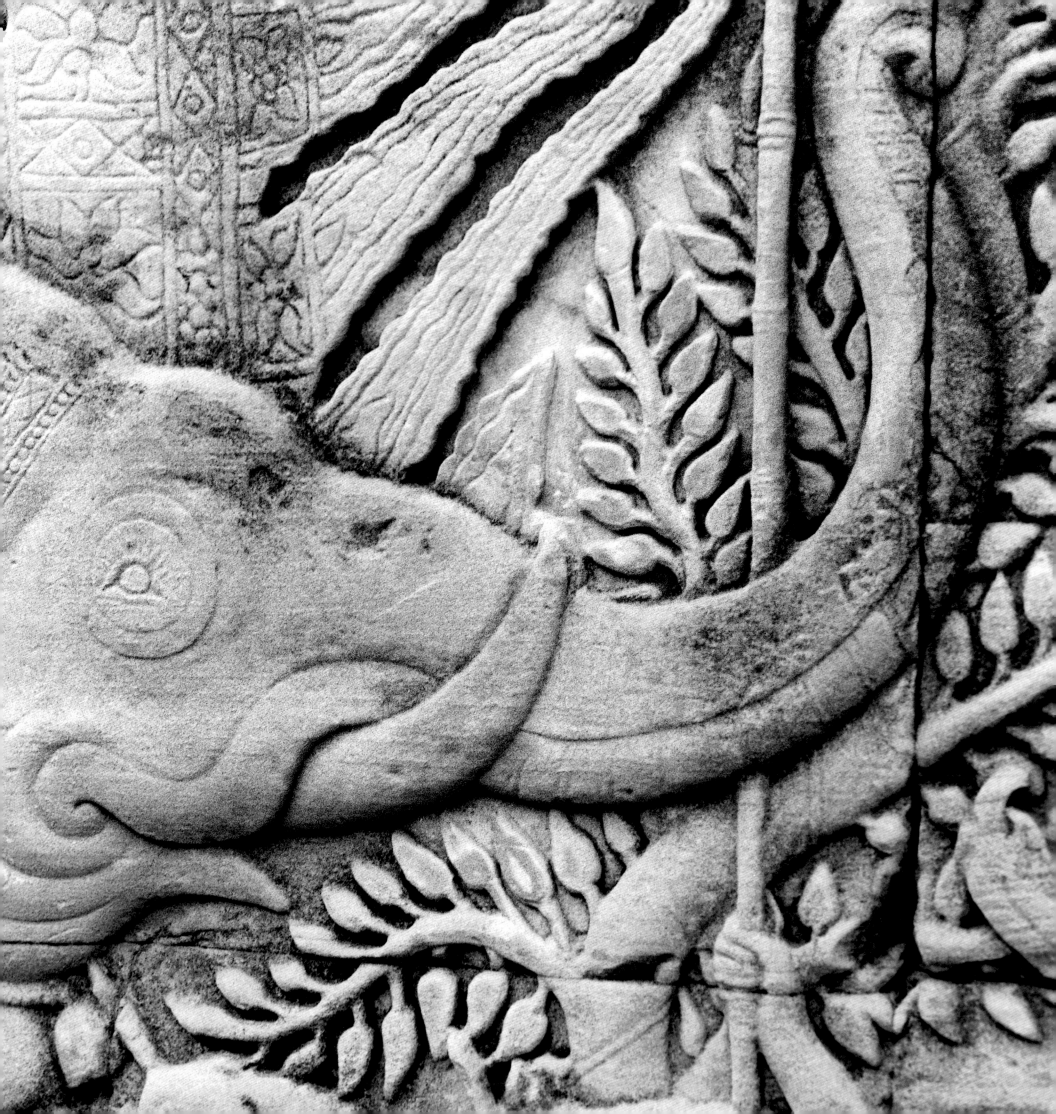

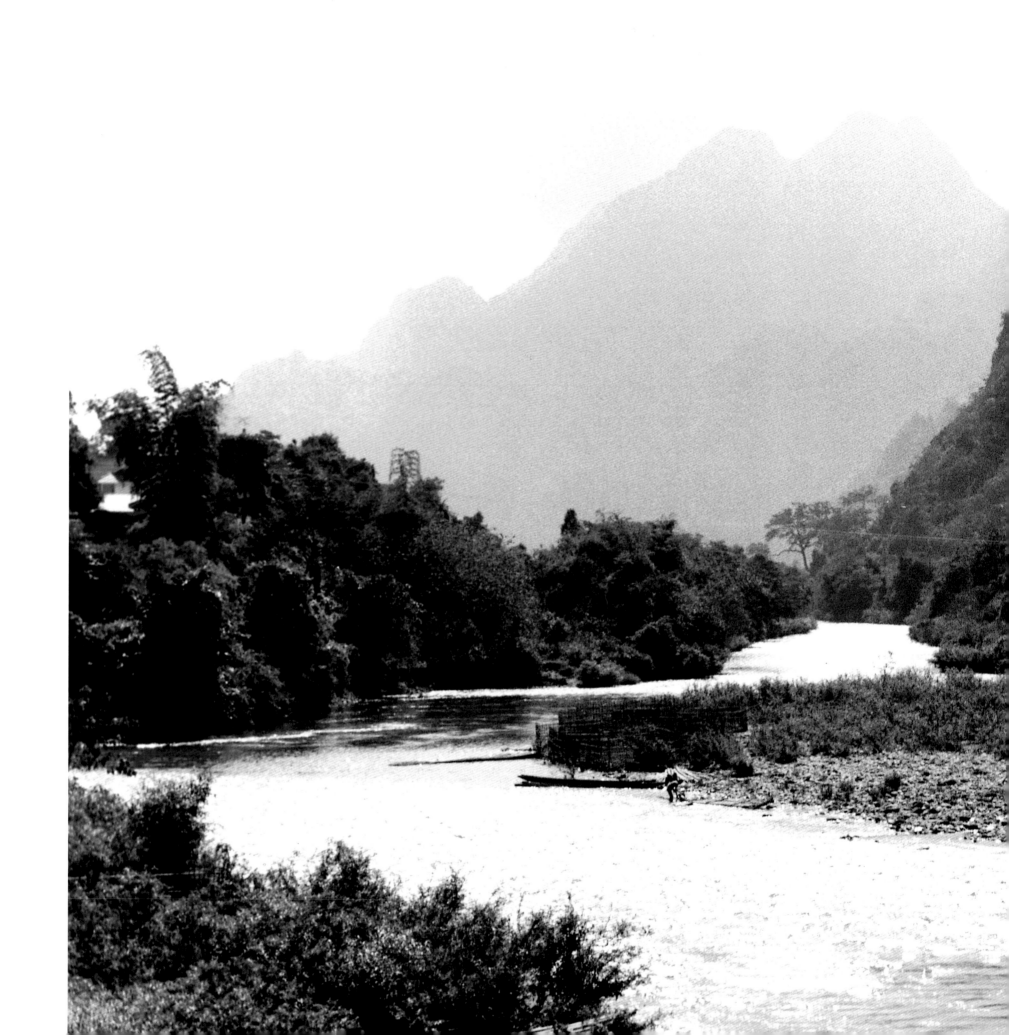

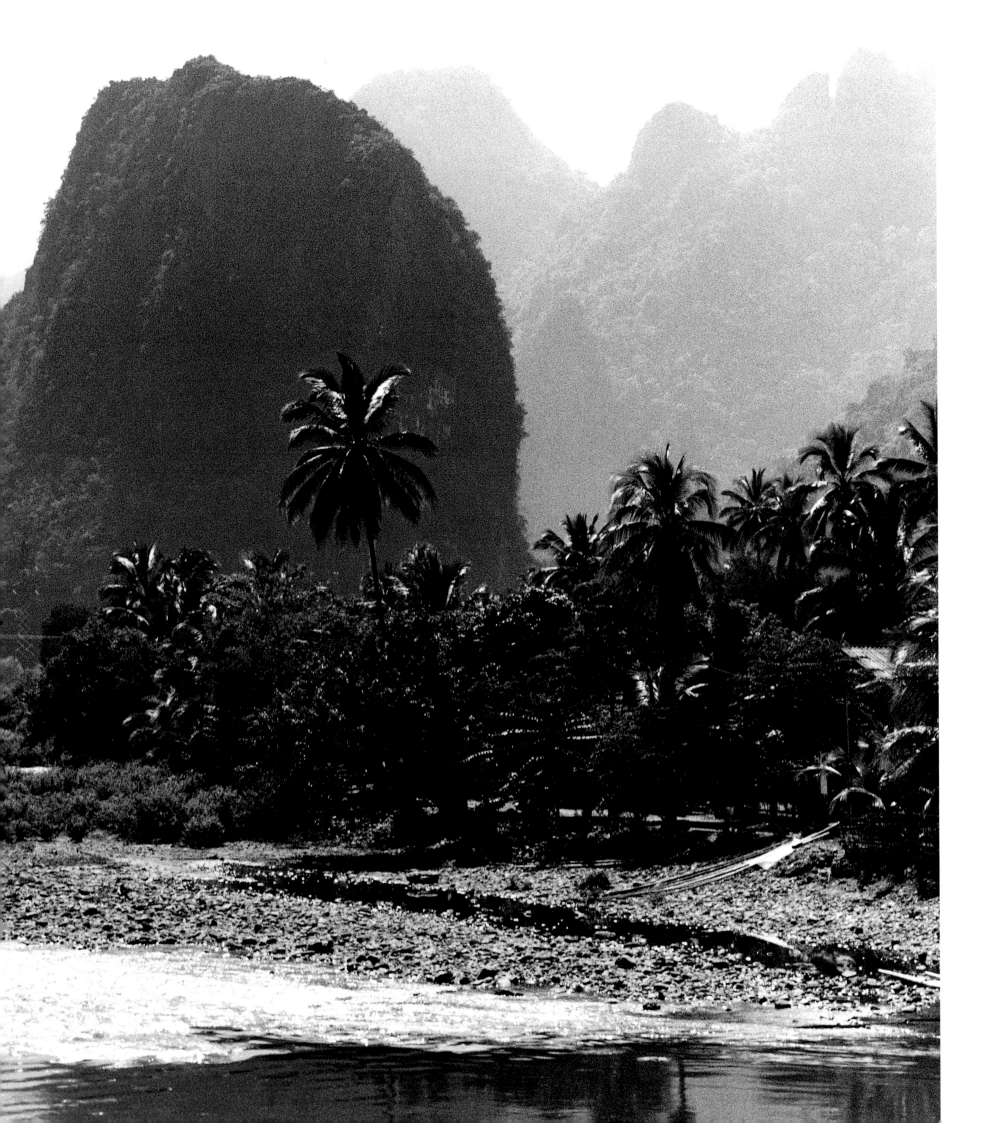

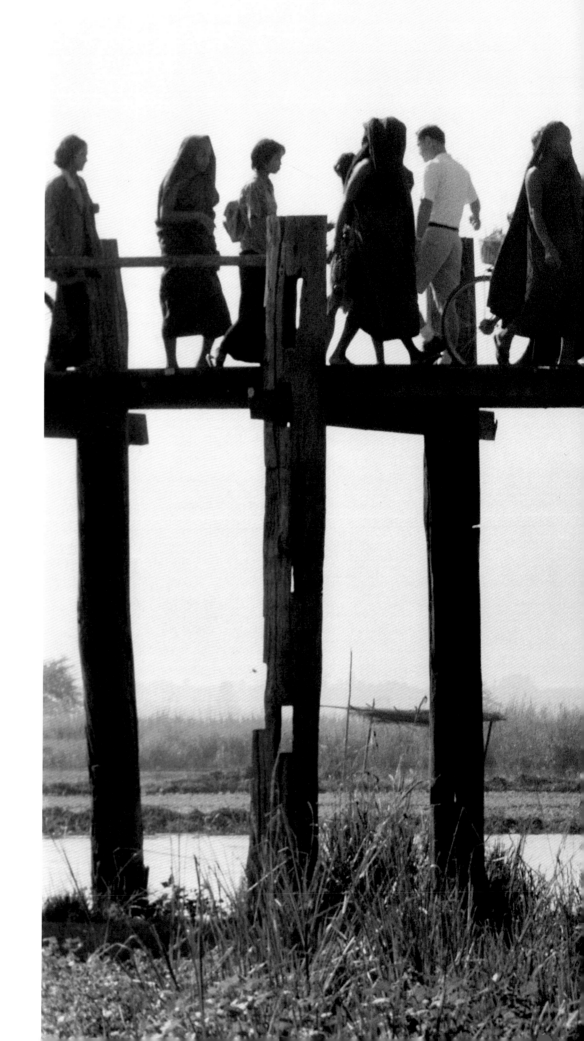

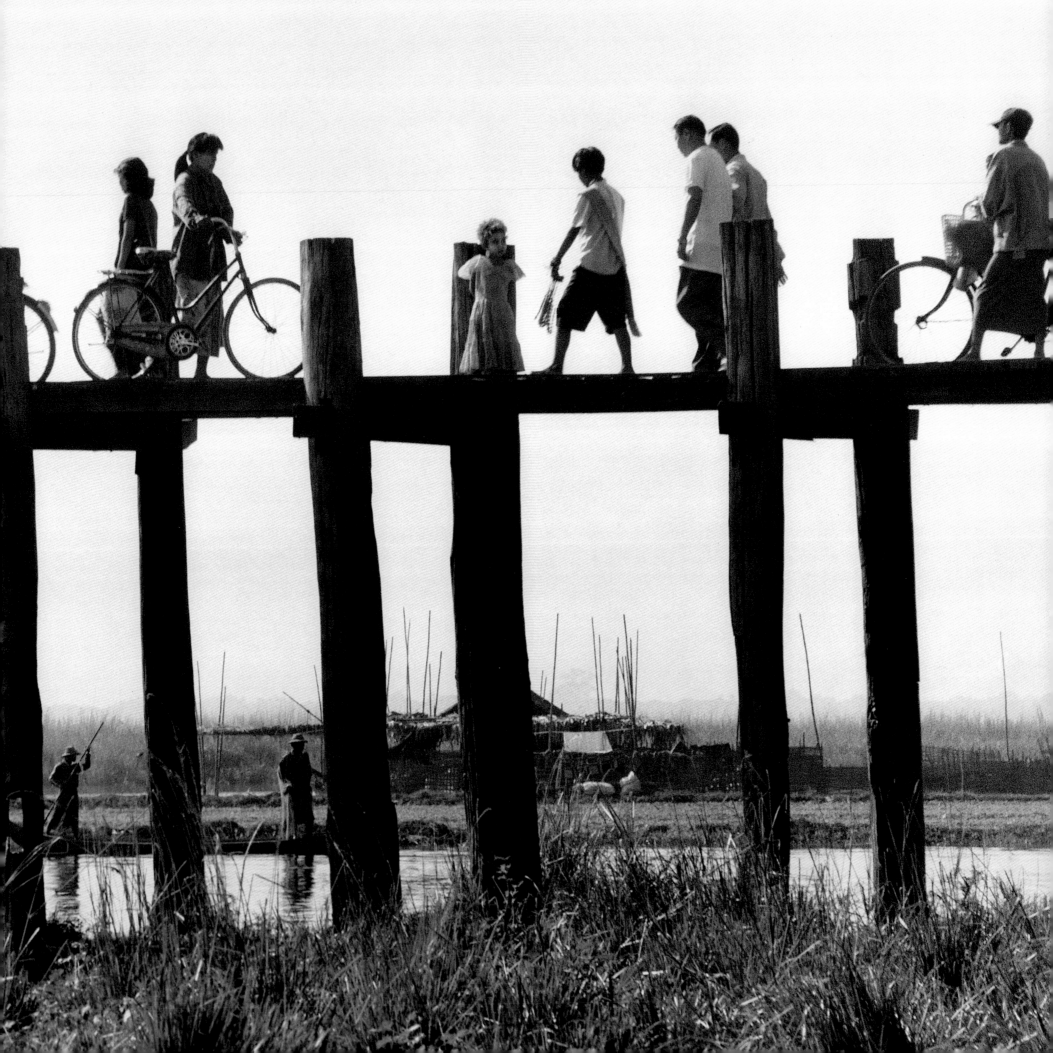

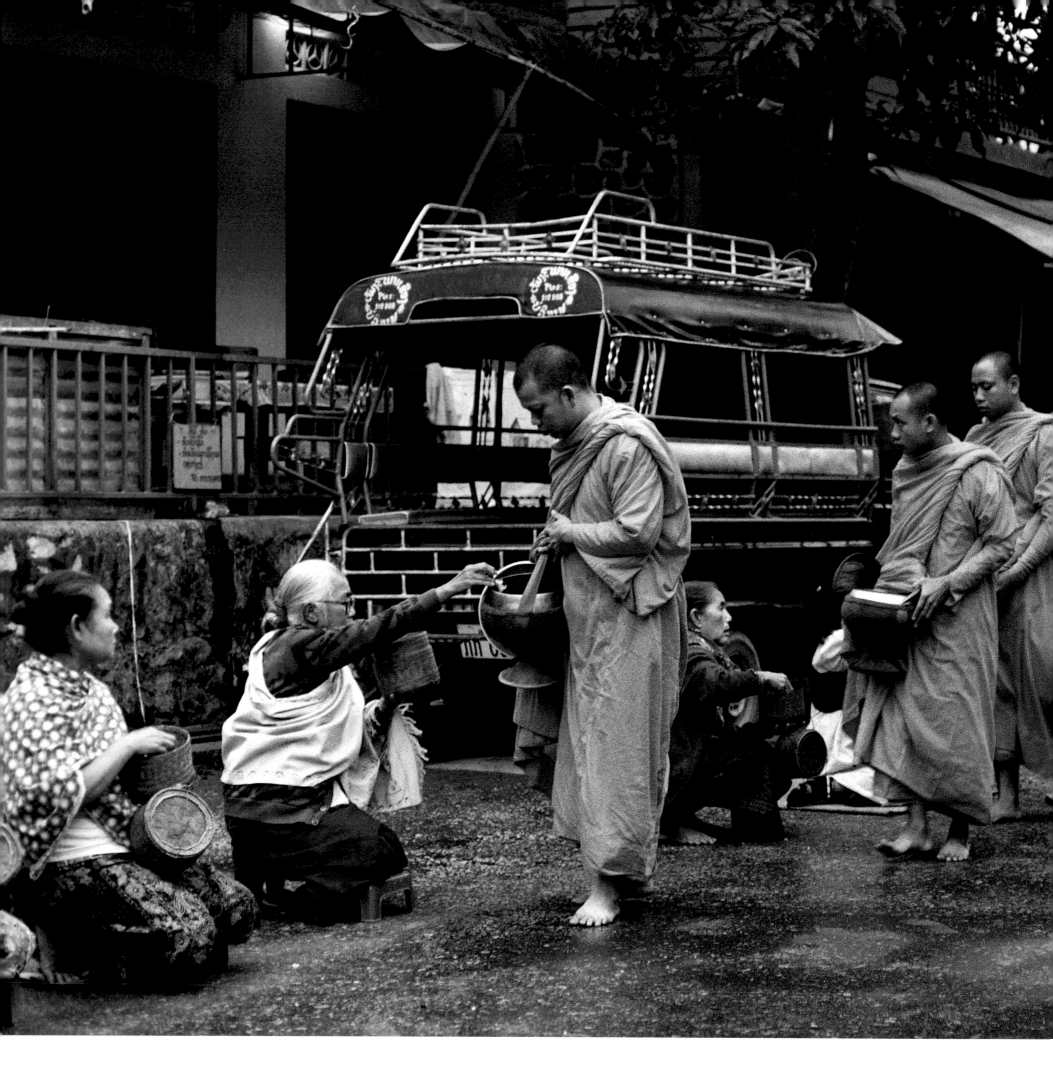

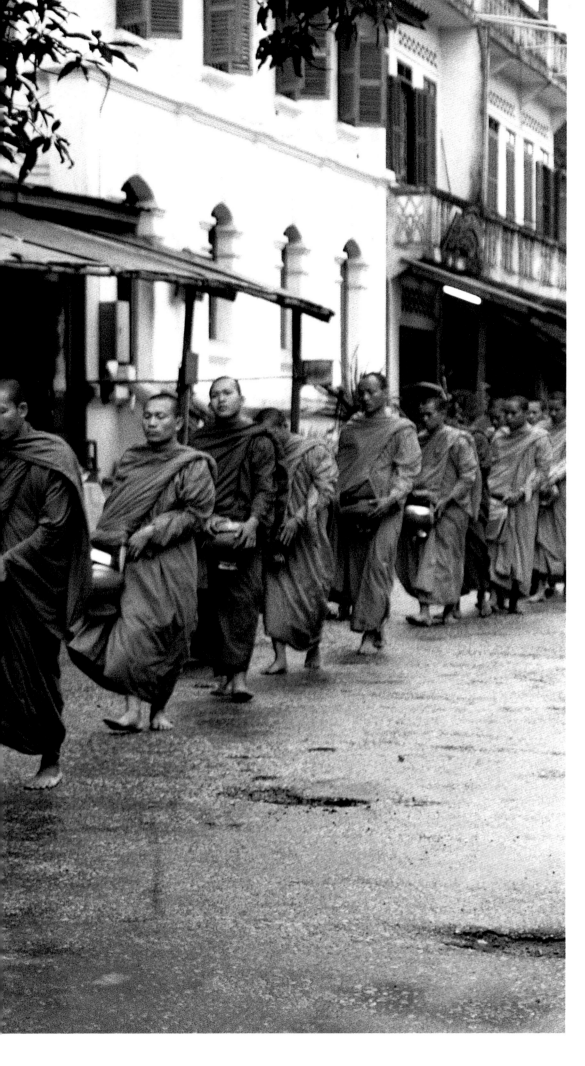

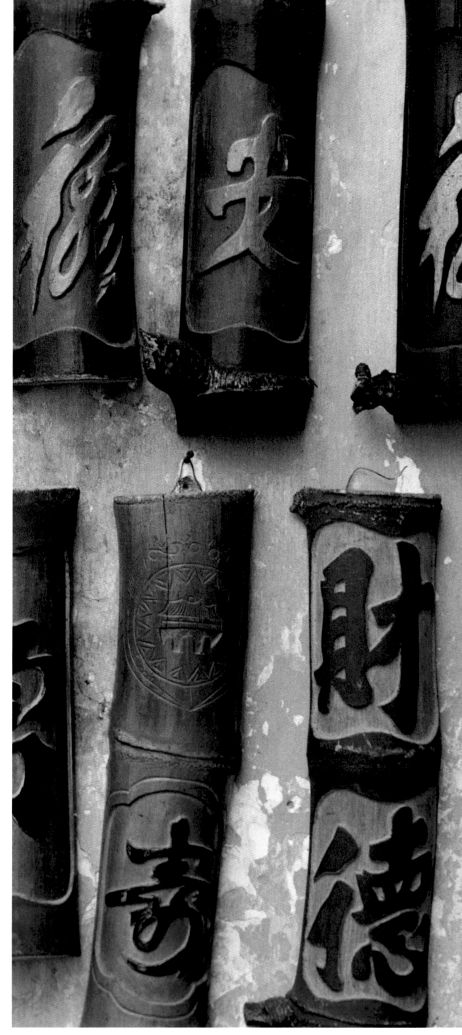

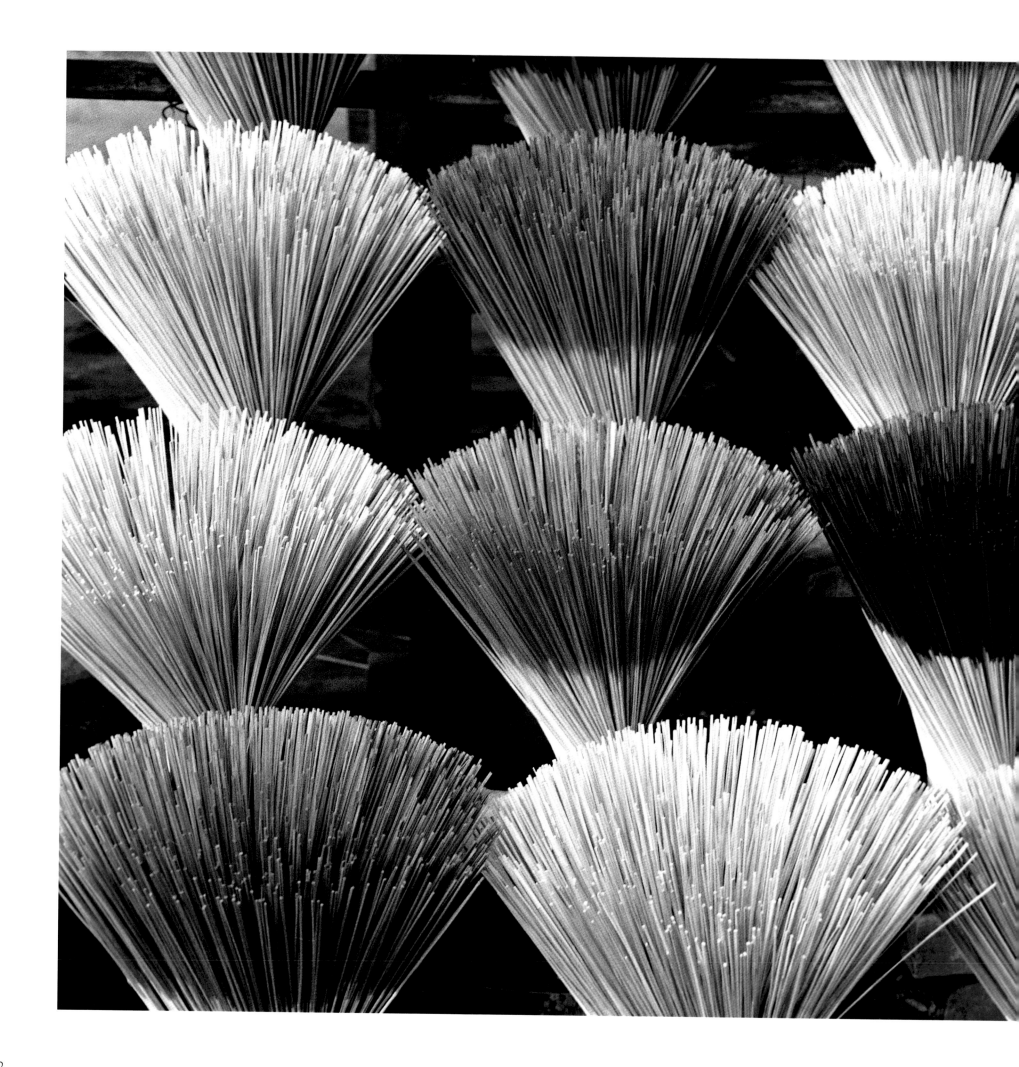

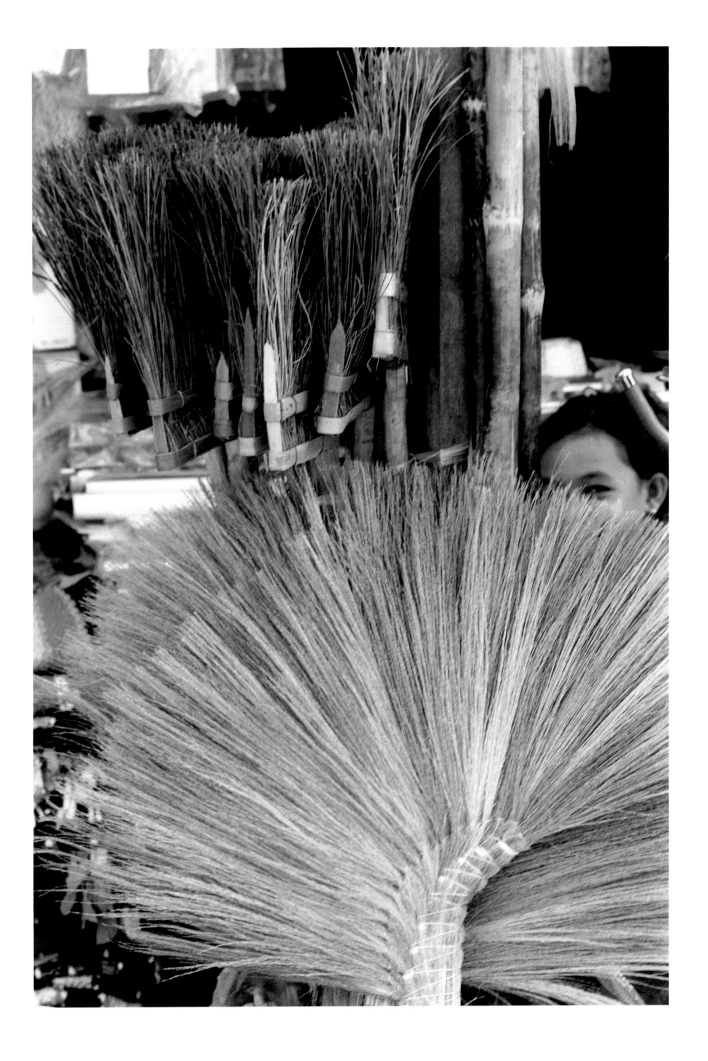

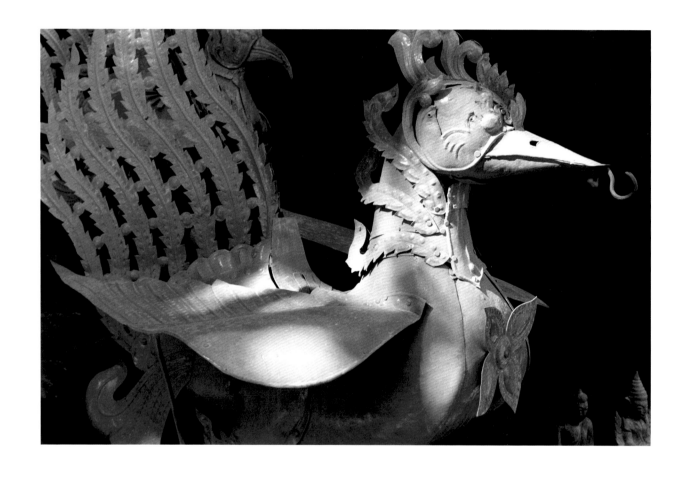

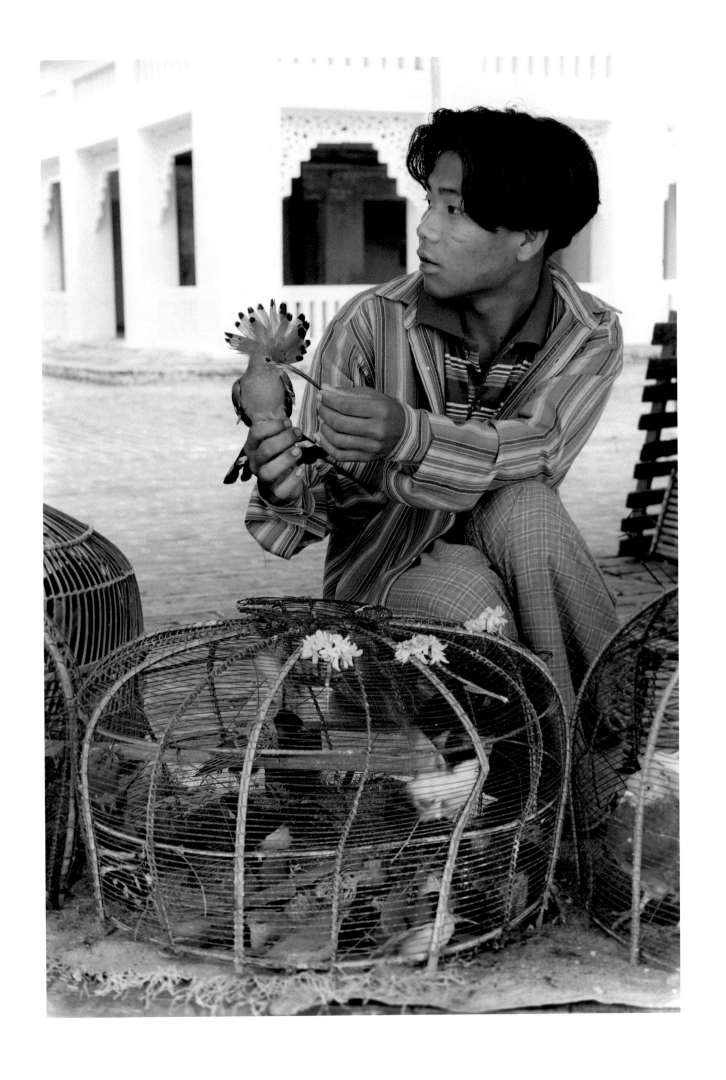

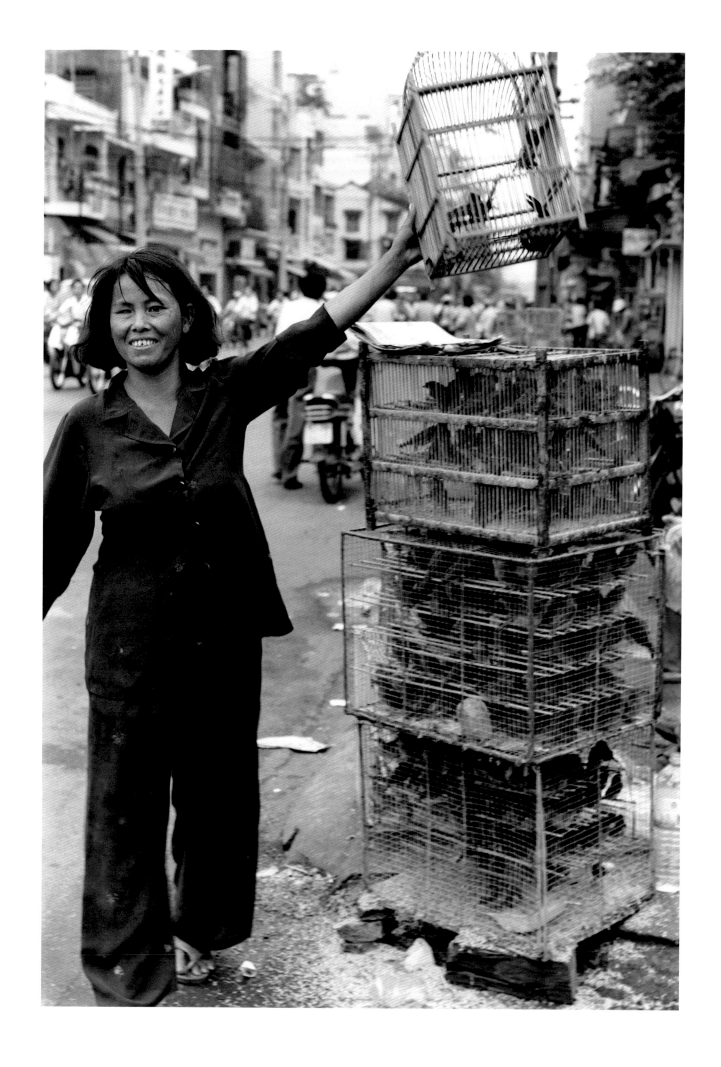

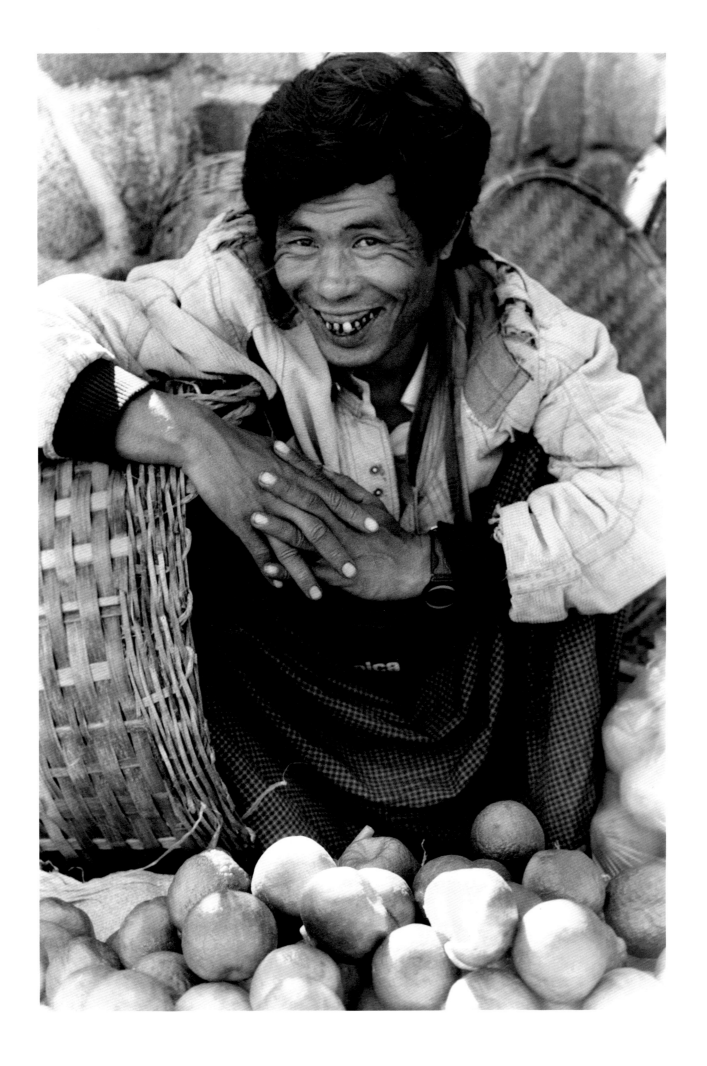

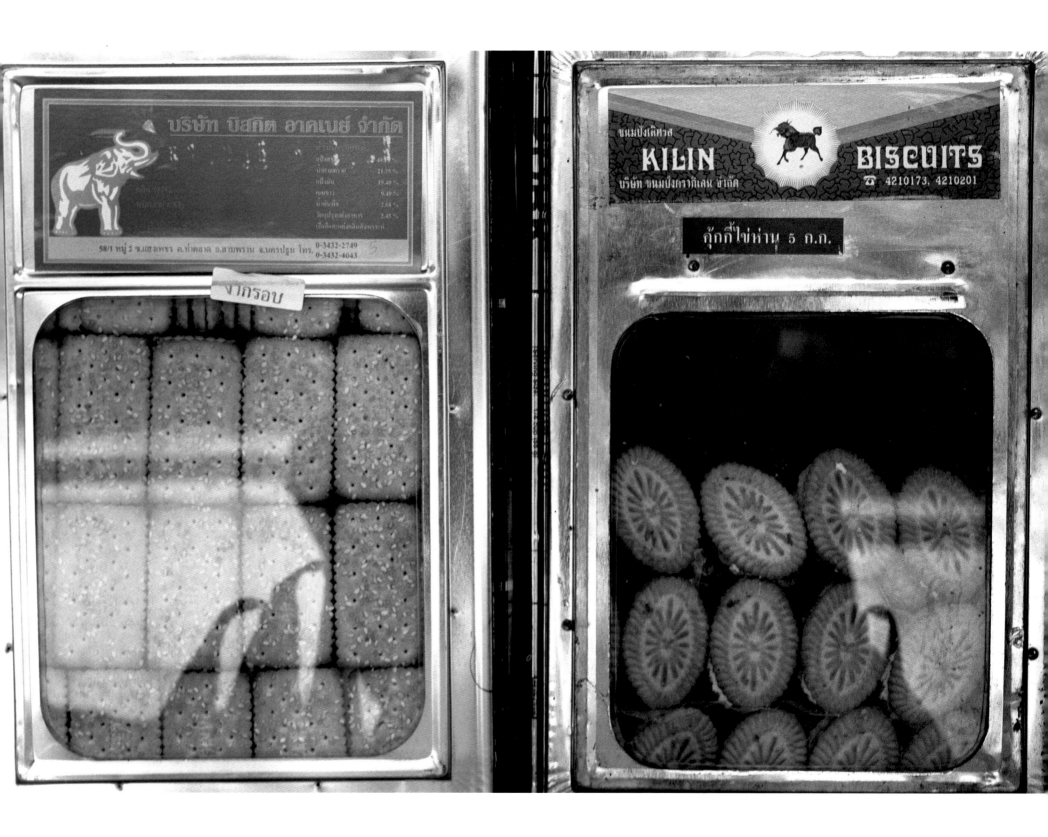

58

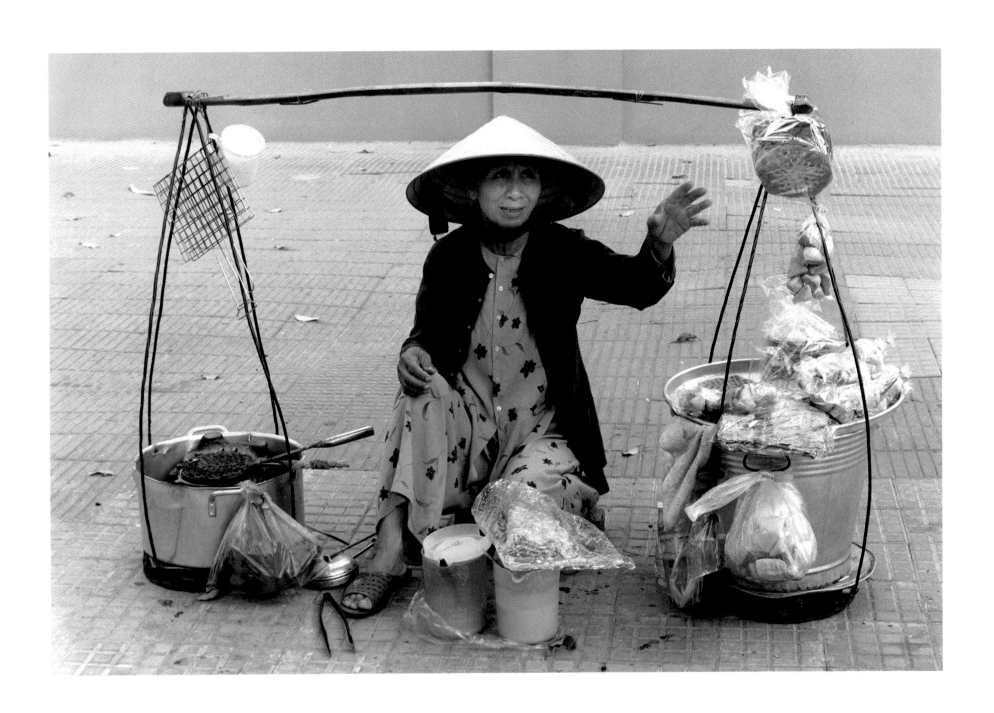

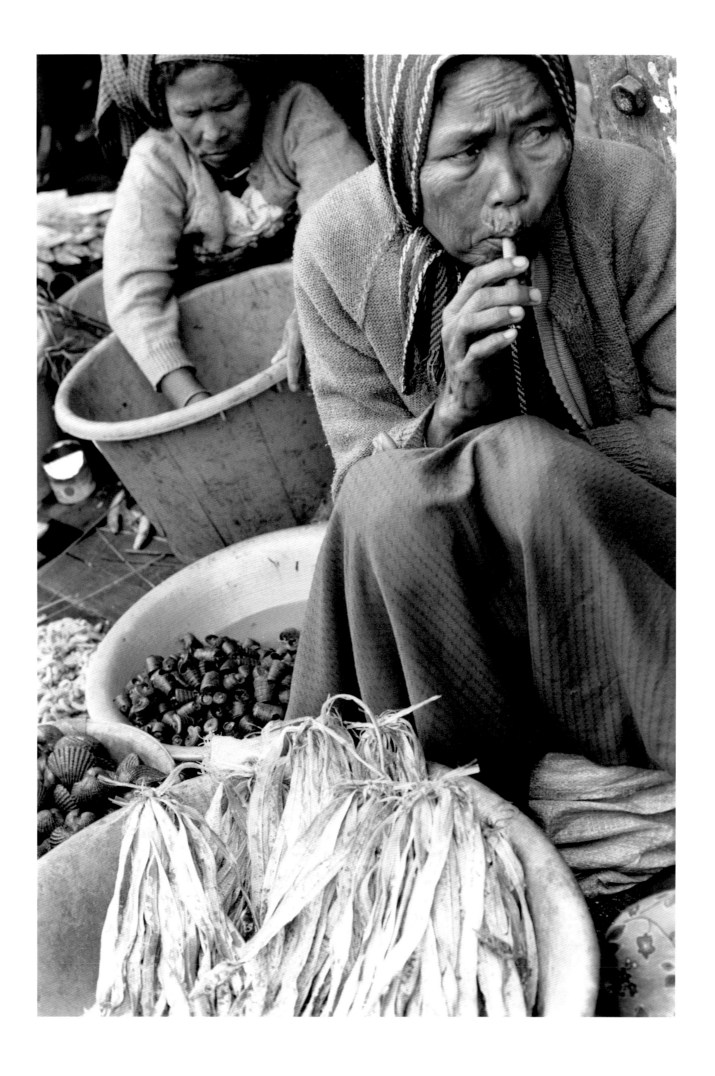

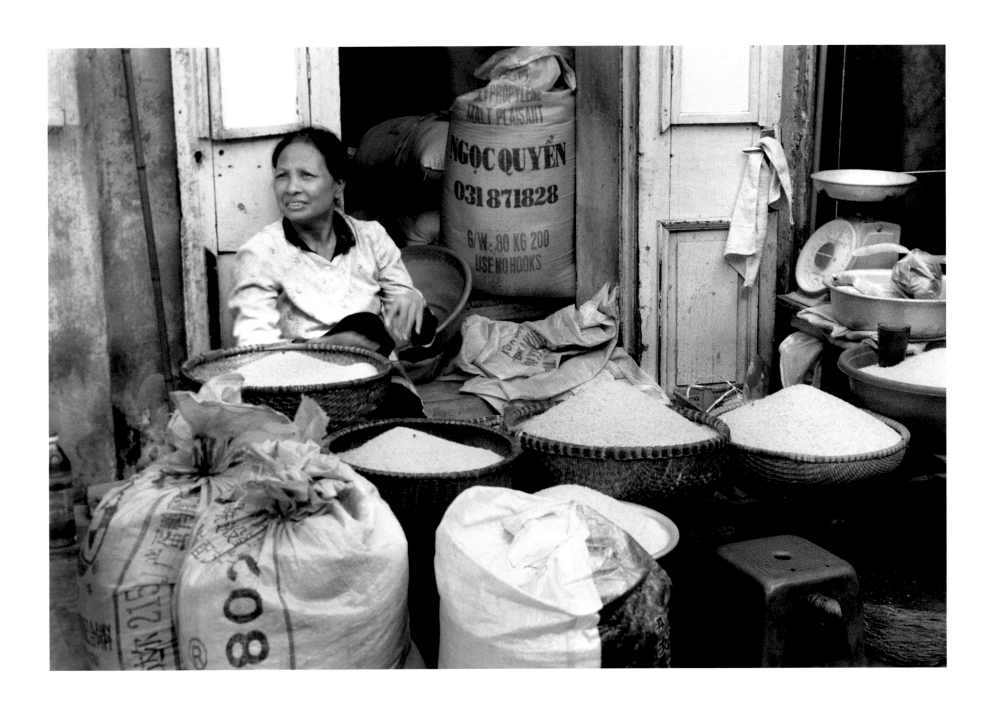

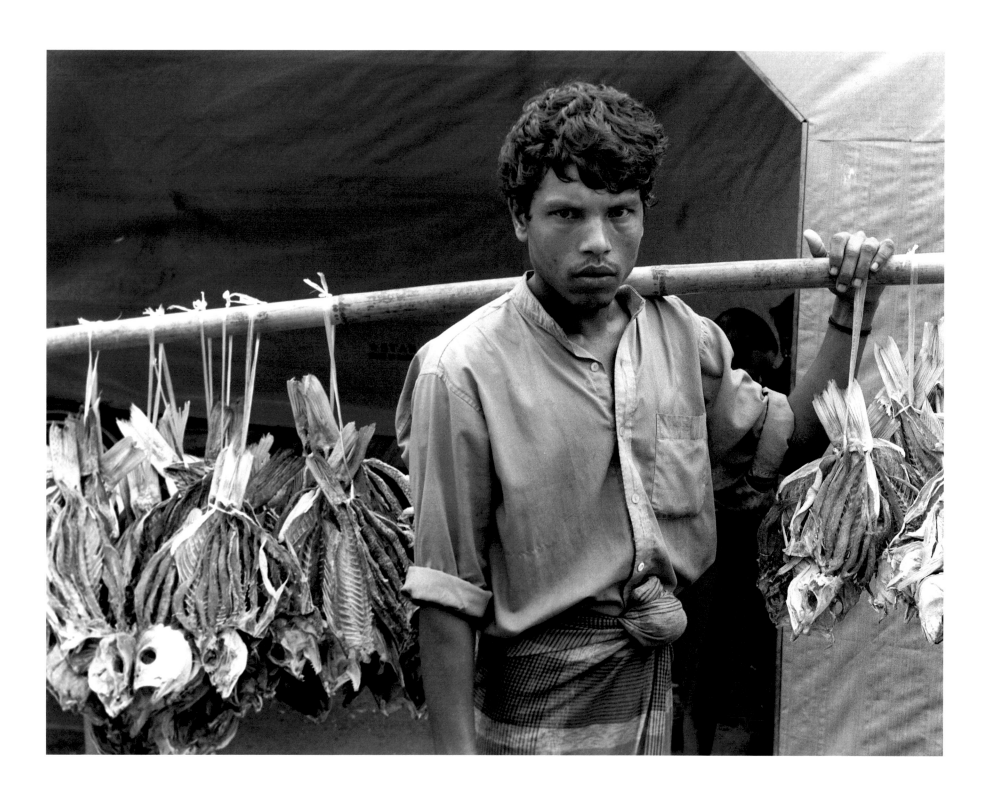

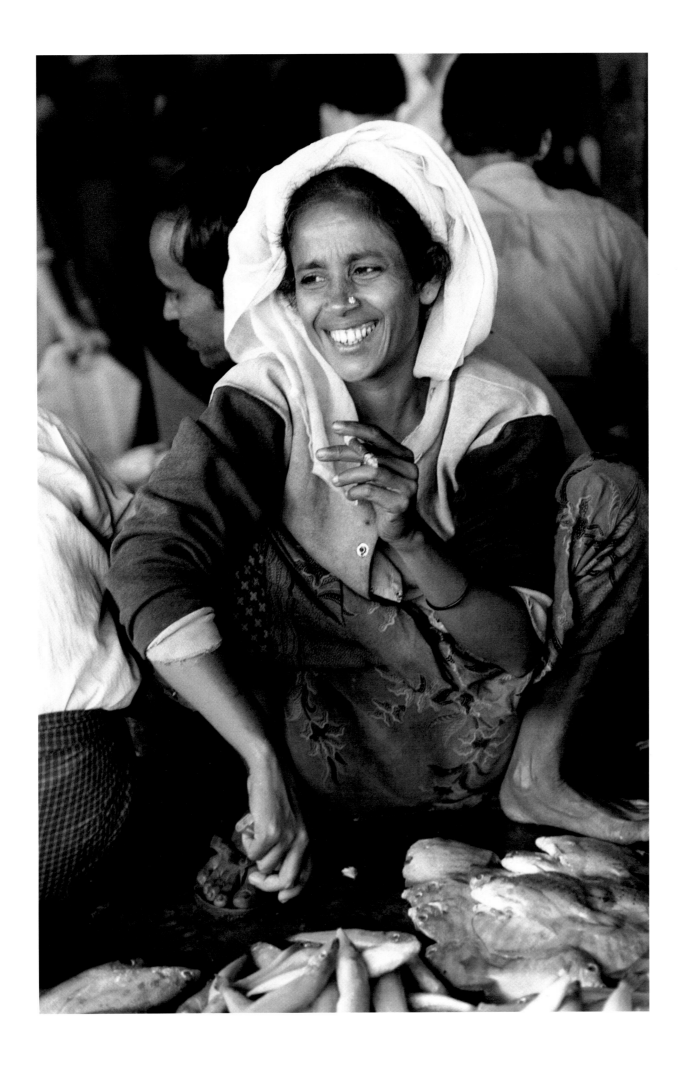

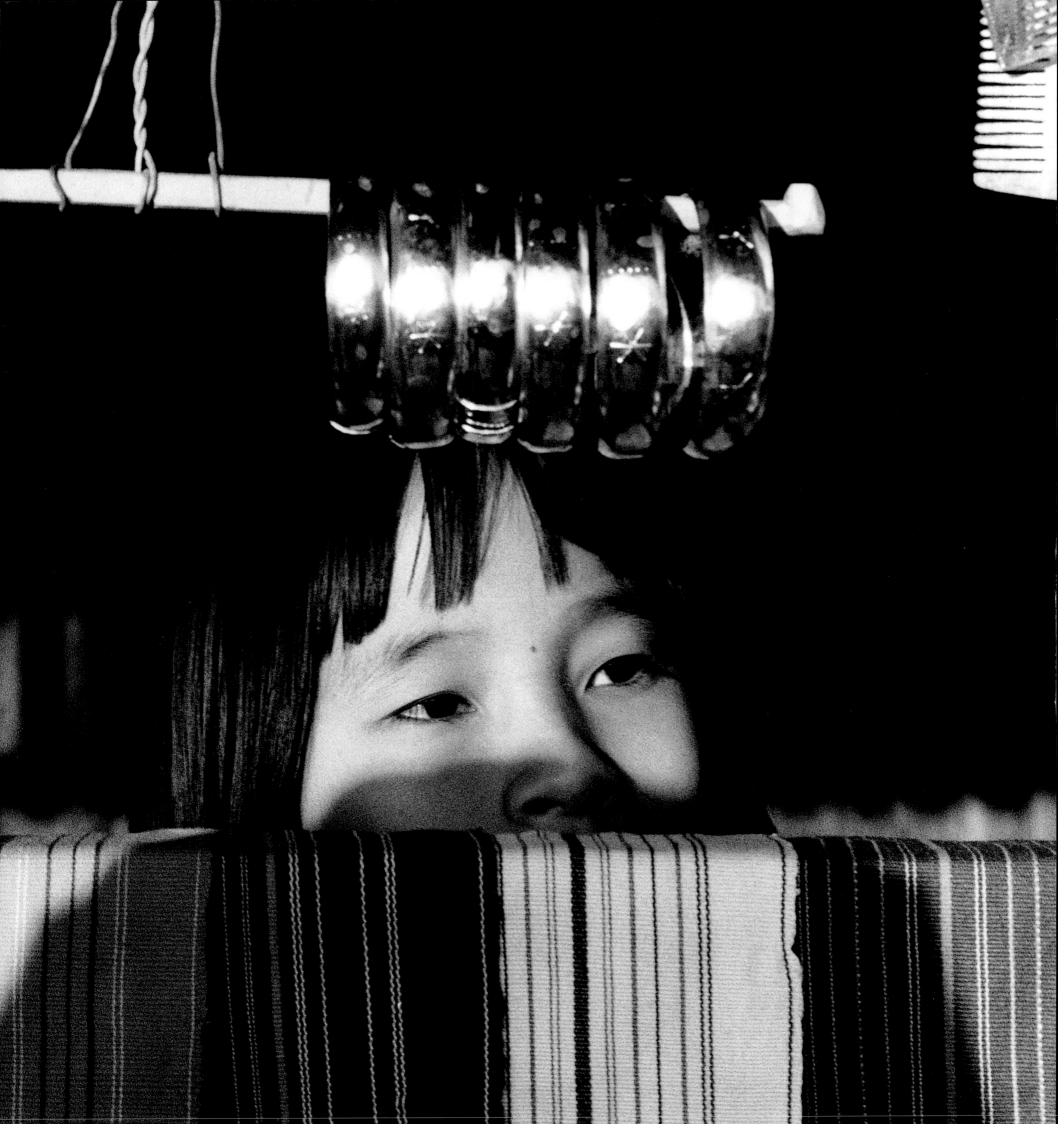

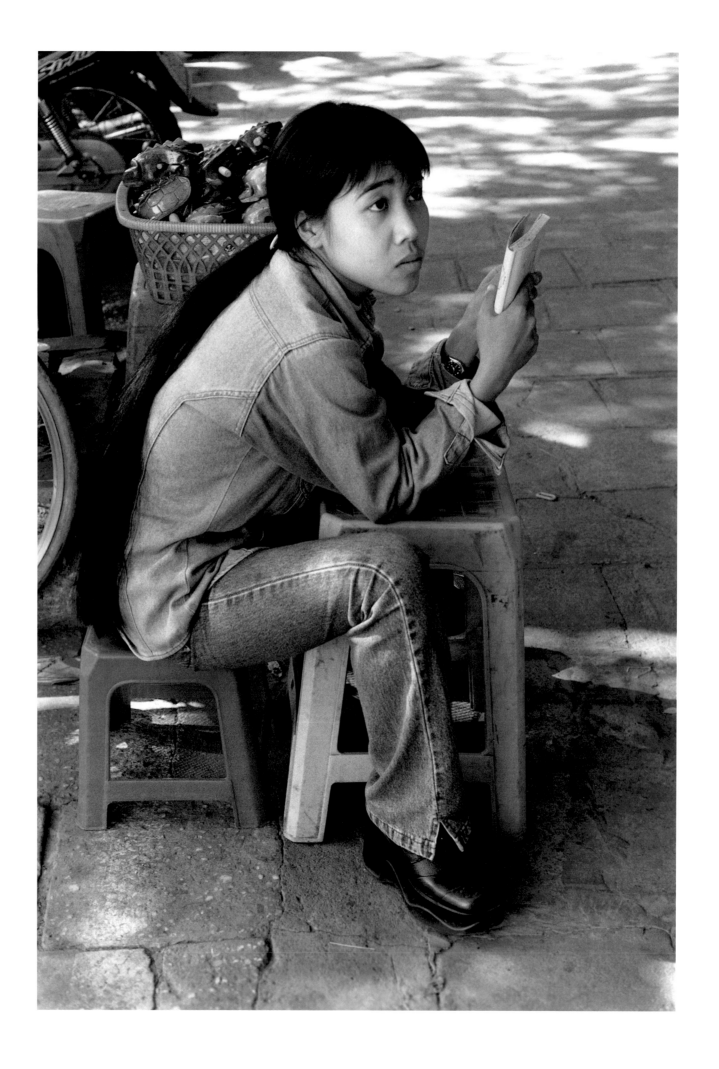

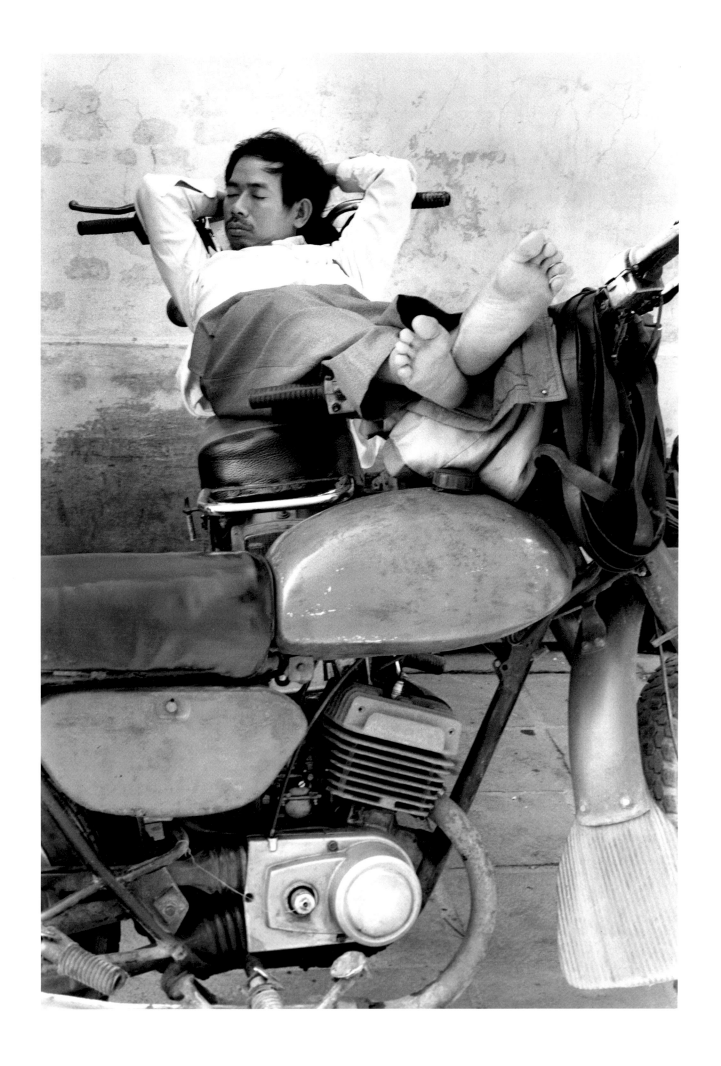

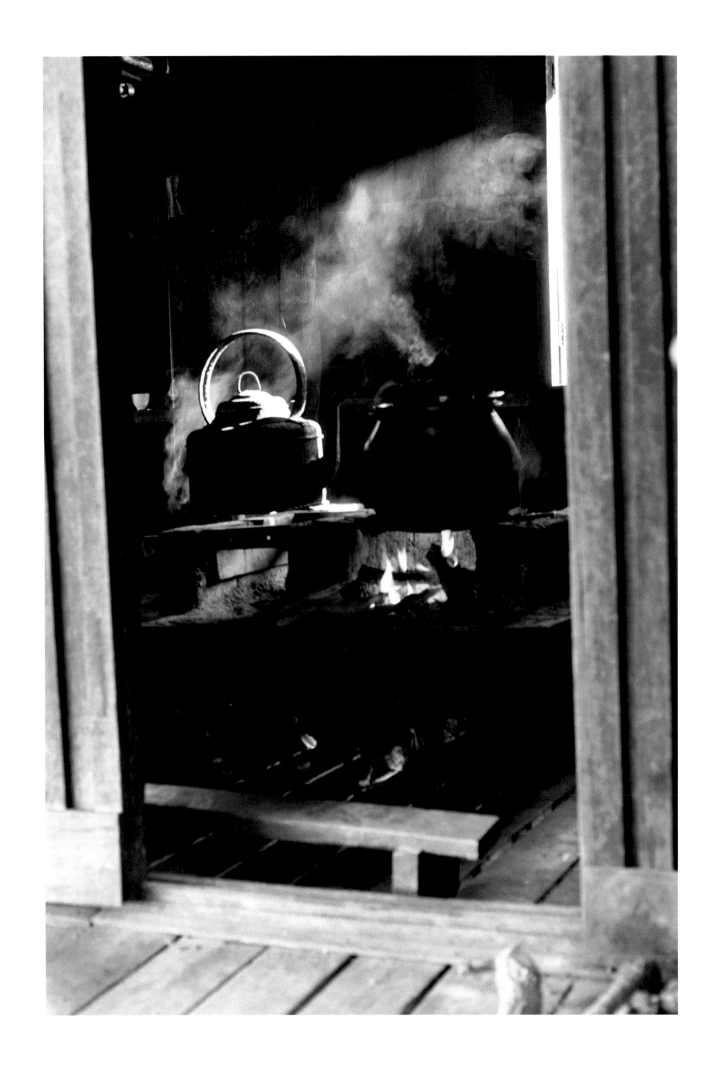

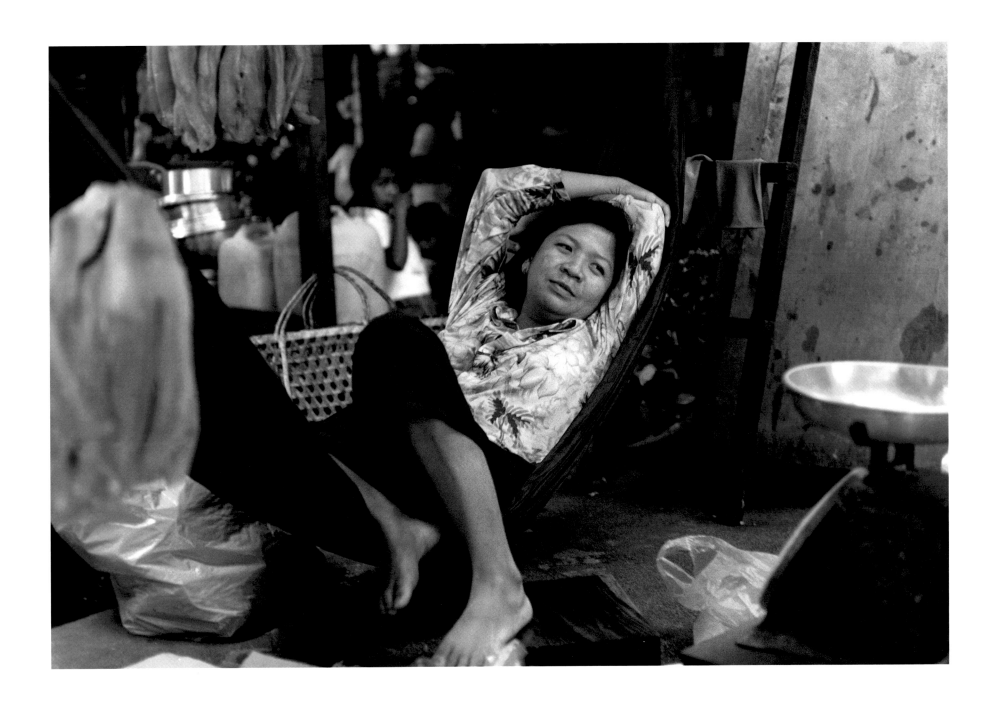

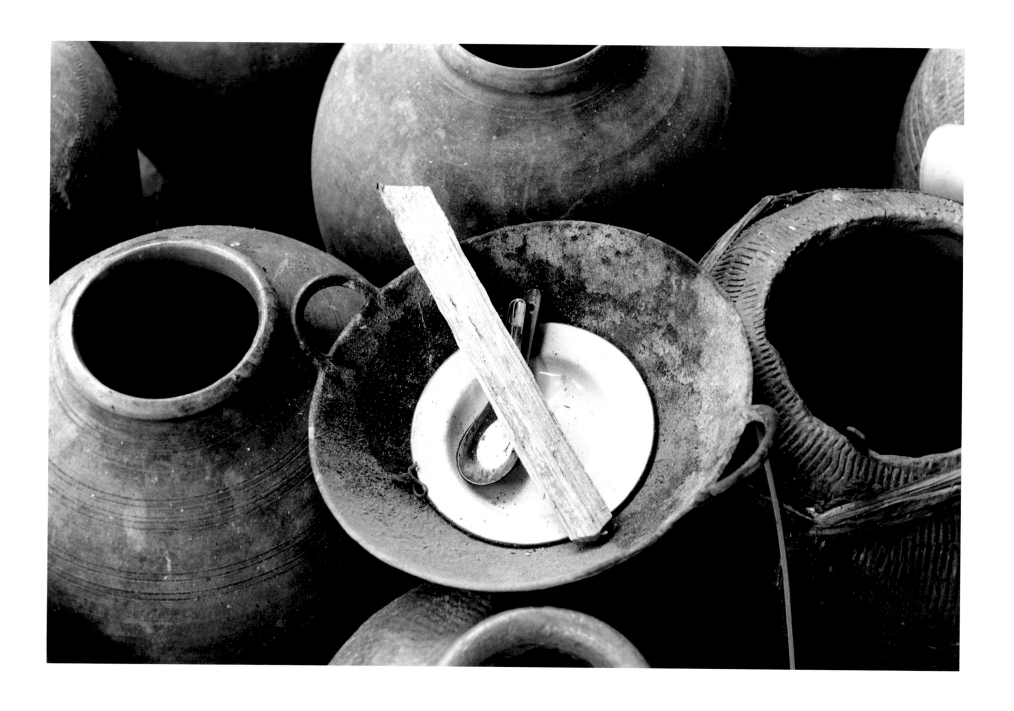

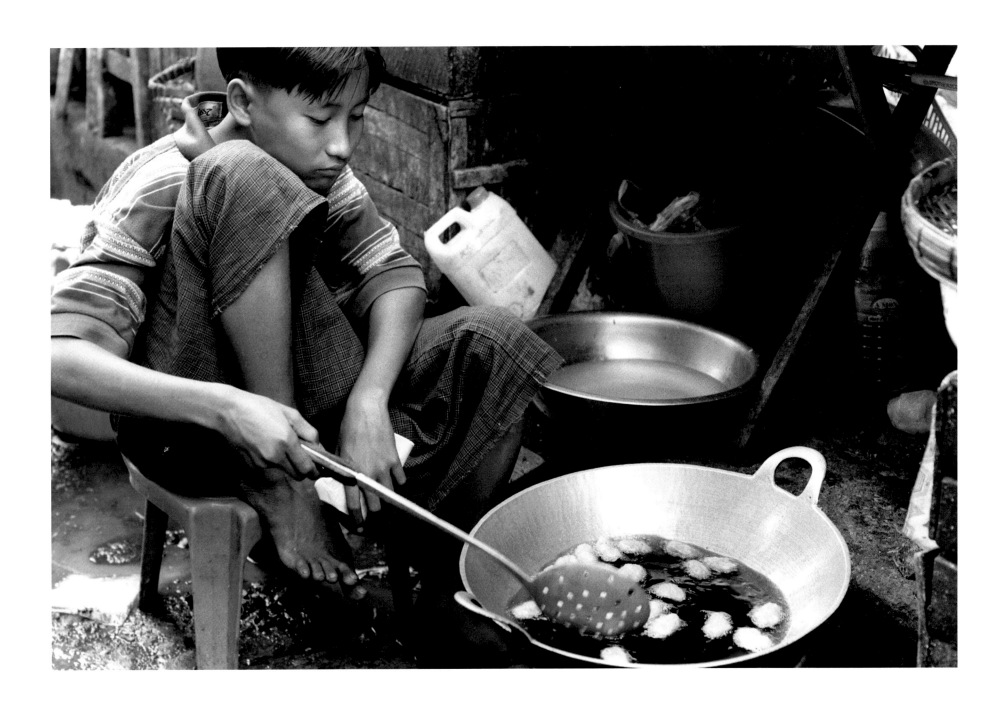

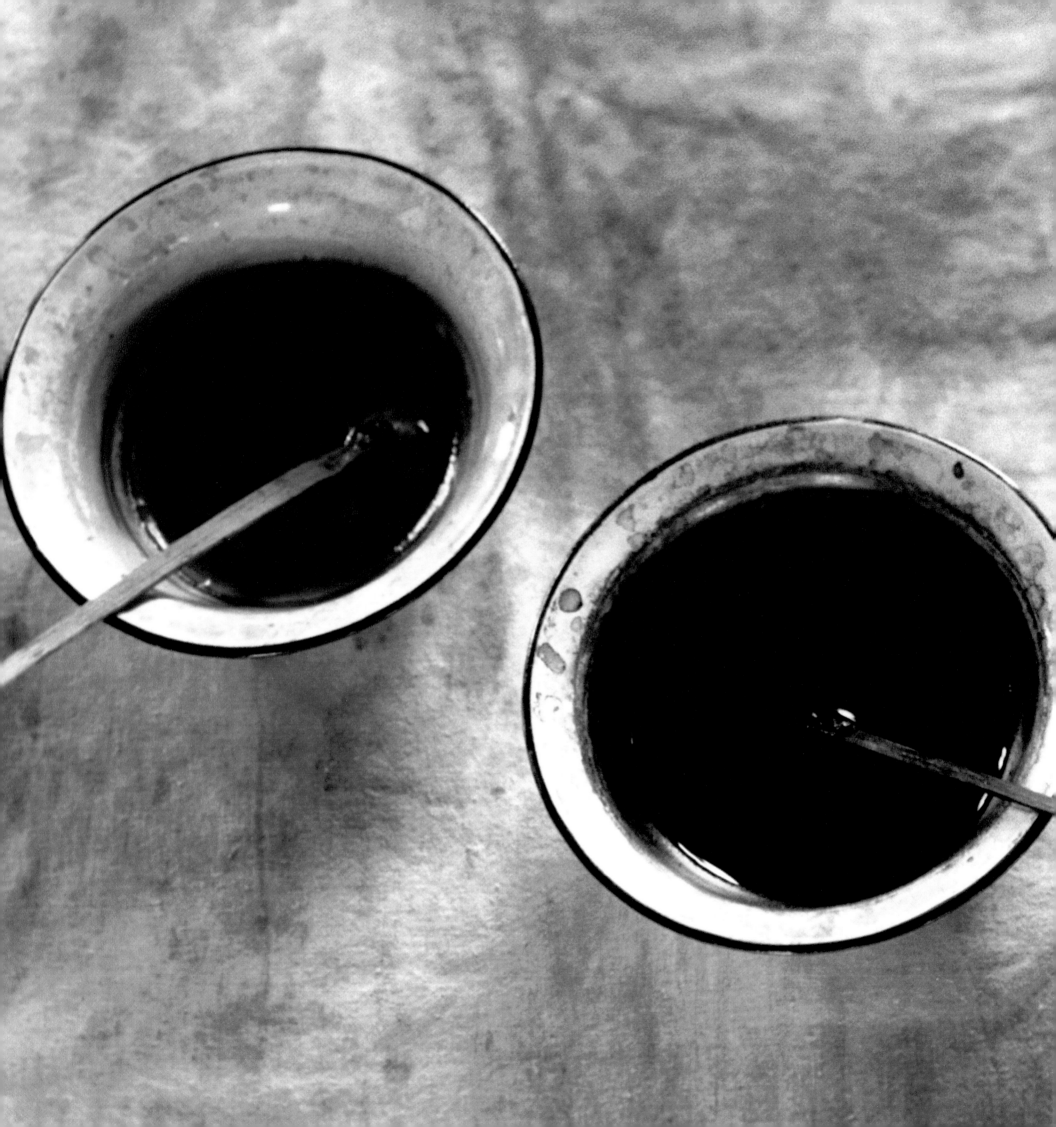

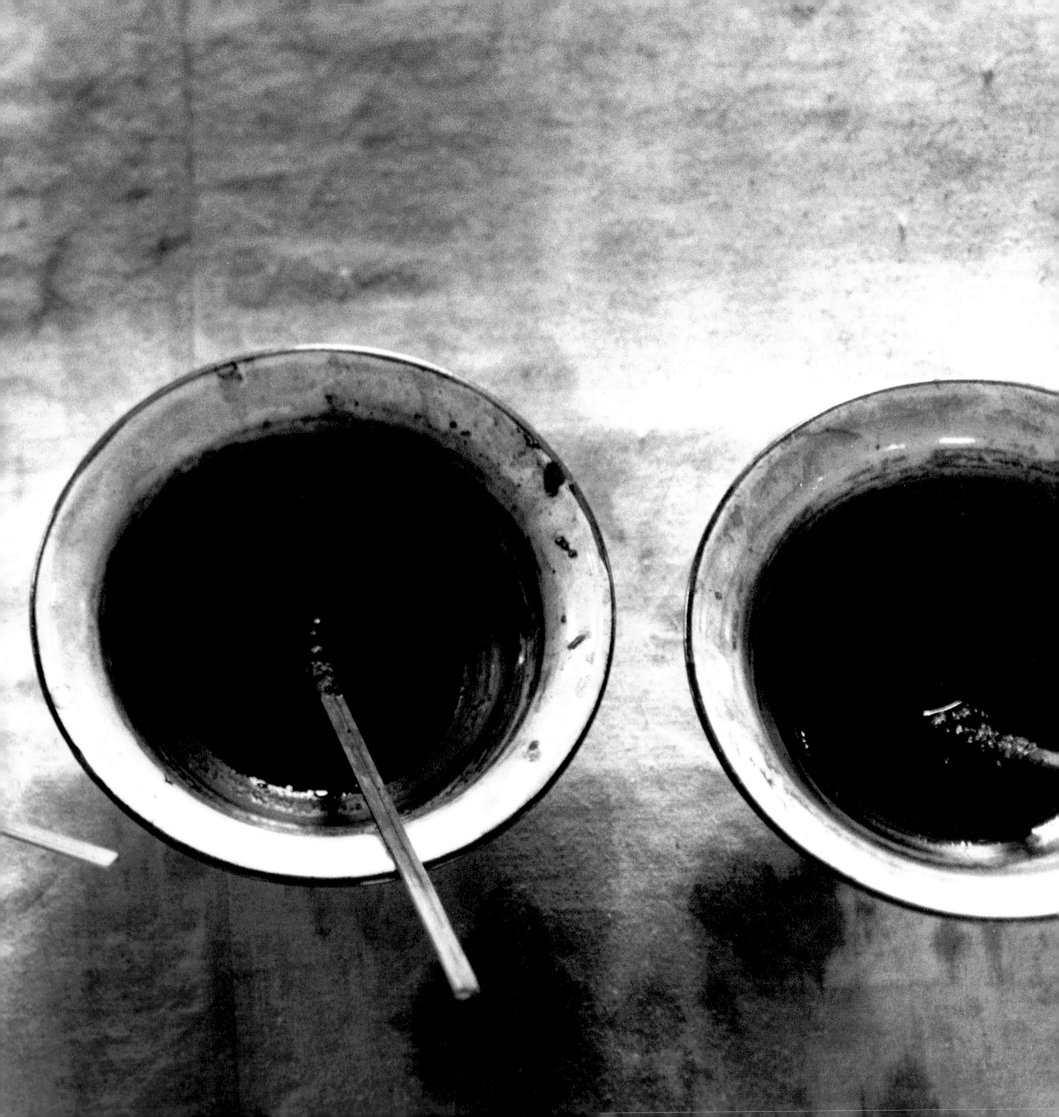

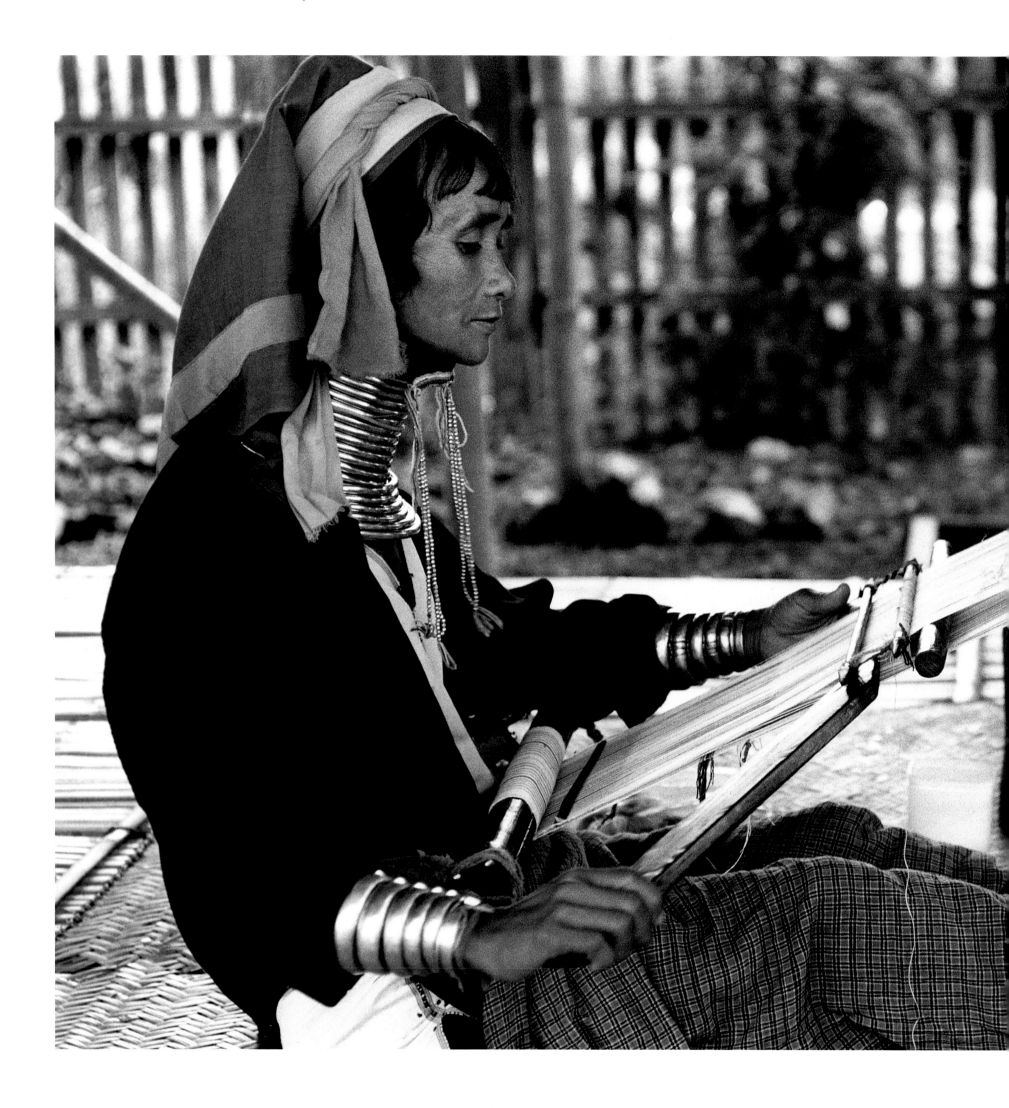

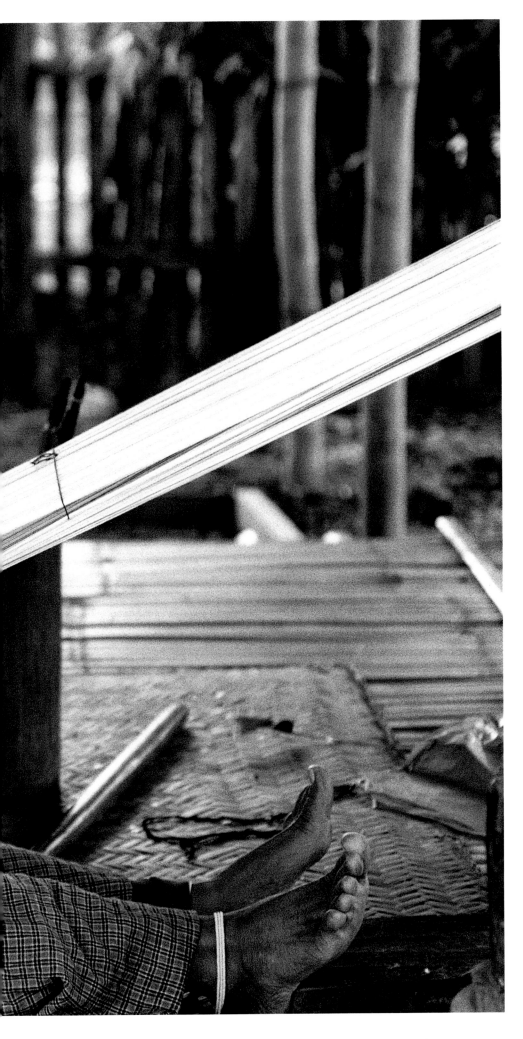

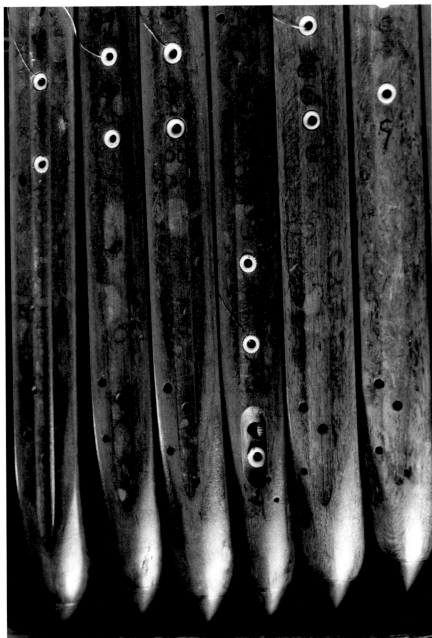

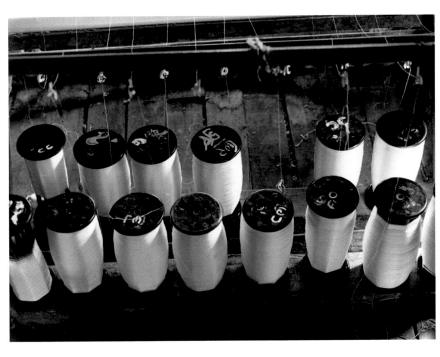

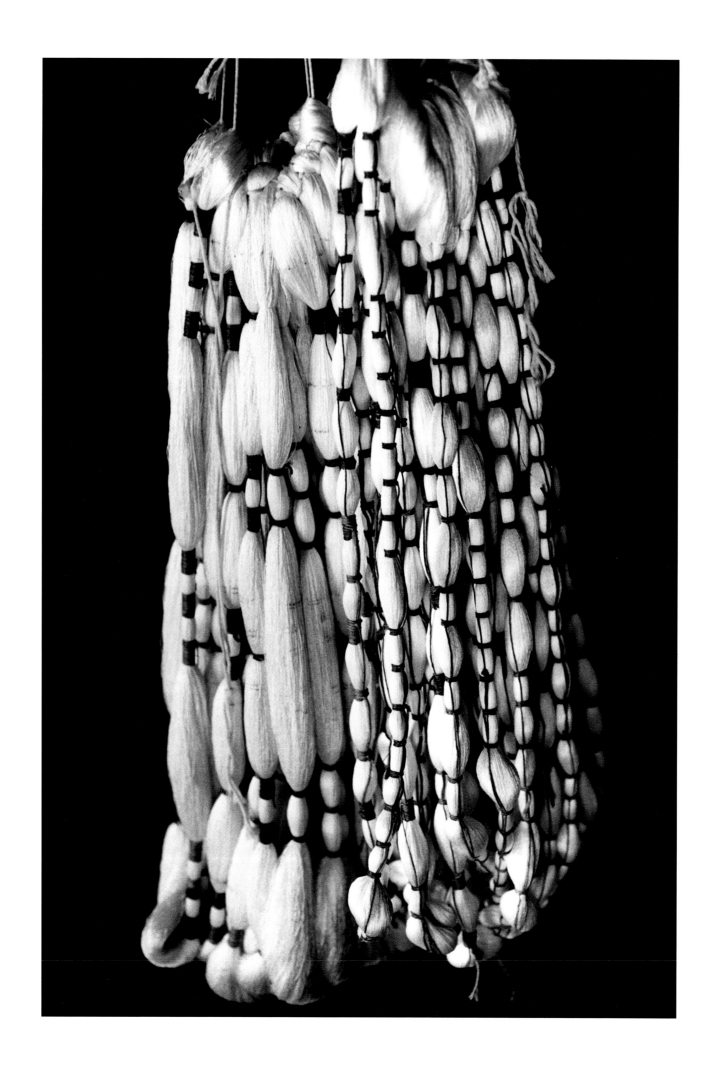

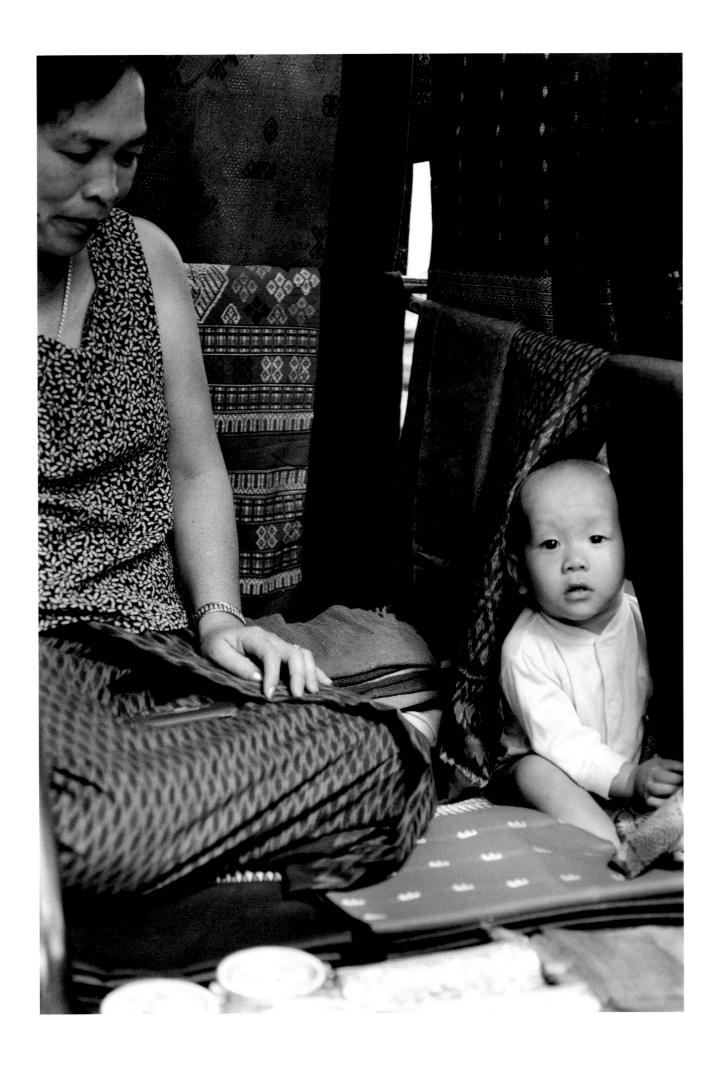

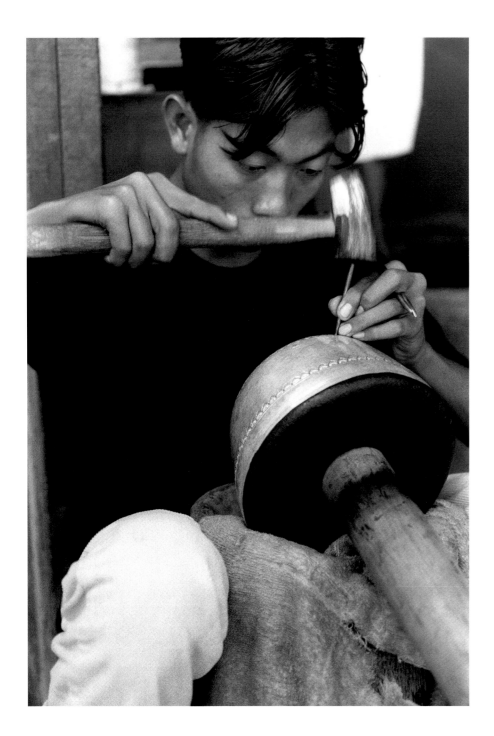

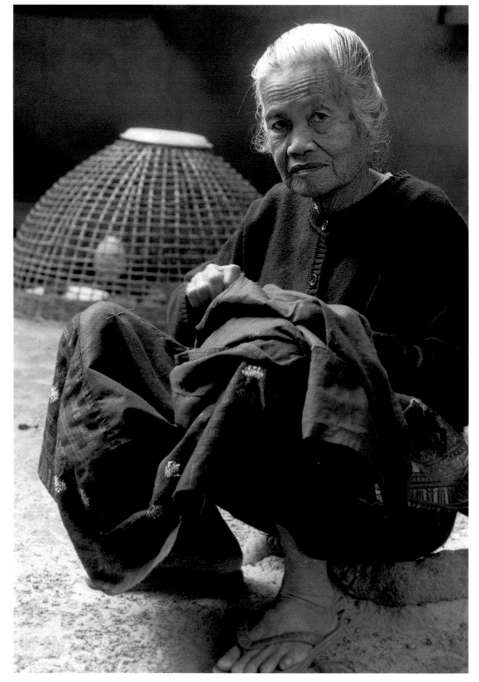

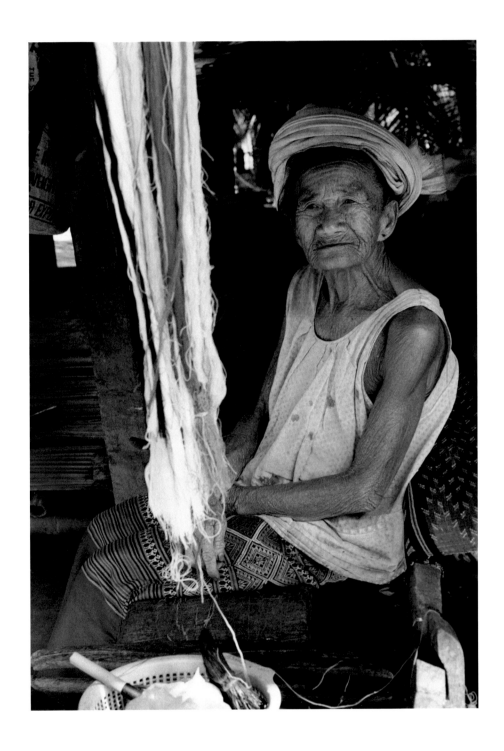

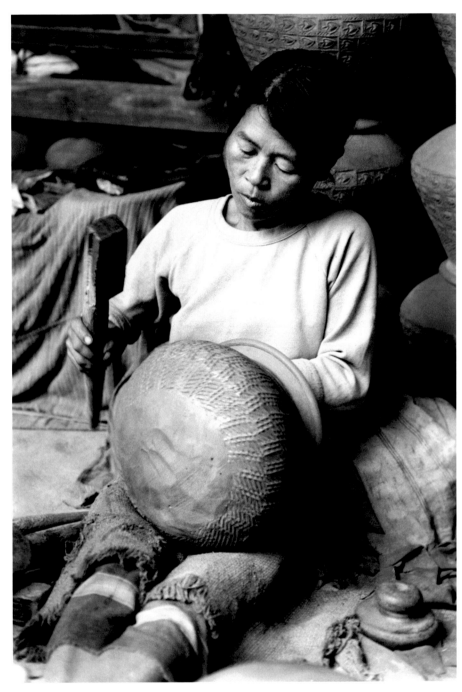

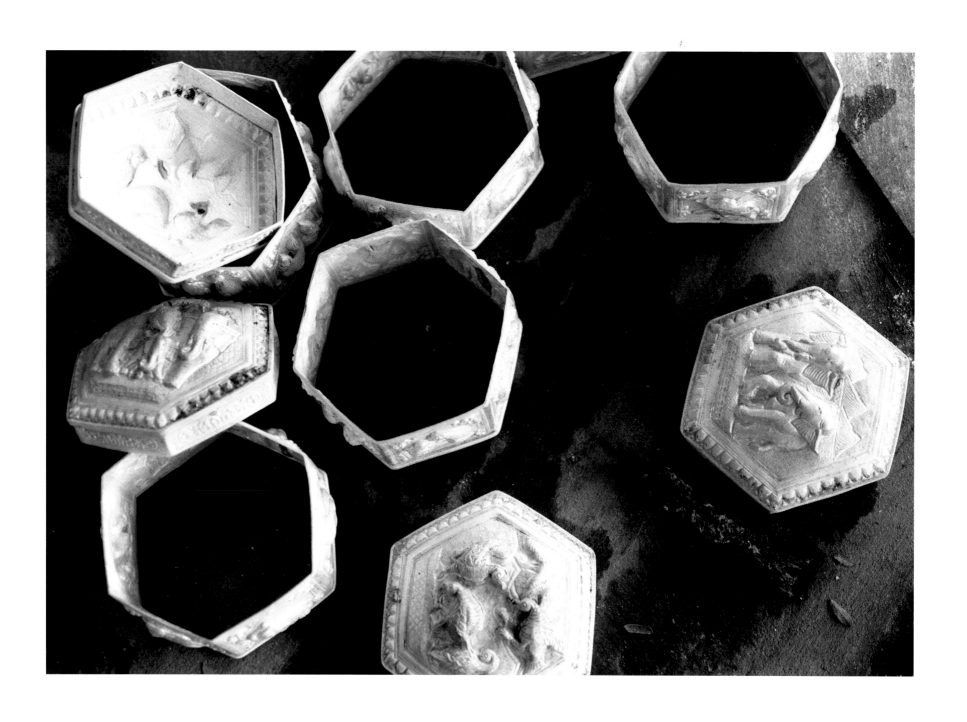

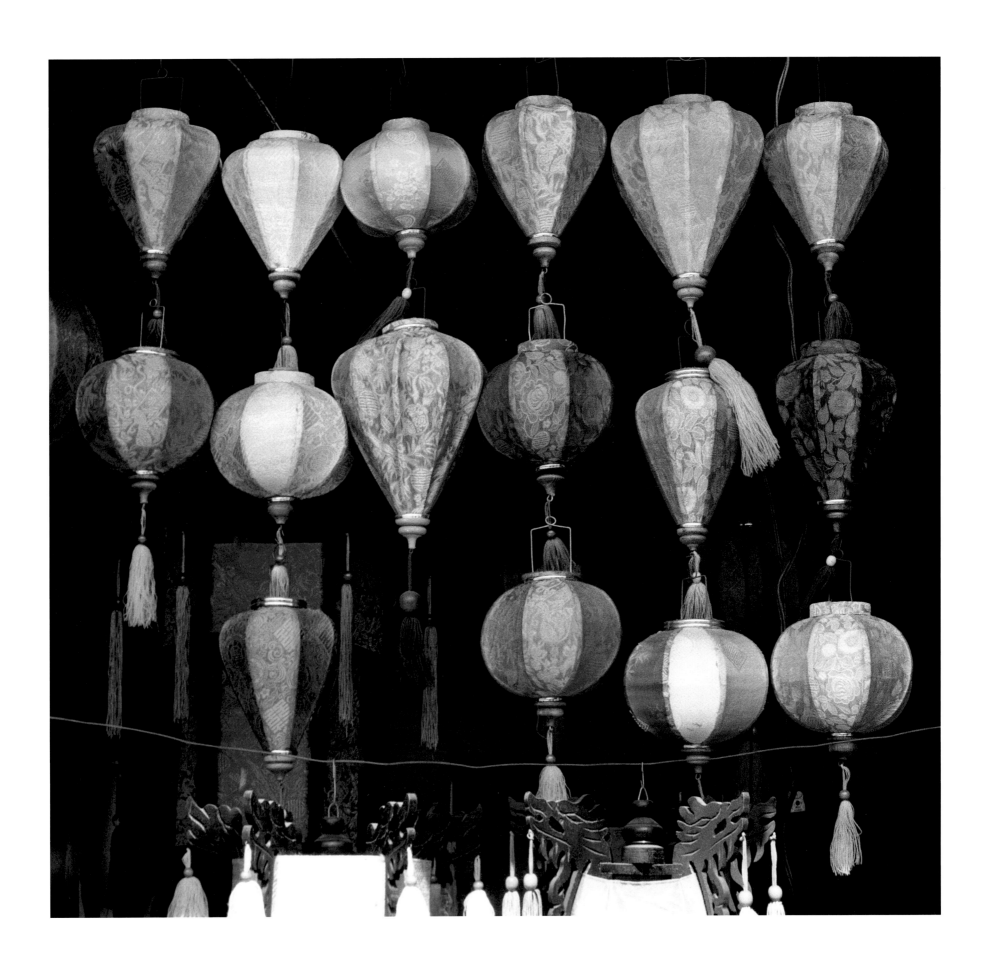

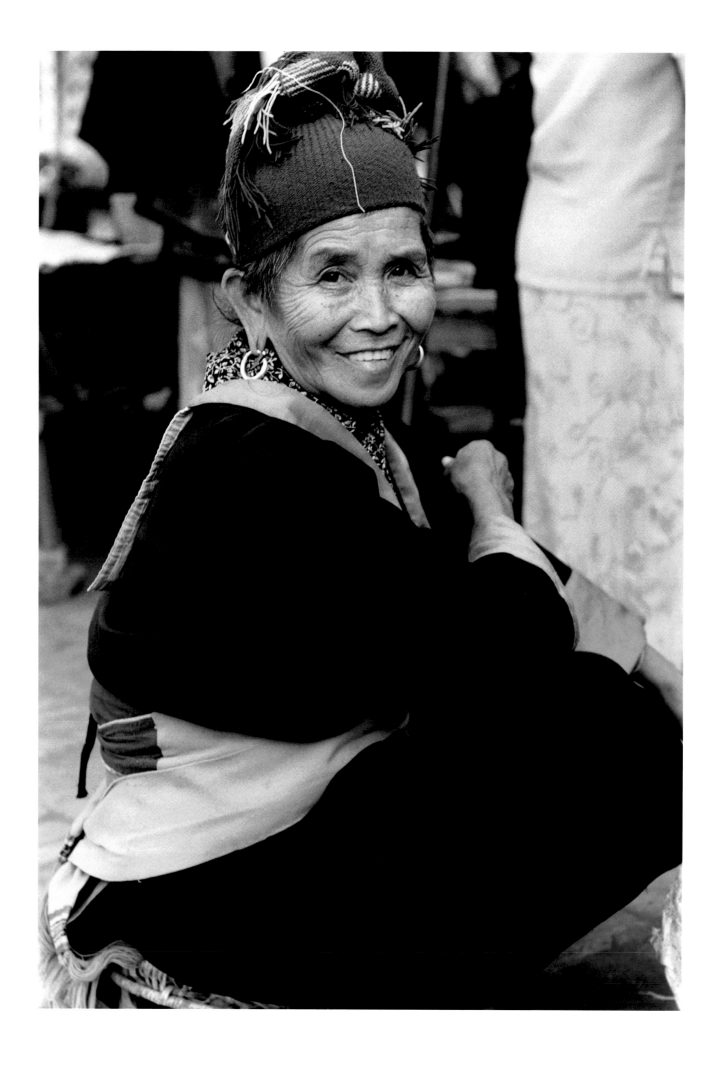

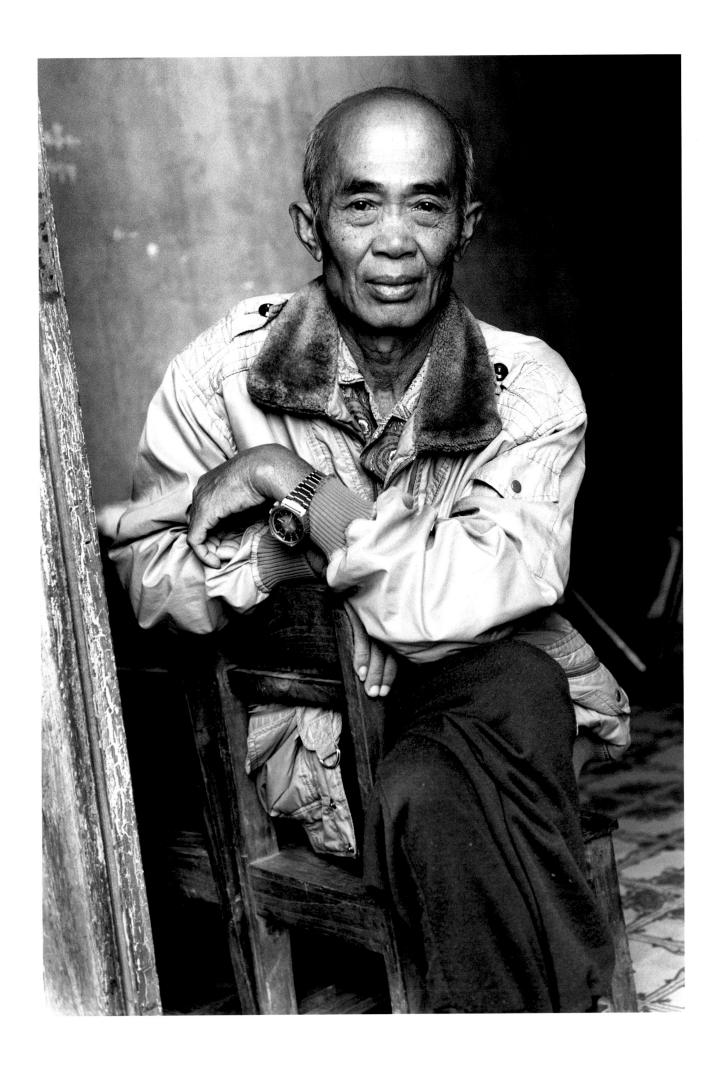

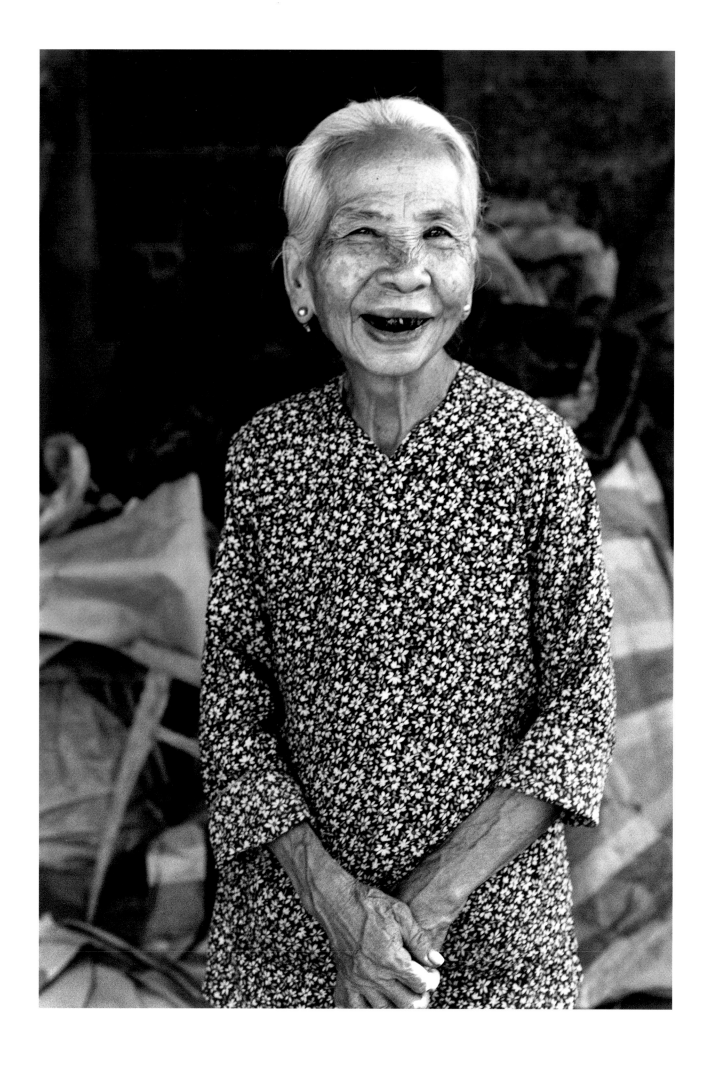

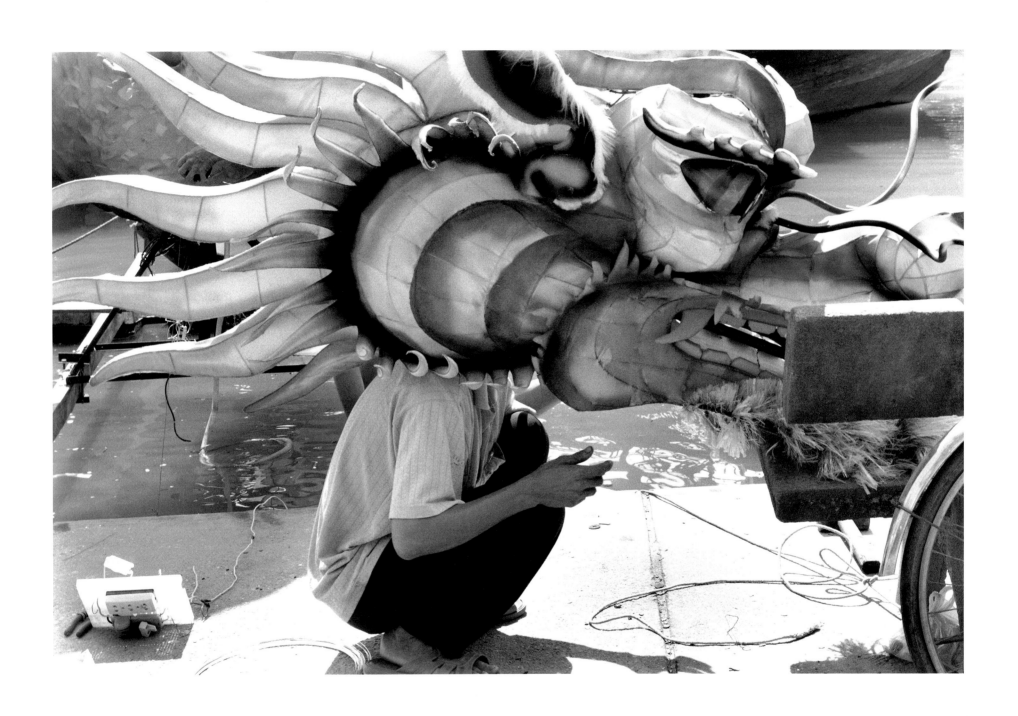

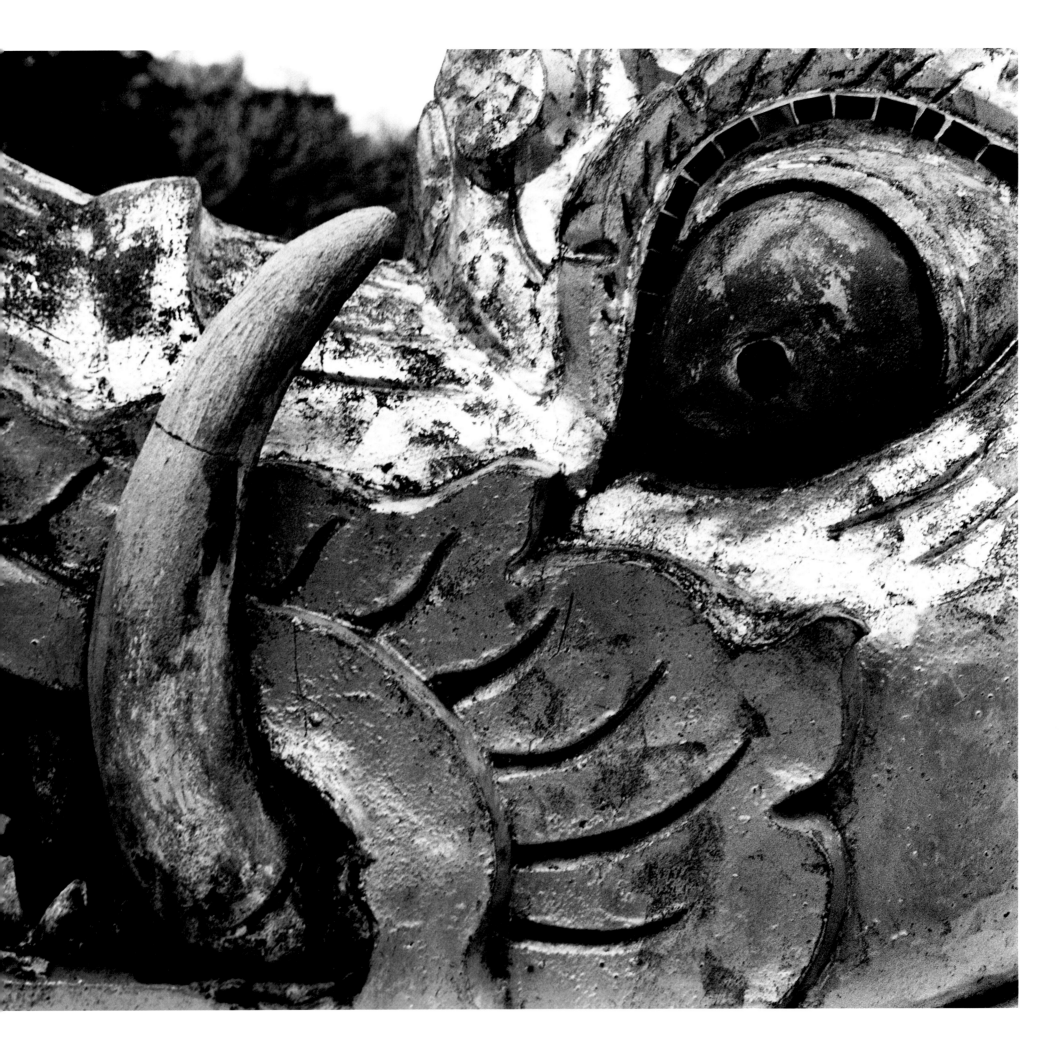

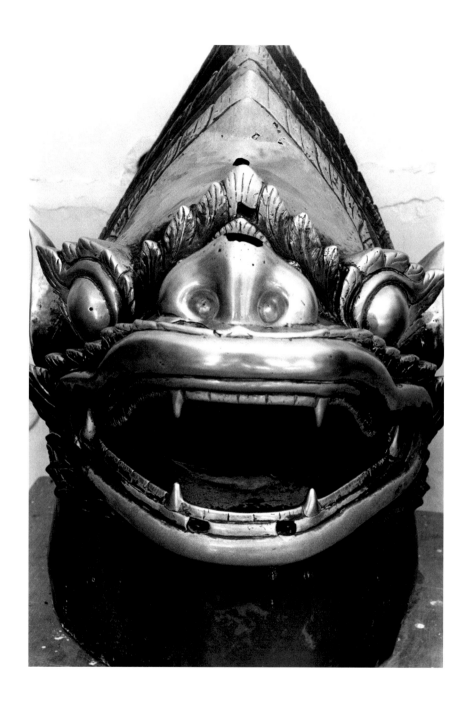

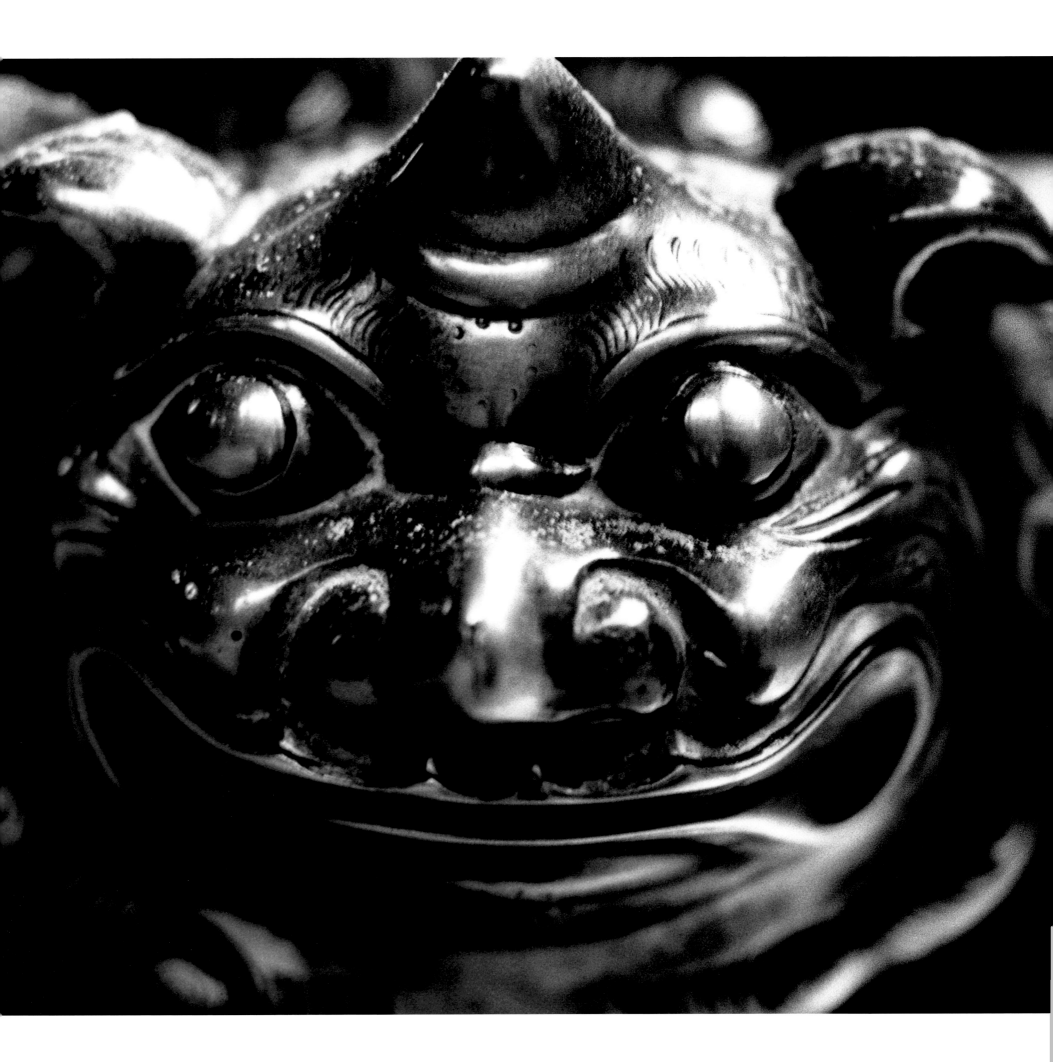

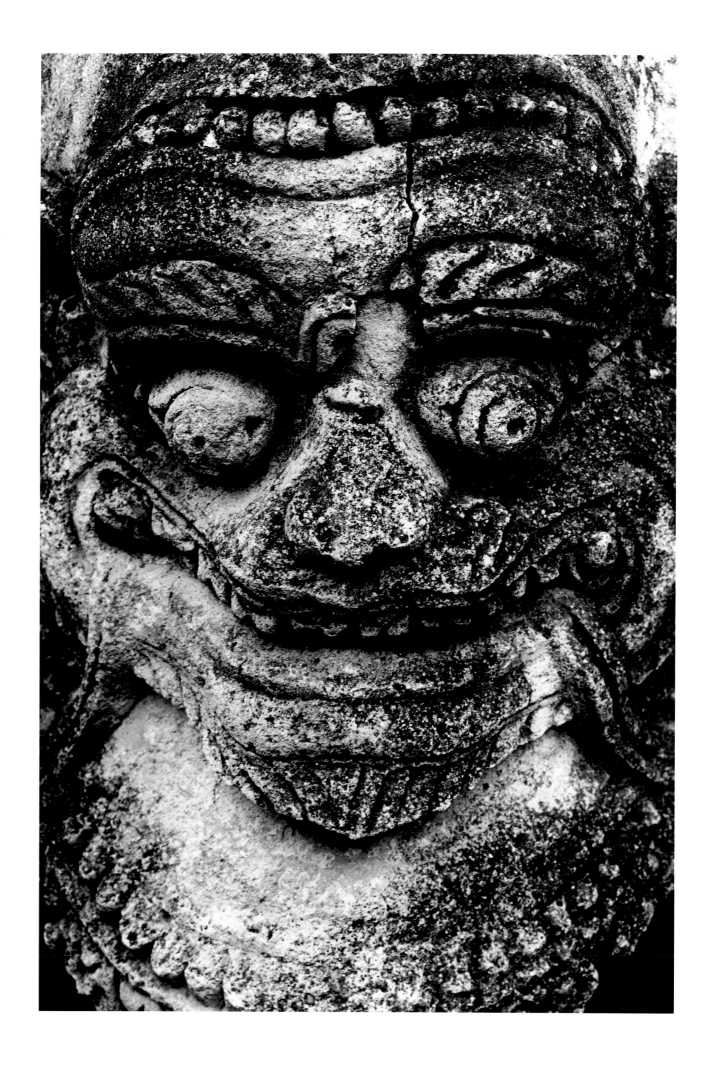

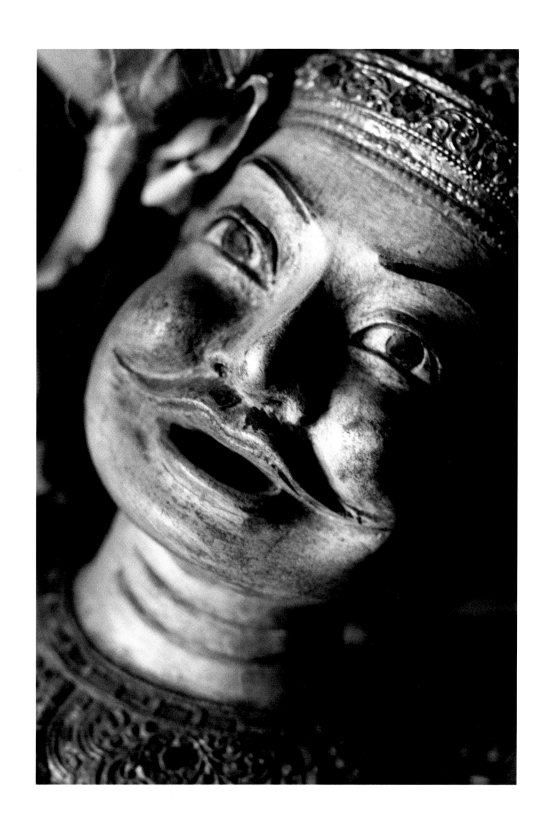

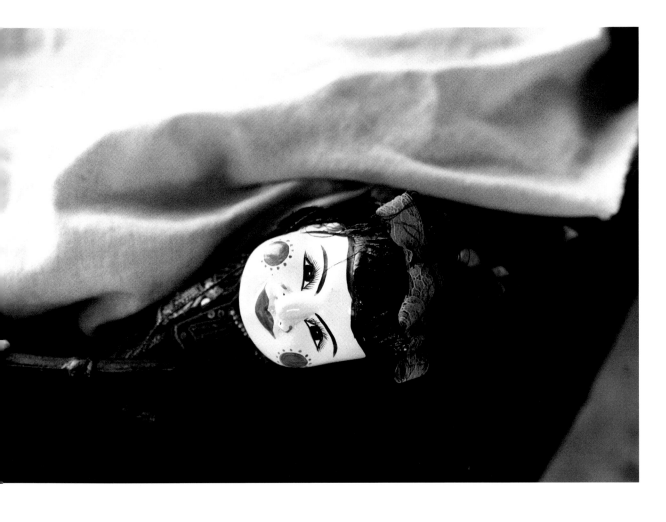

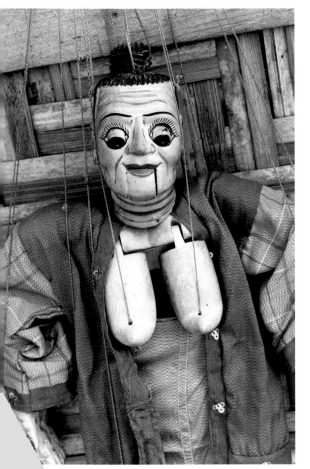

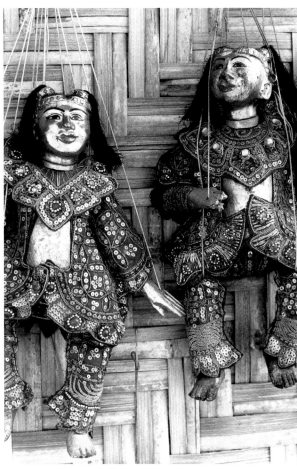

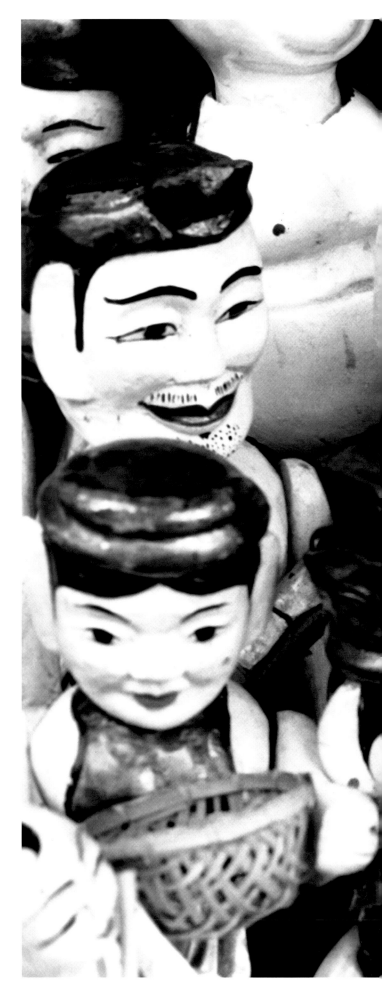

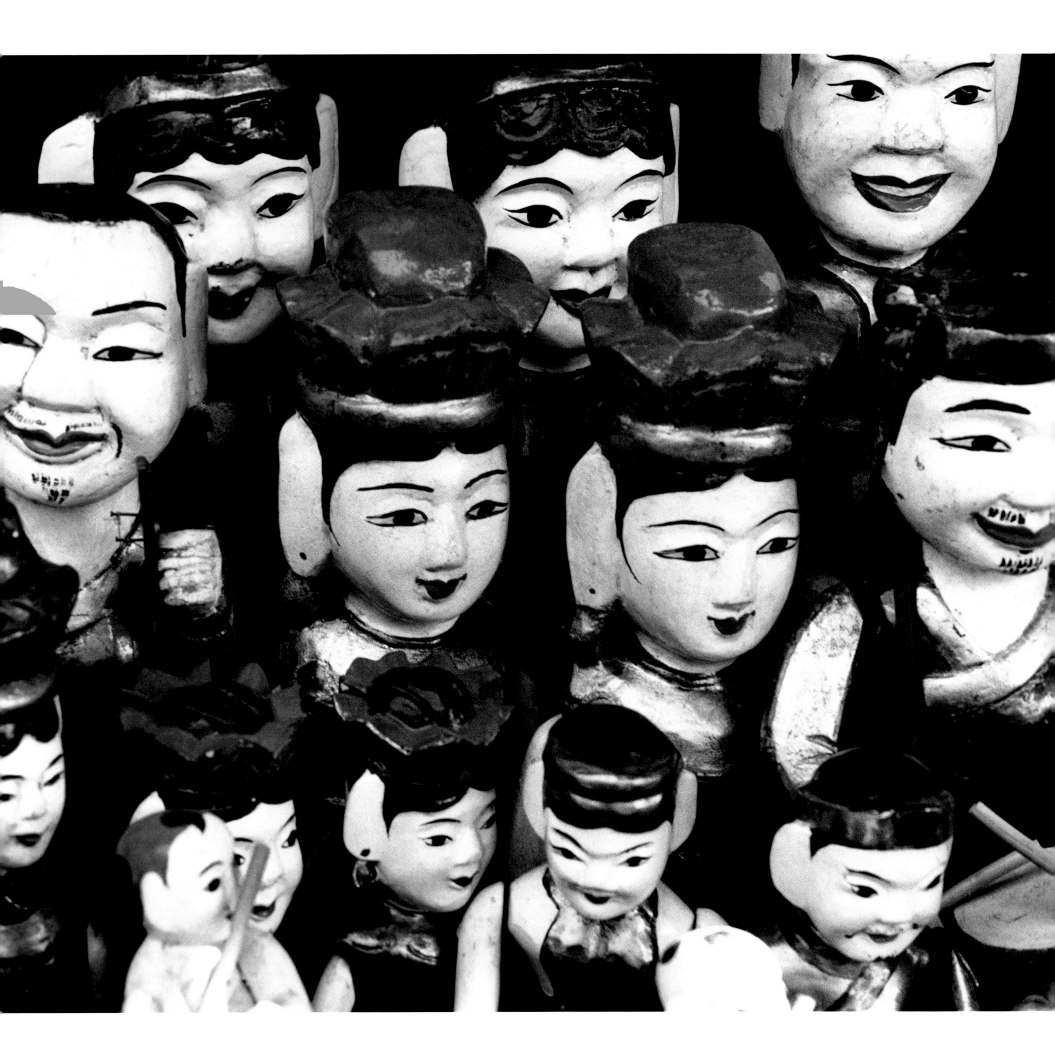

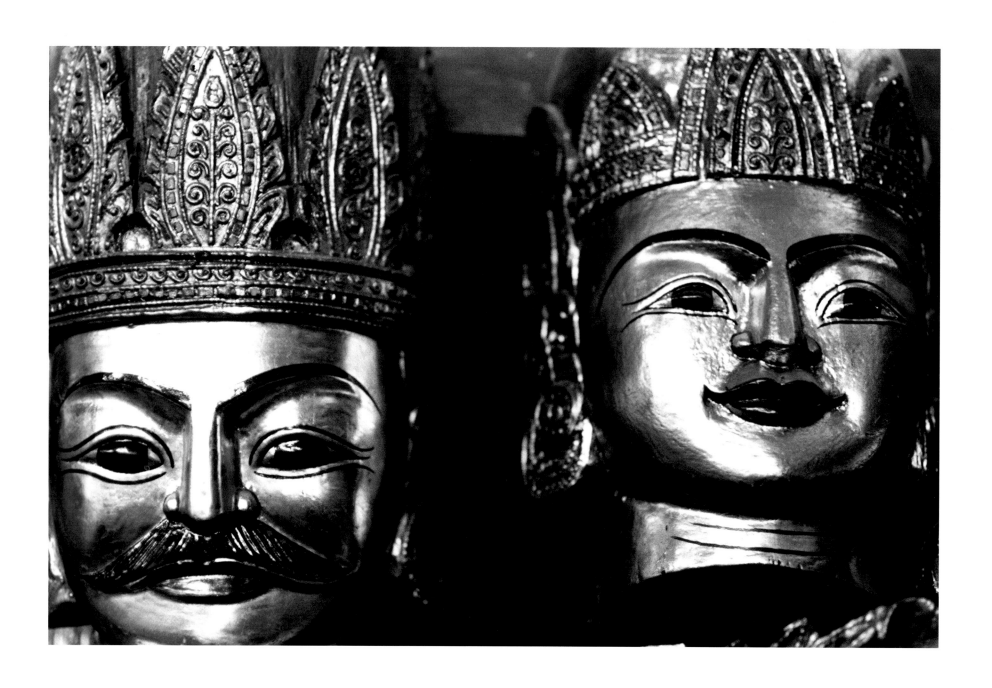

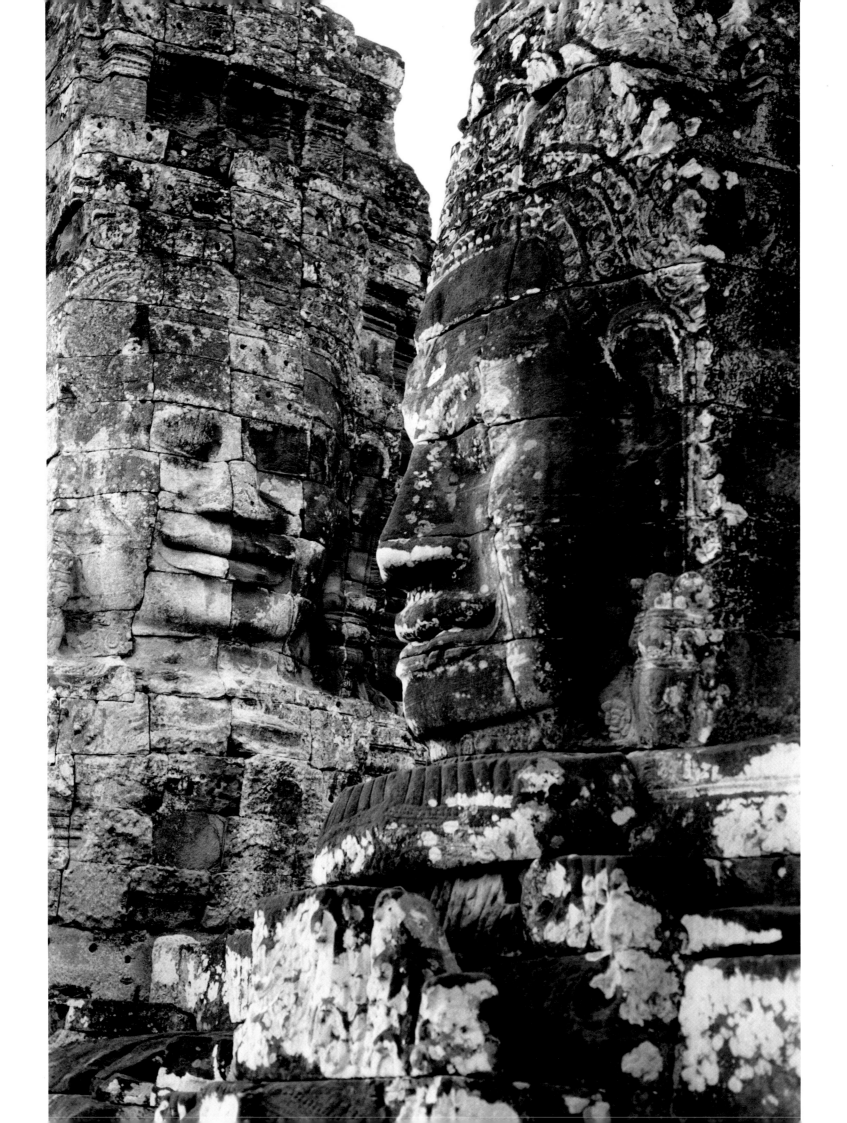

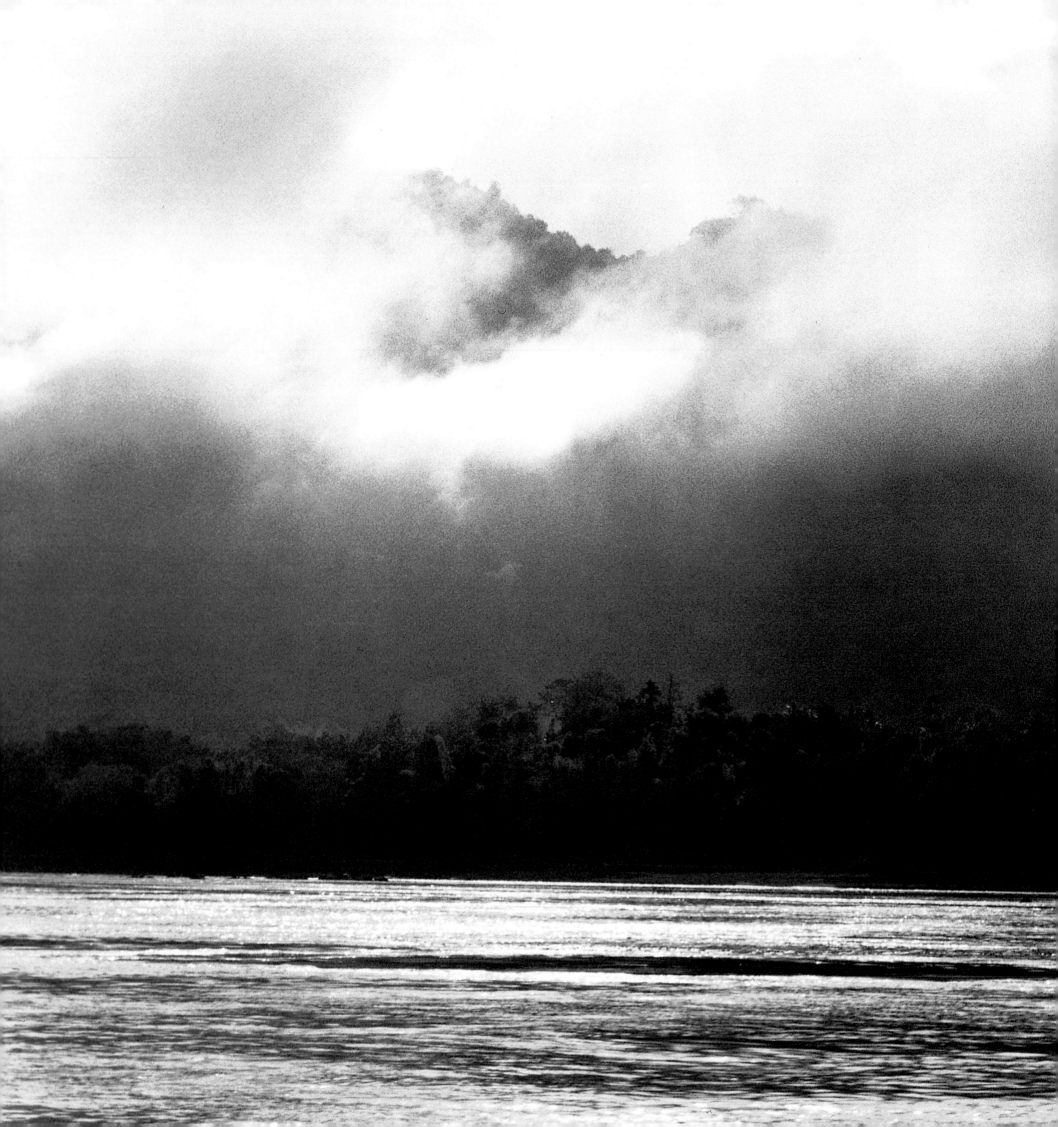

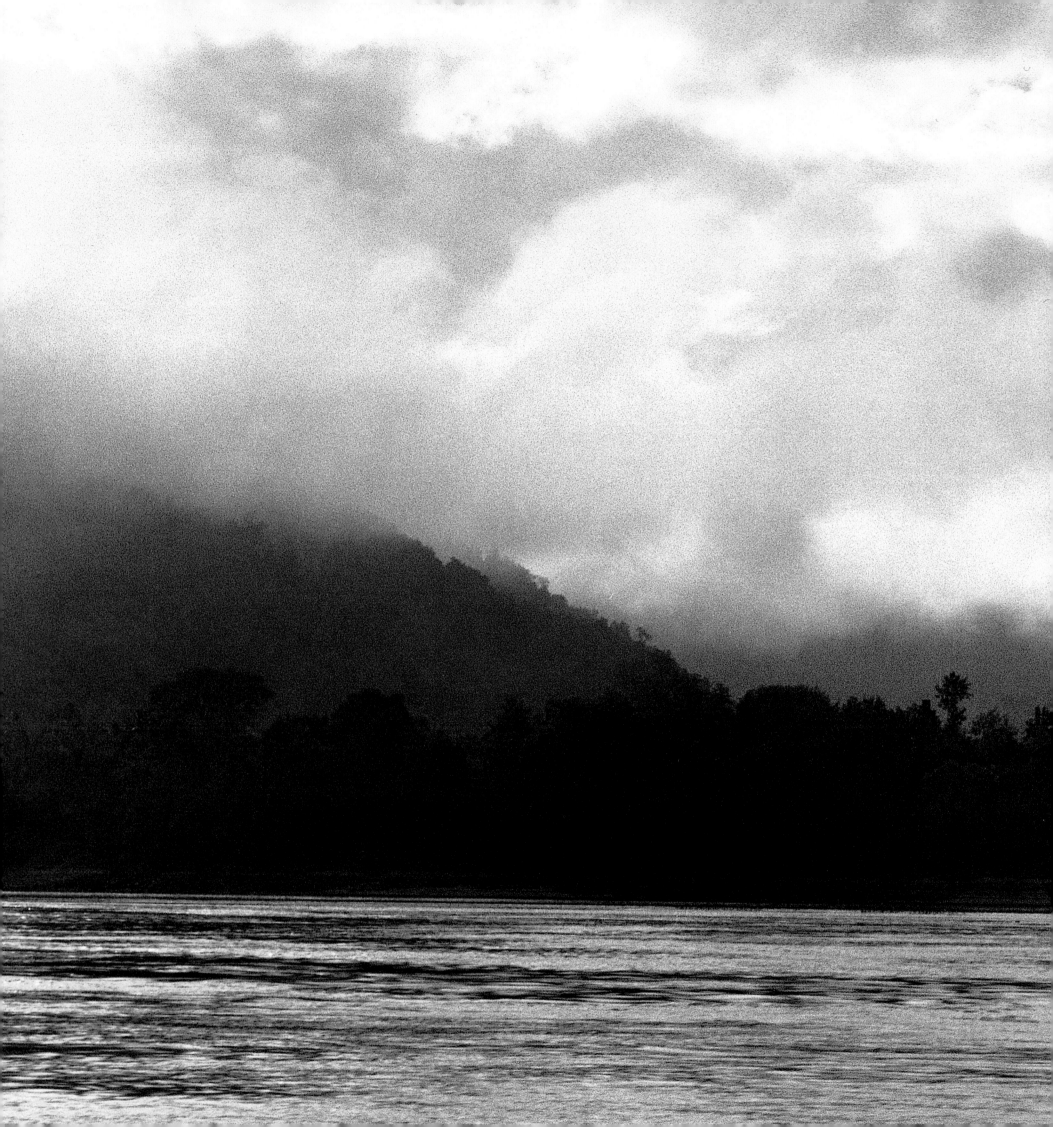

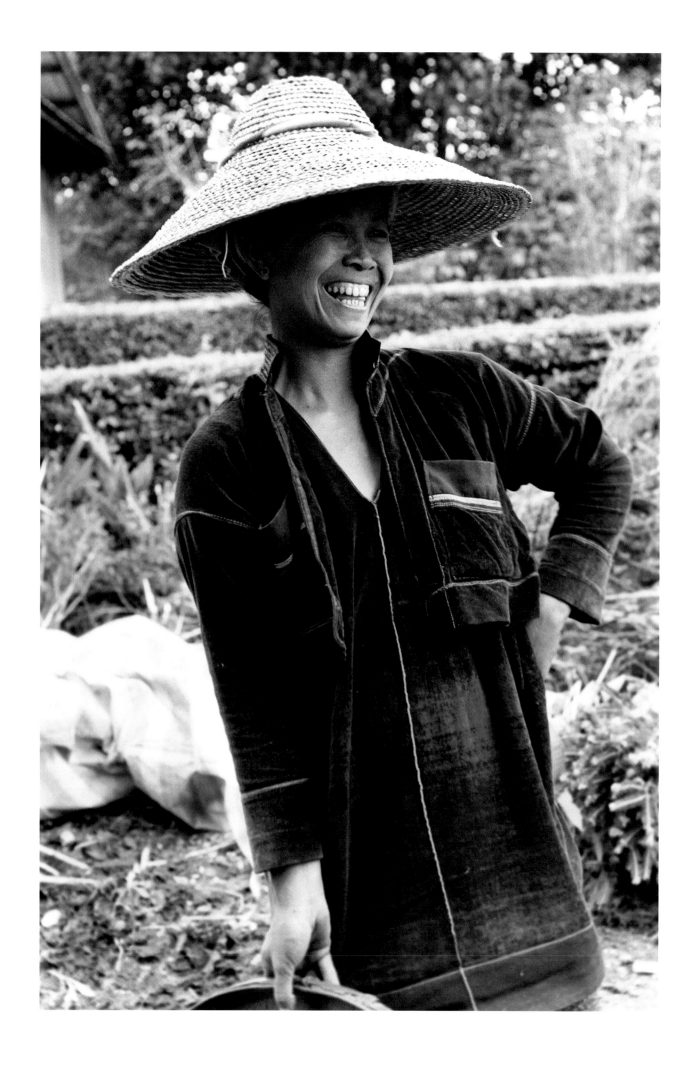

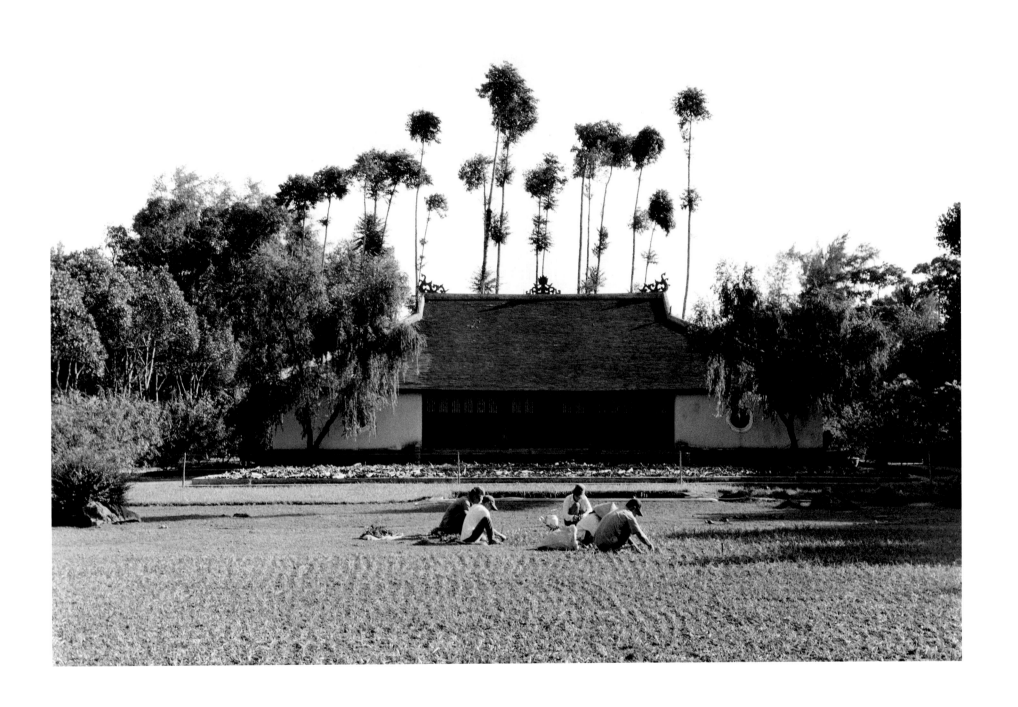

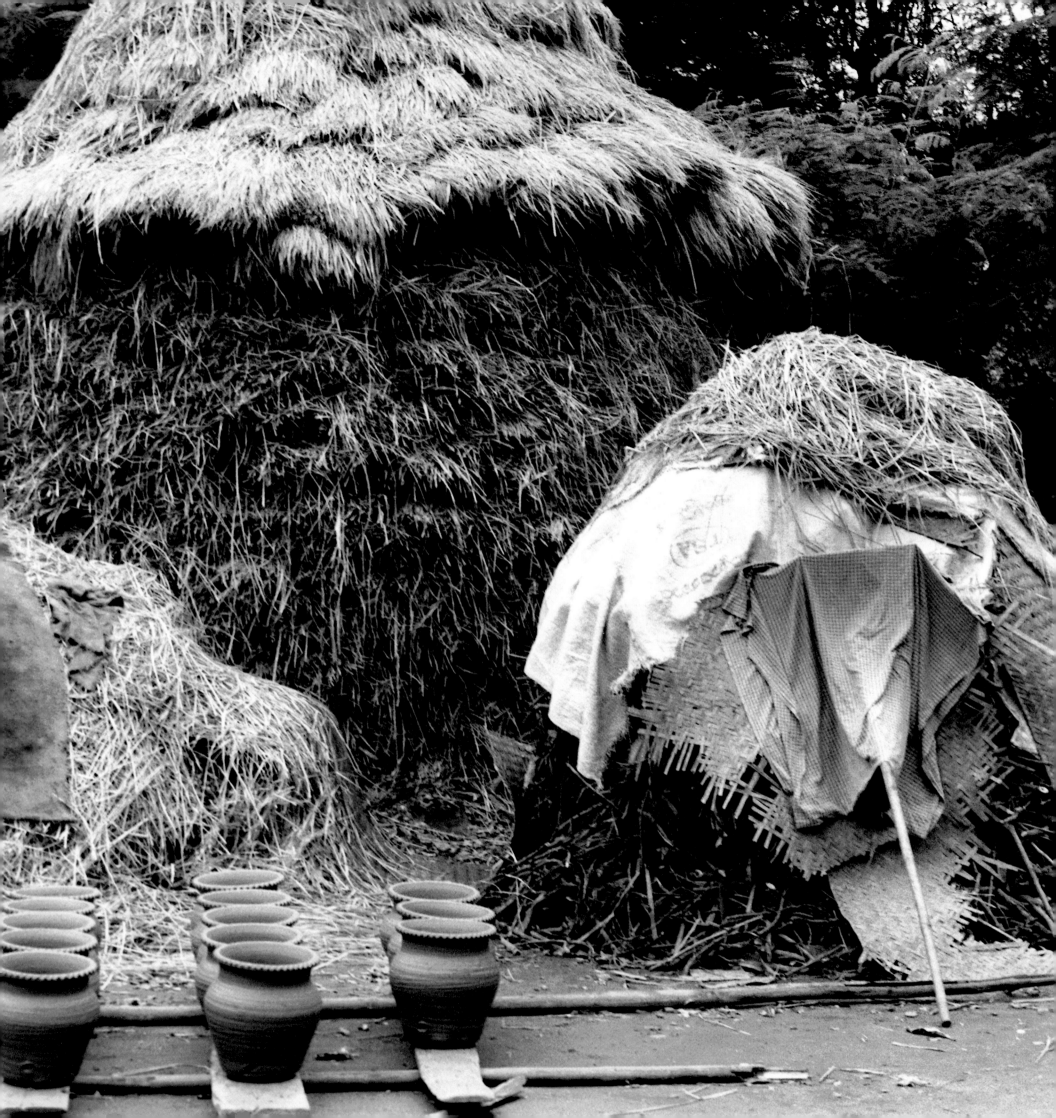

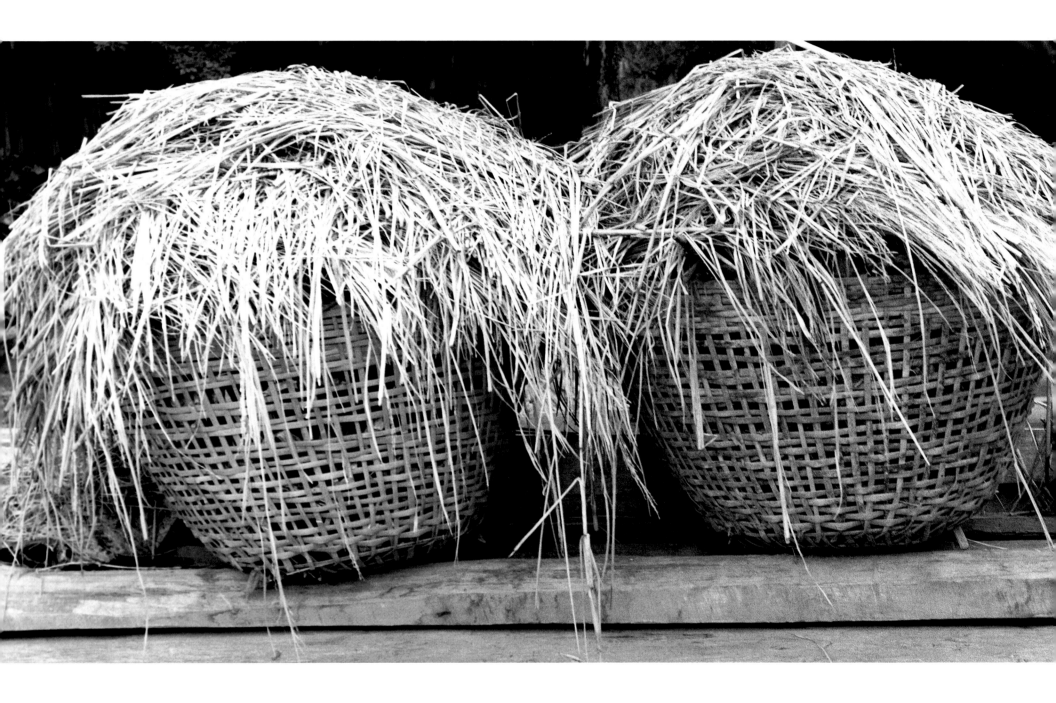

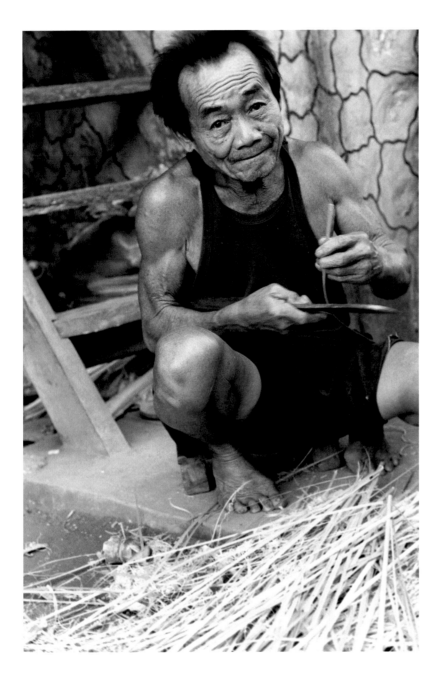

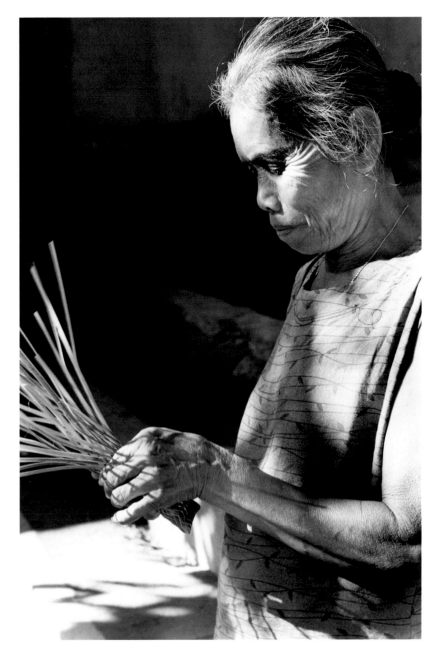

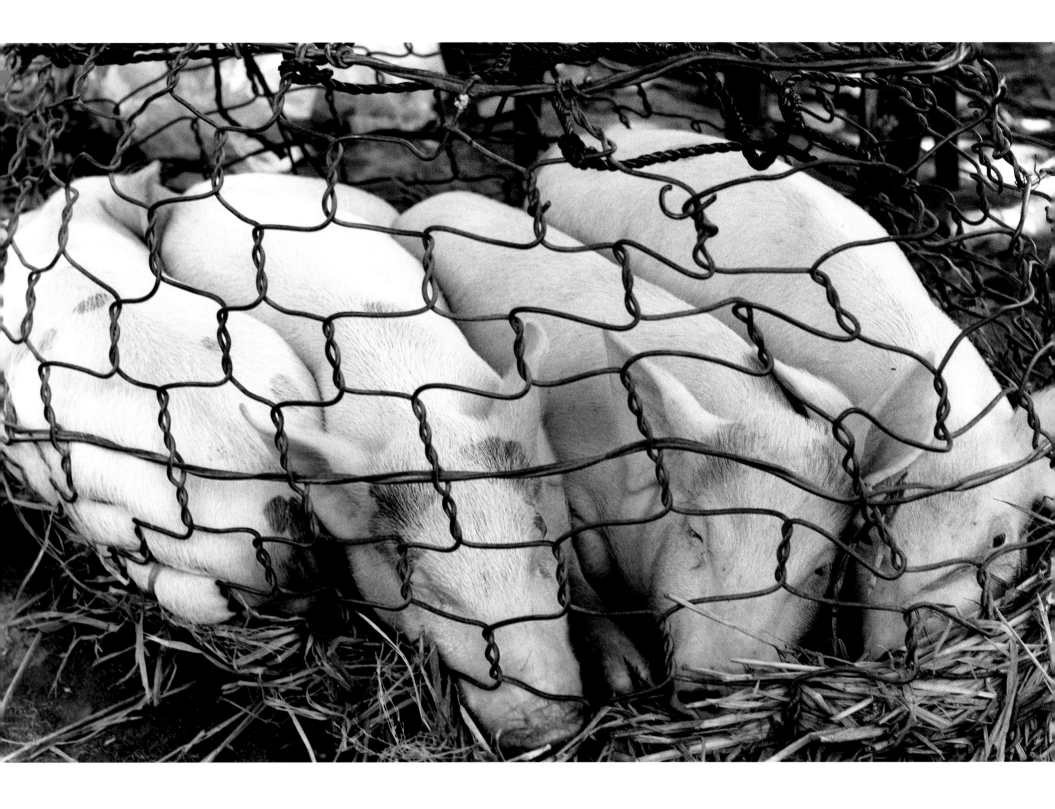

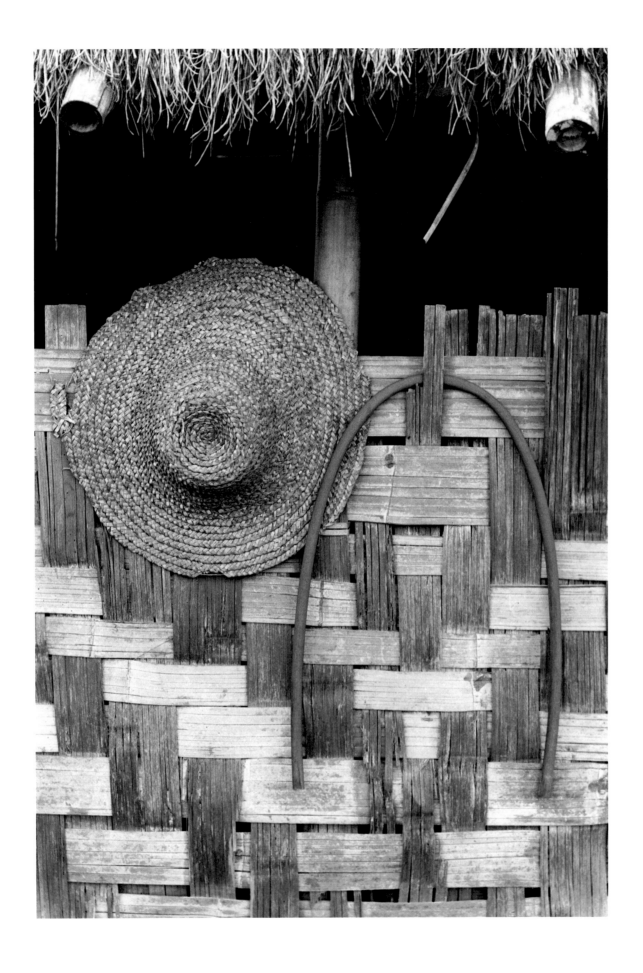

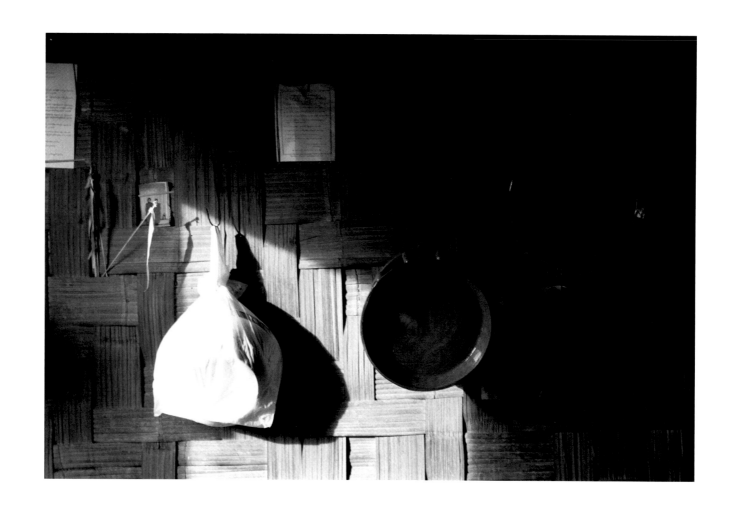

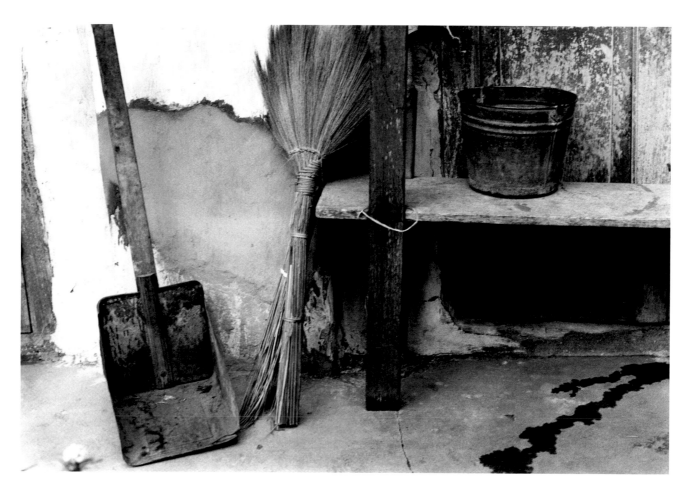

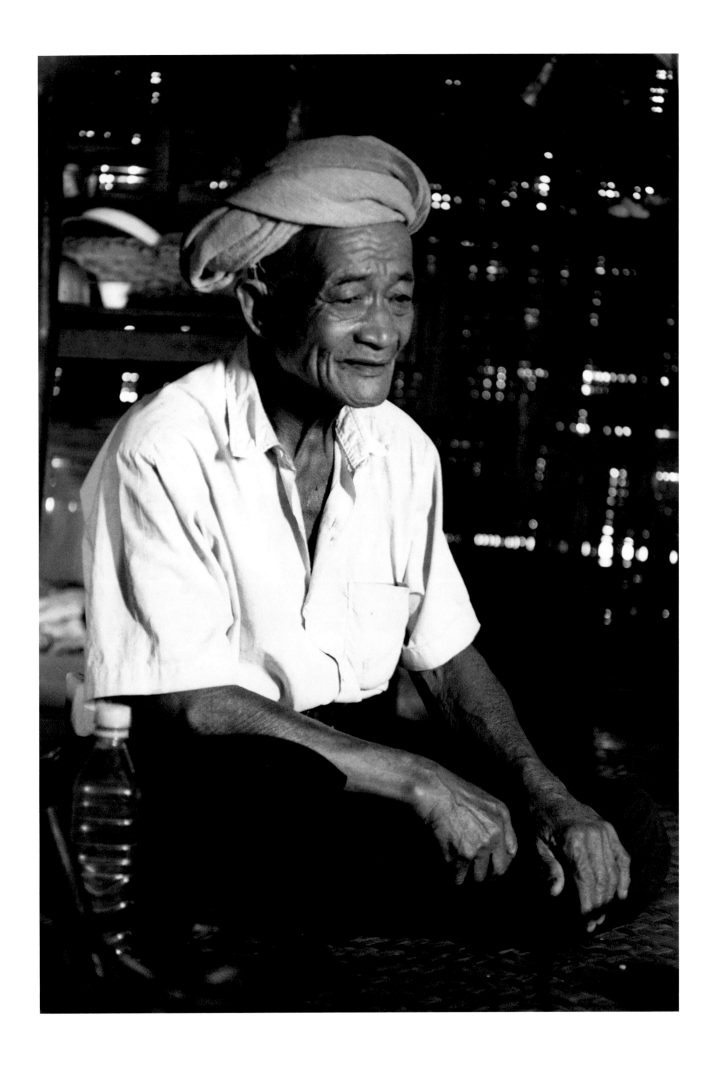

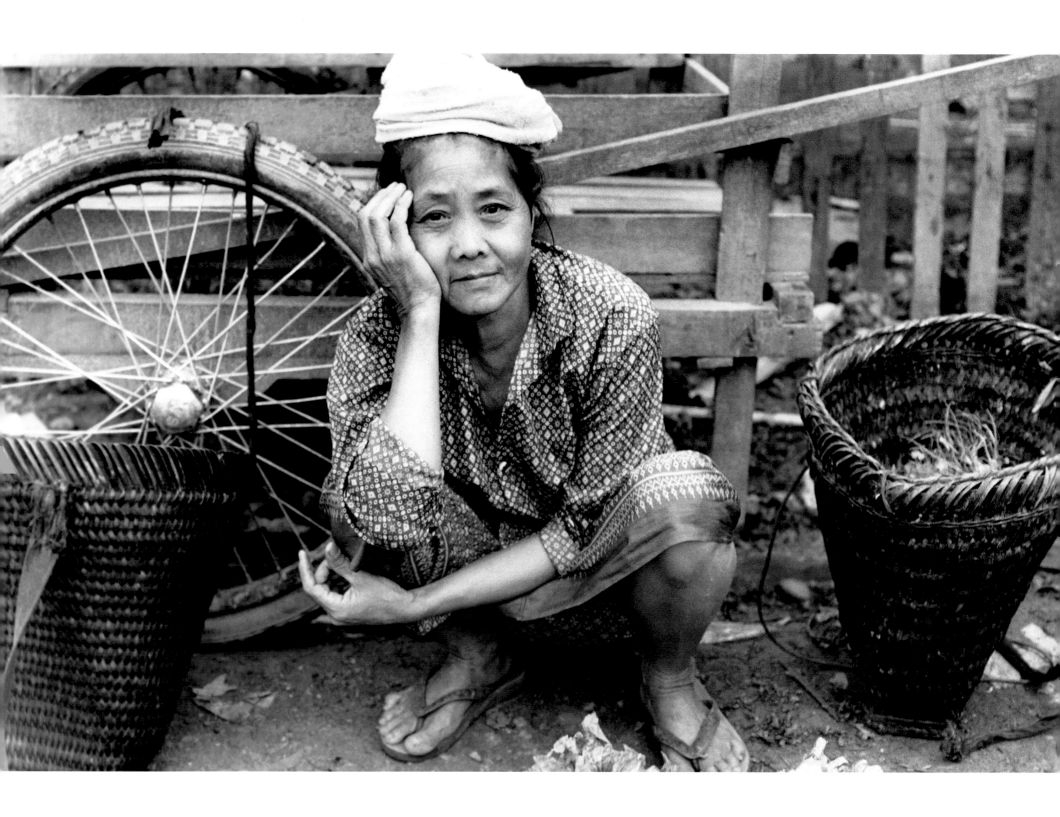

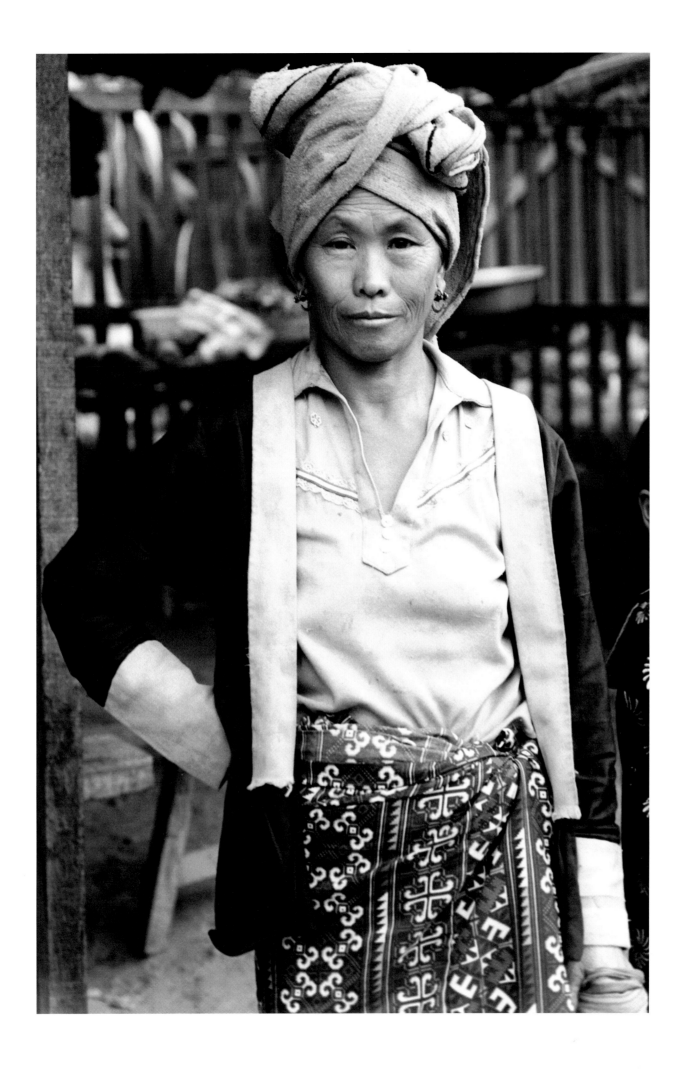

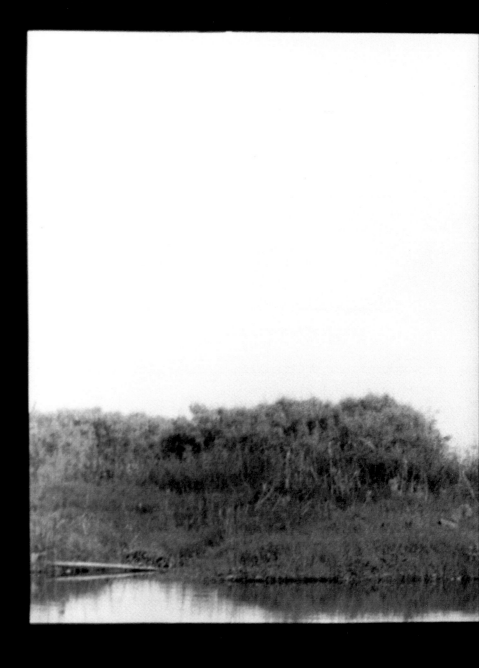

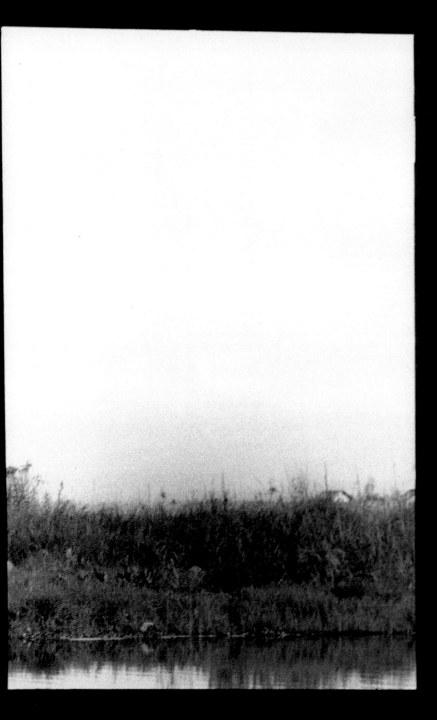

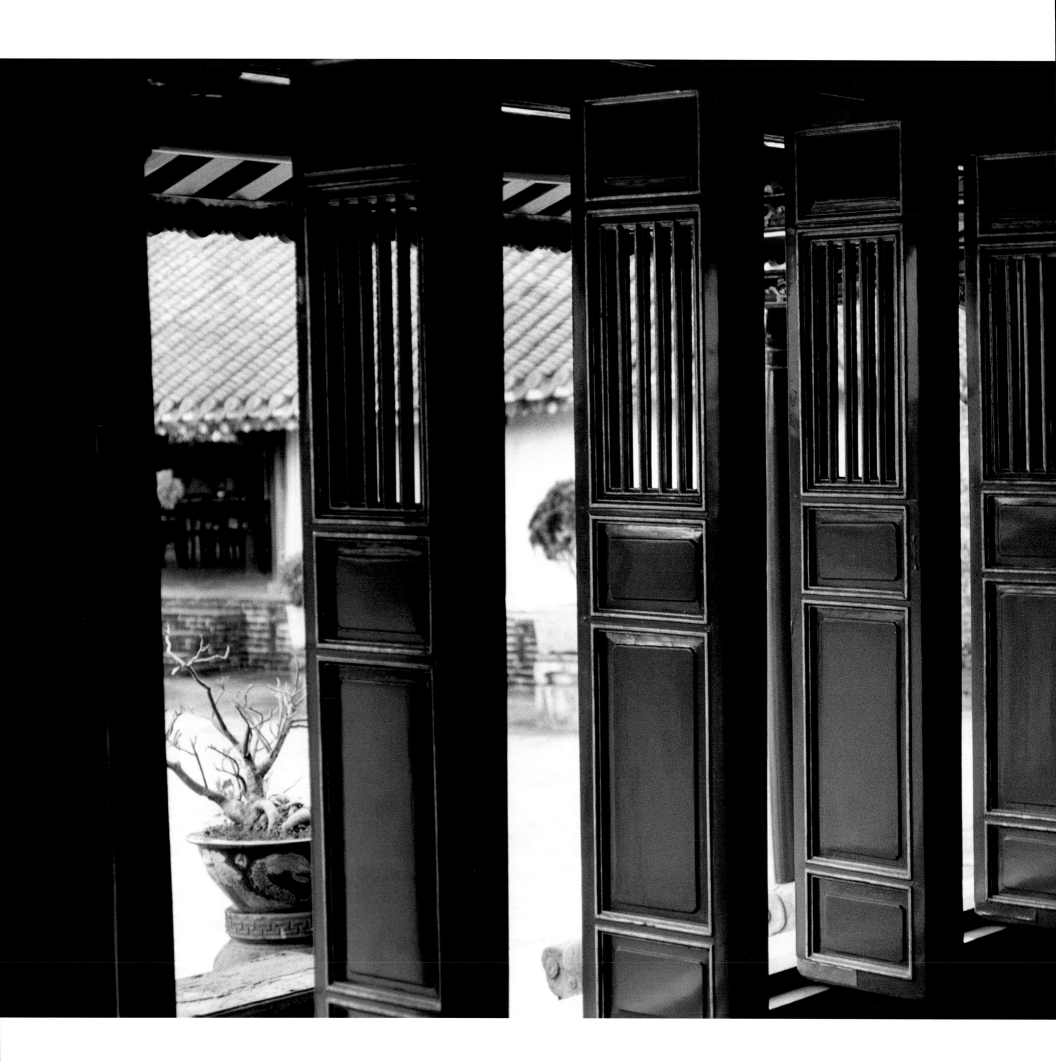

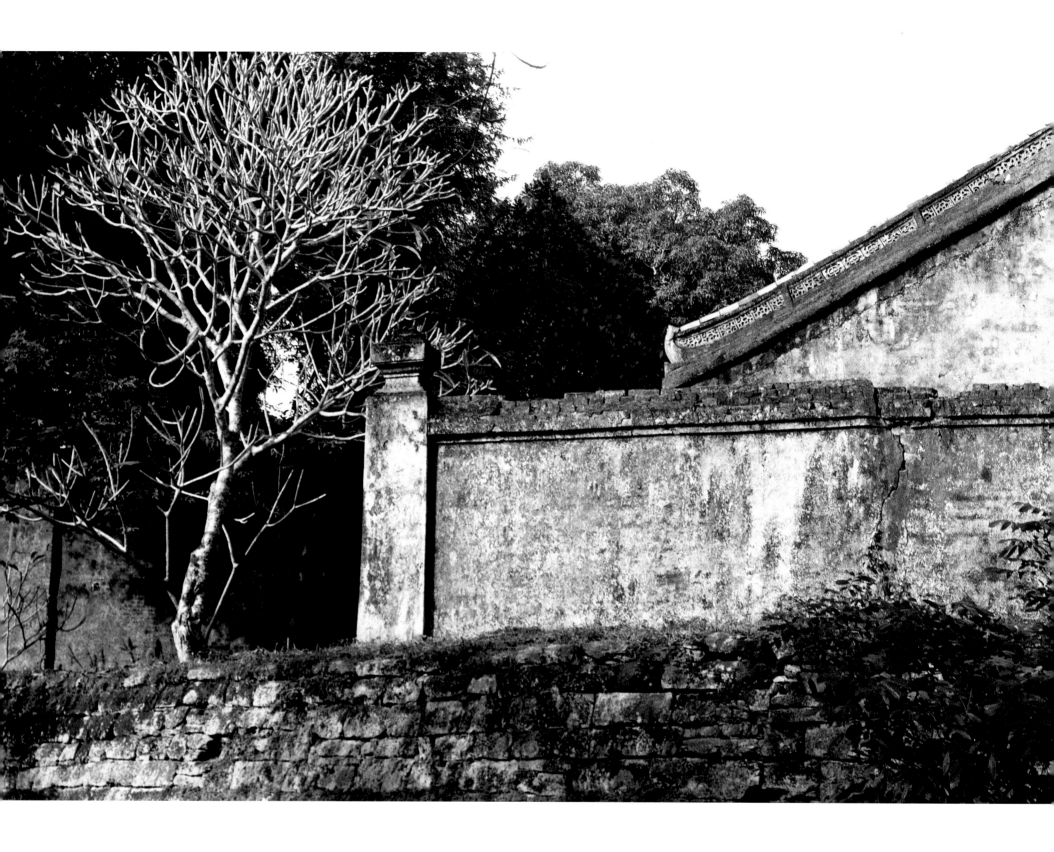

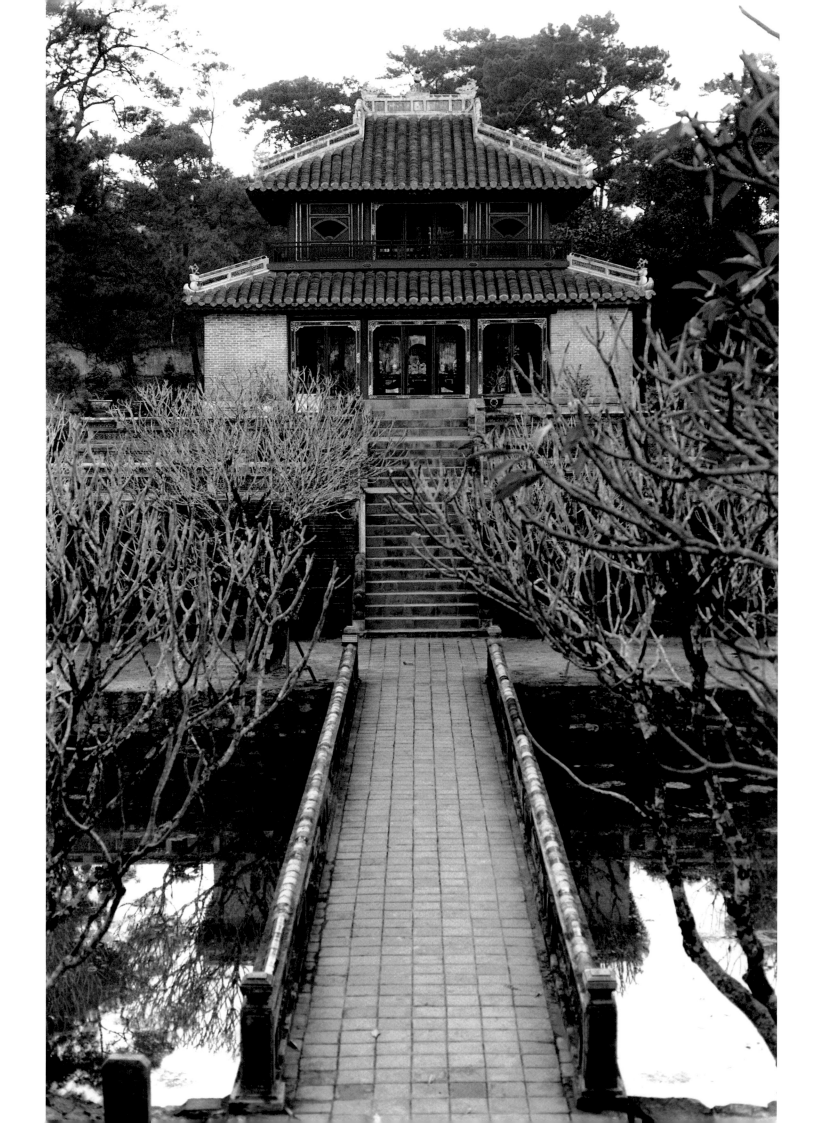

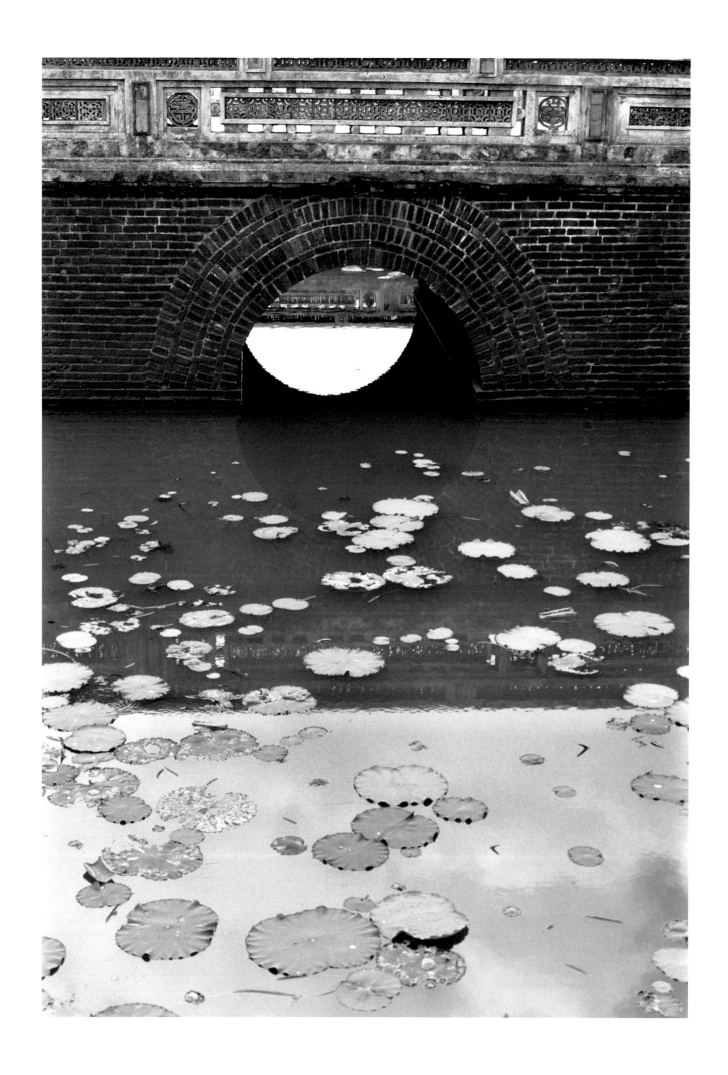

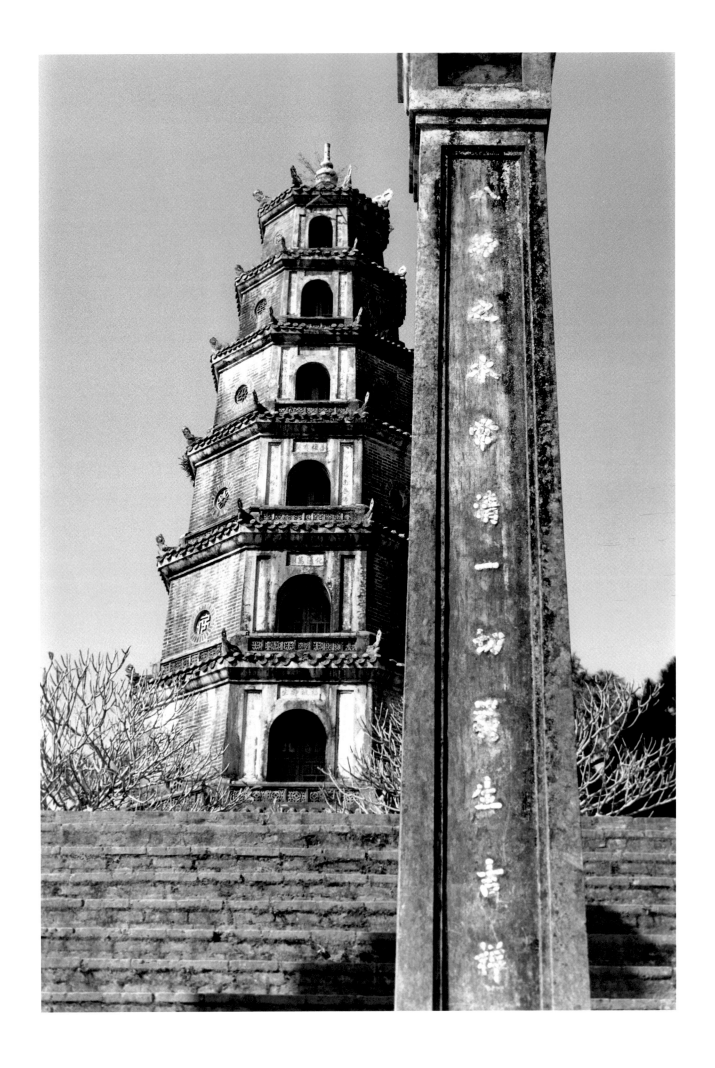

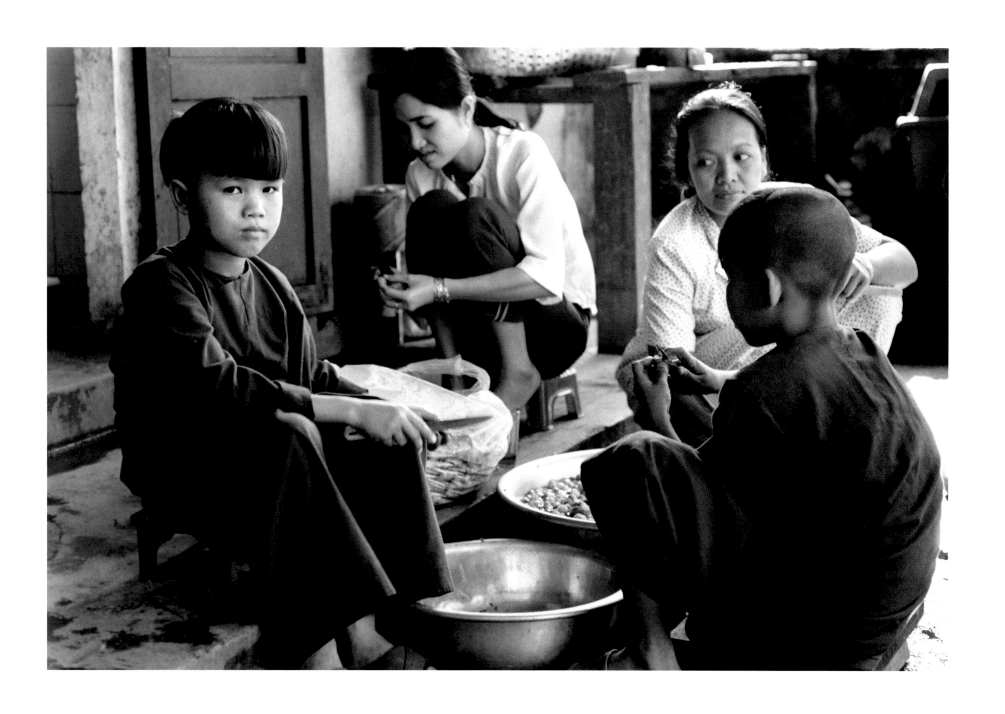

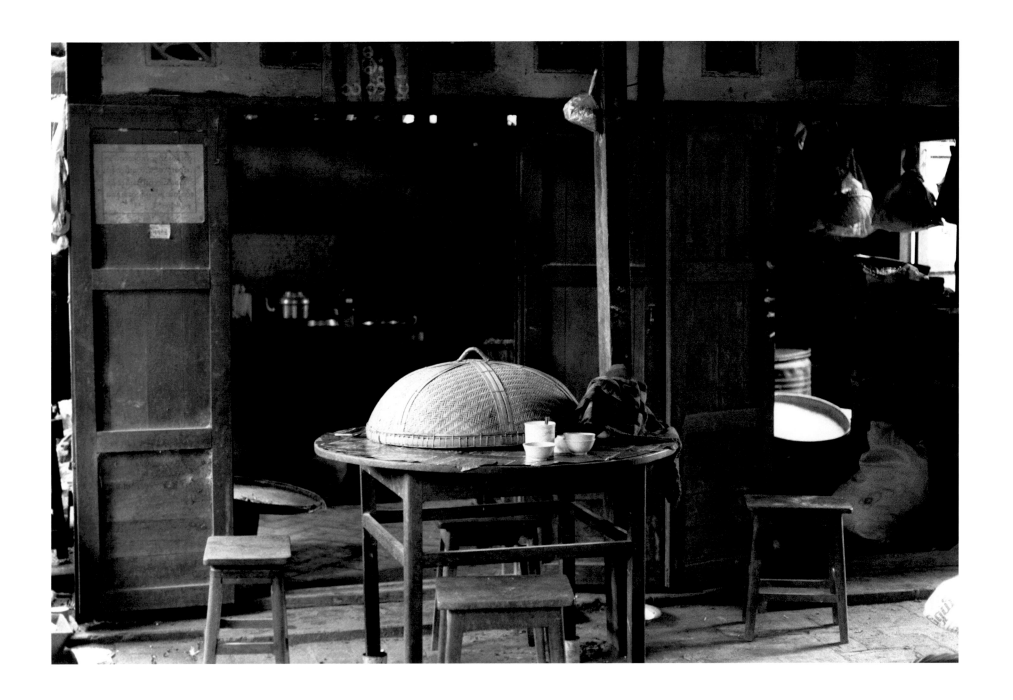

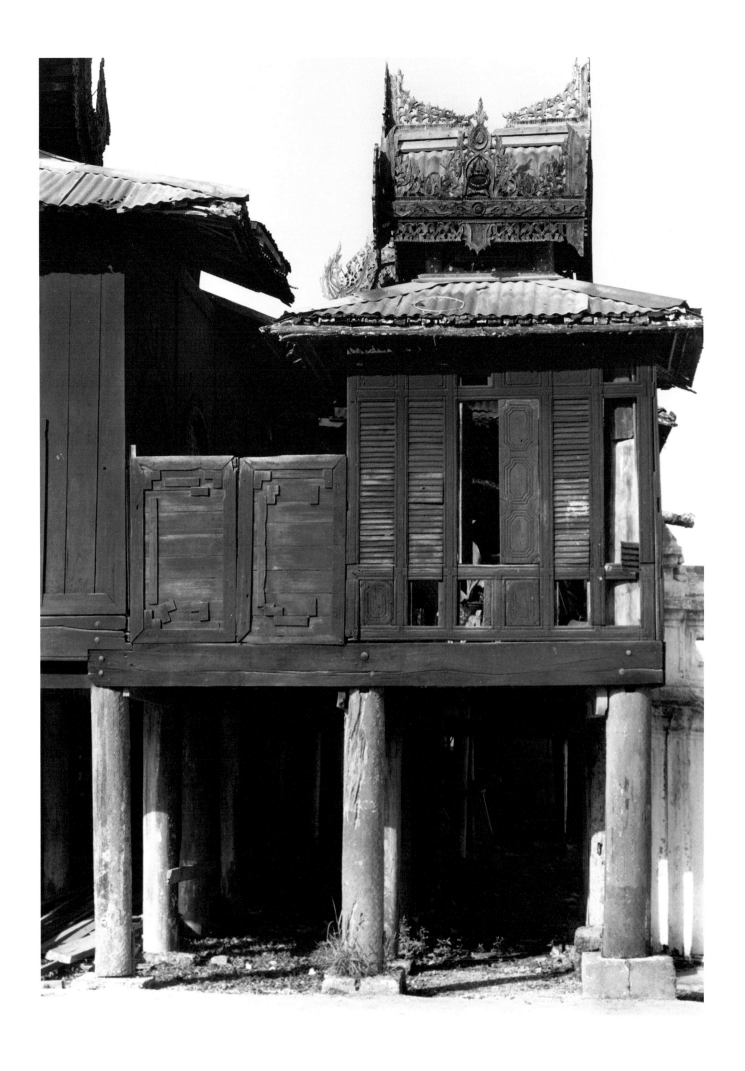

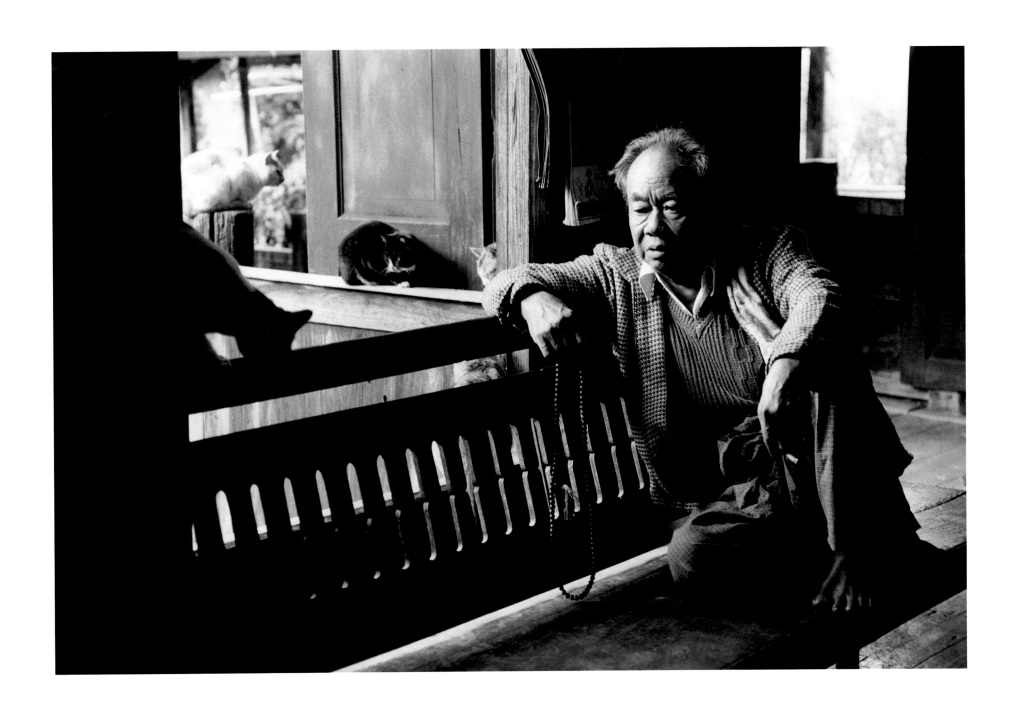

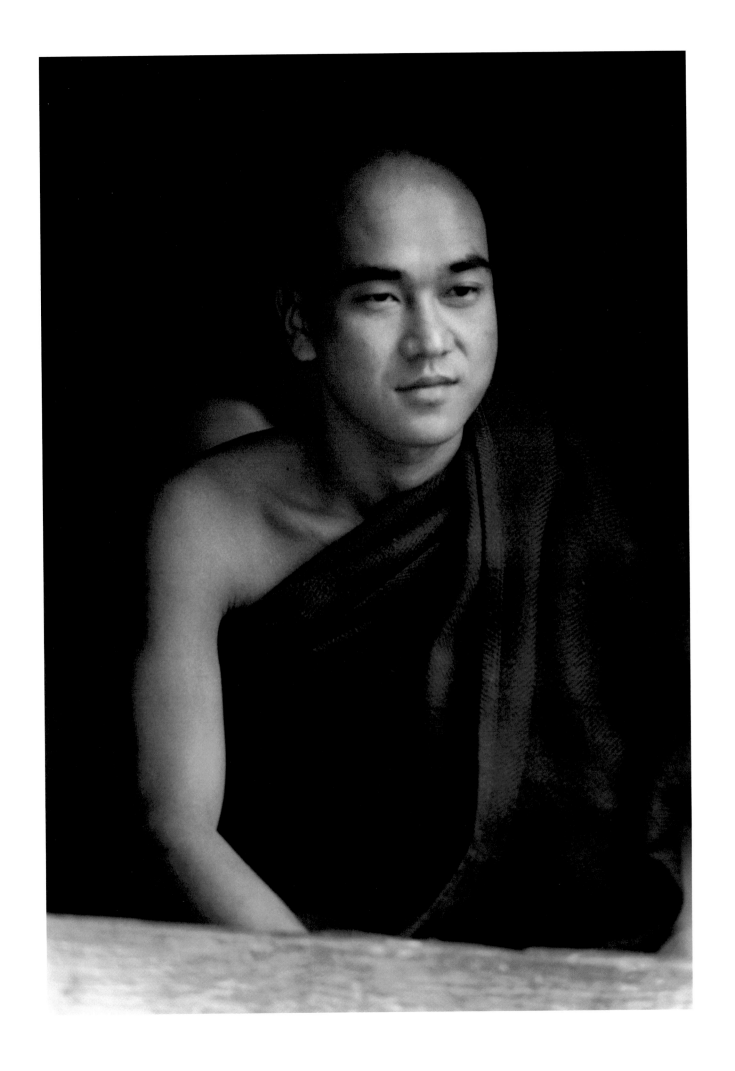

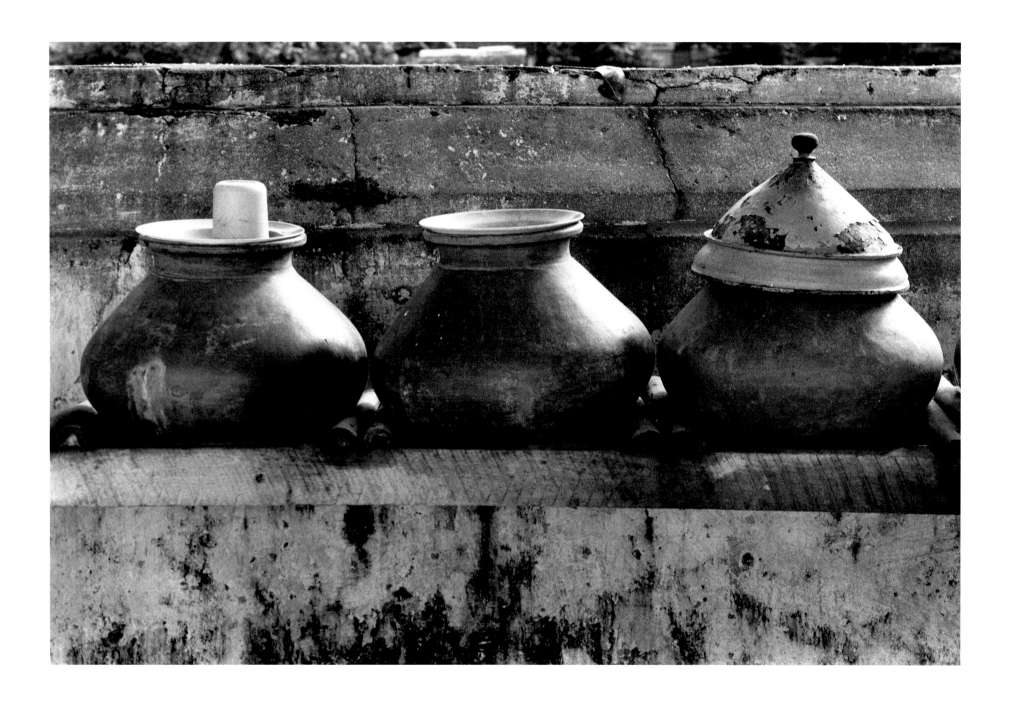

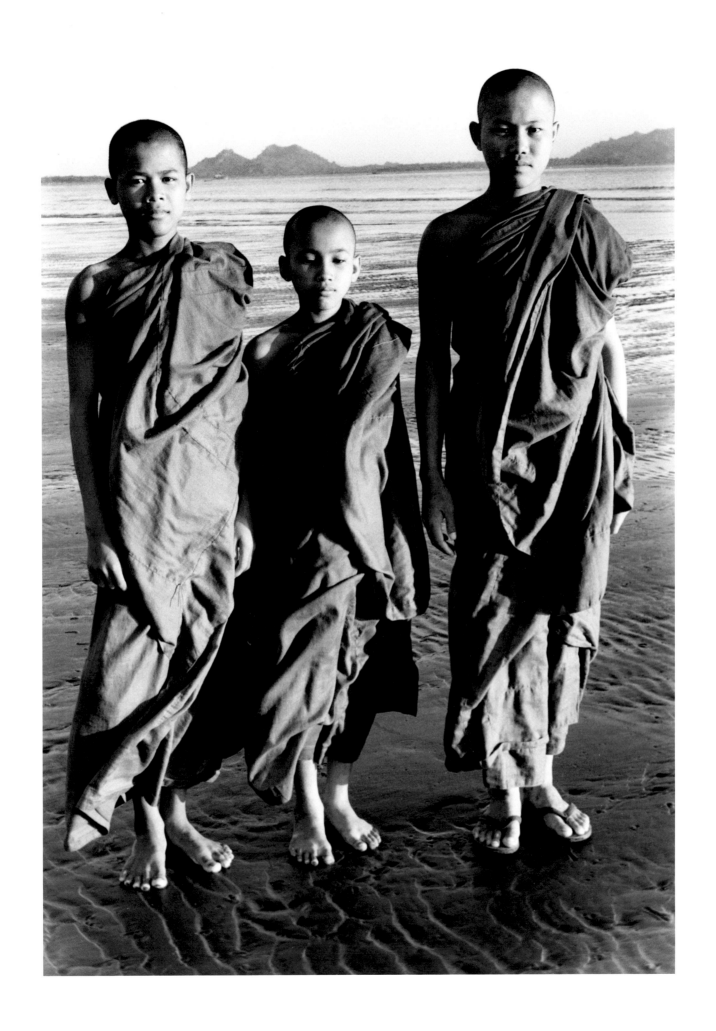

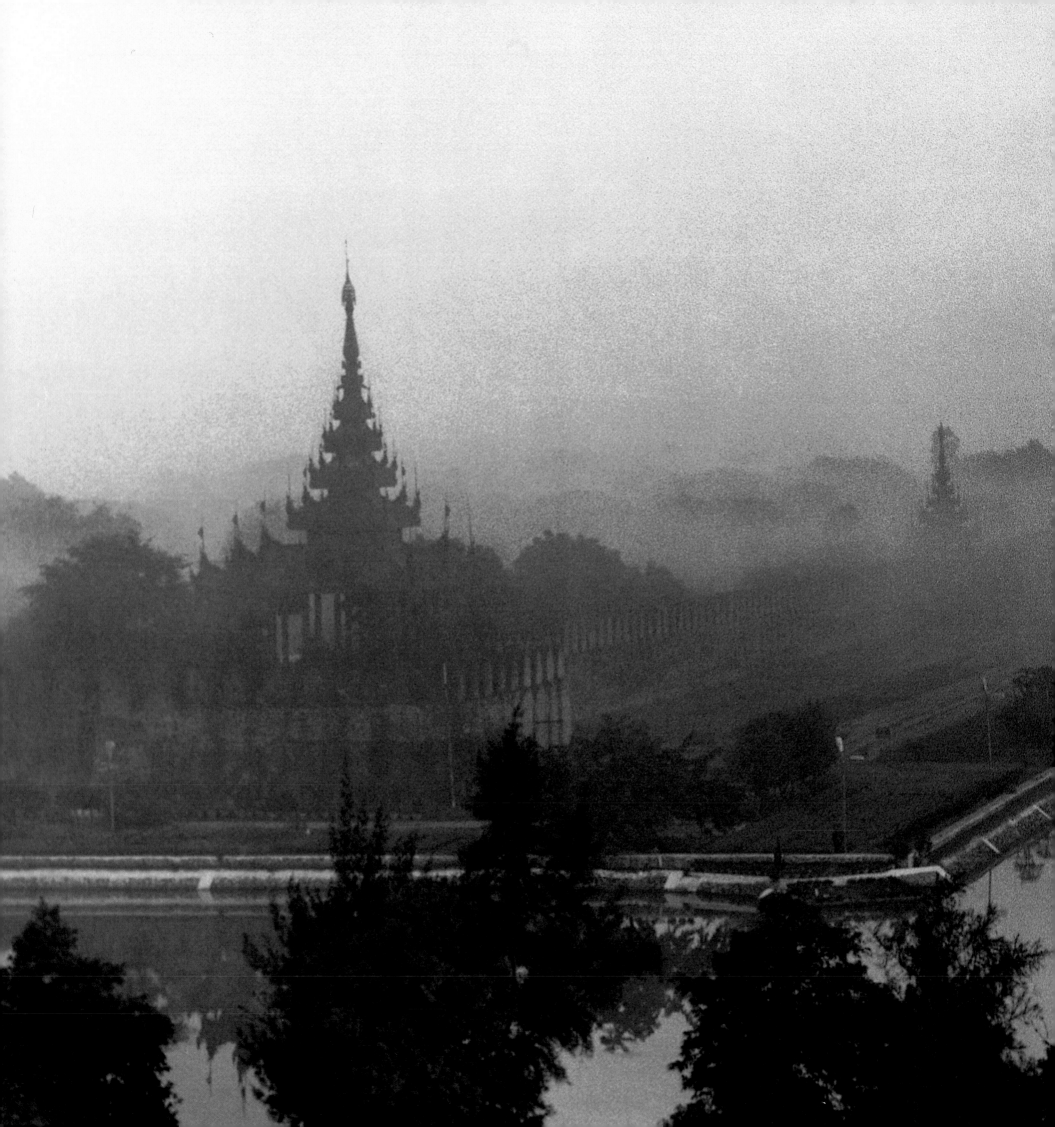

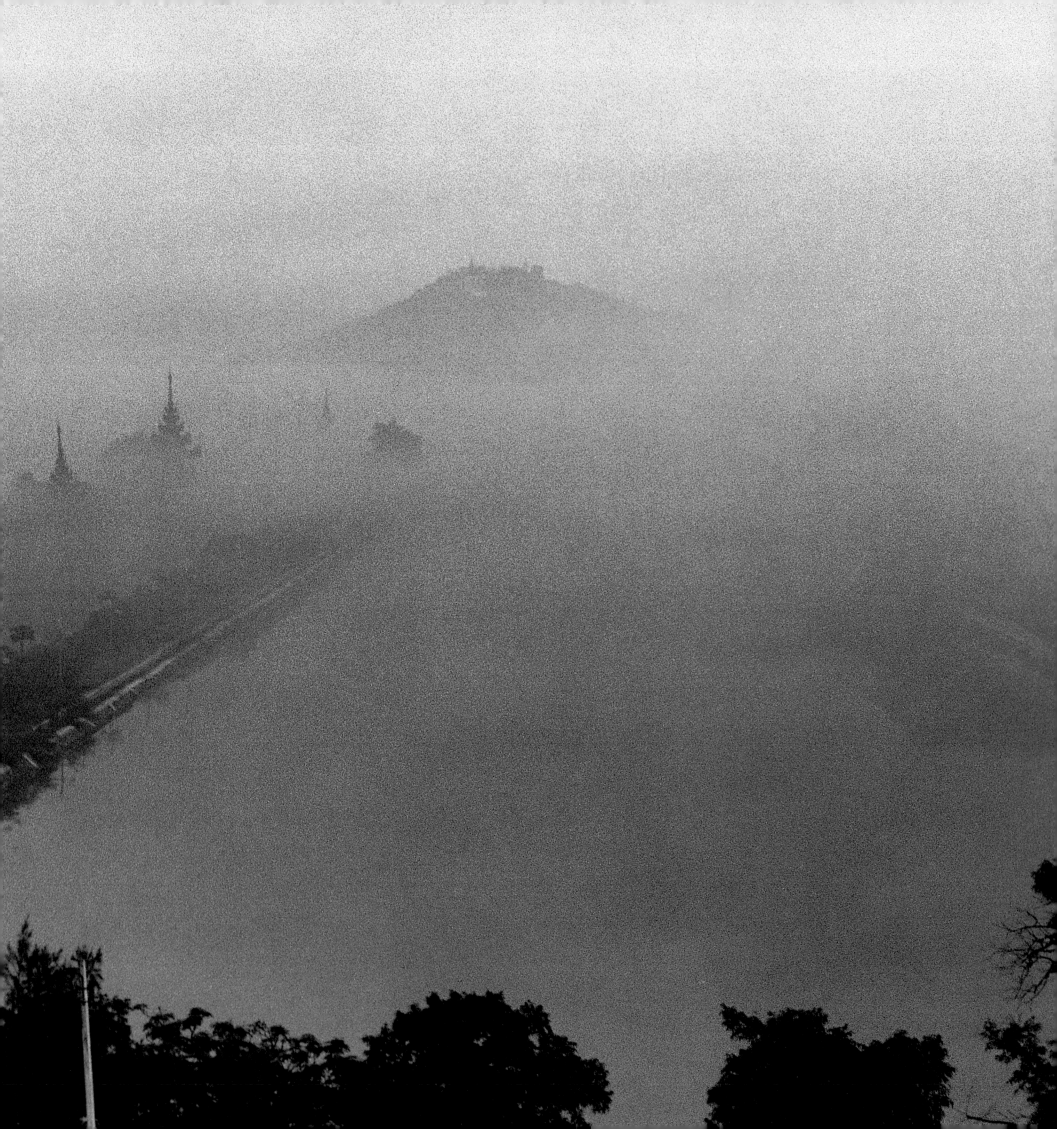

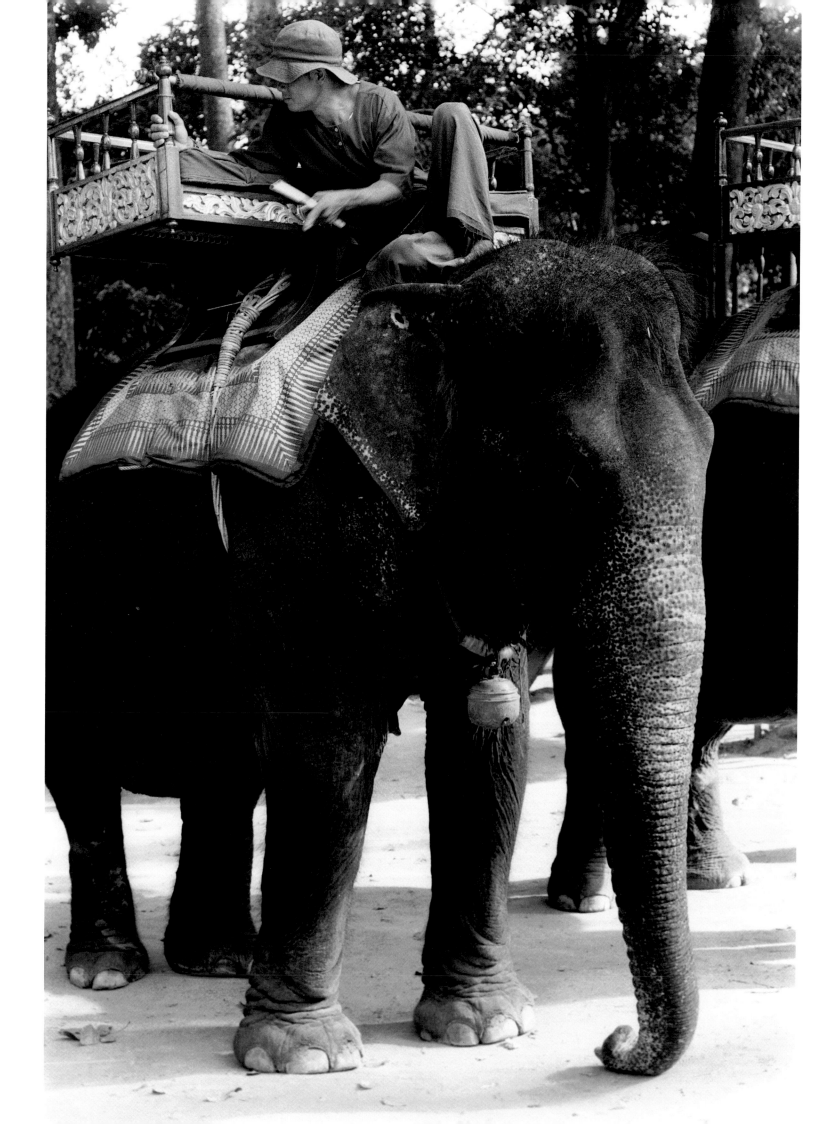

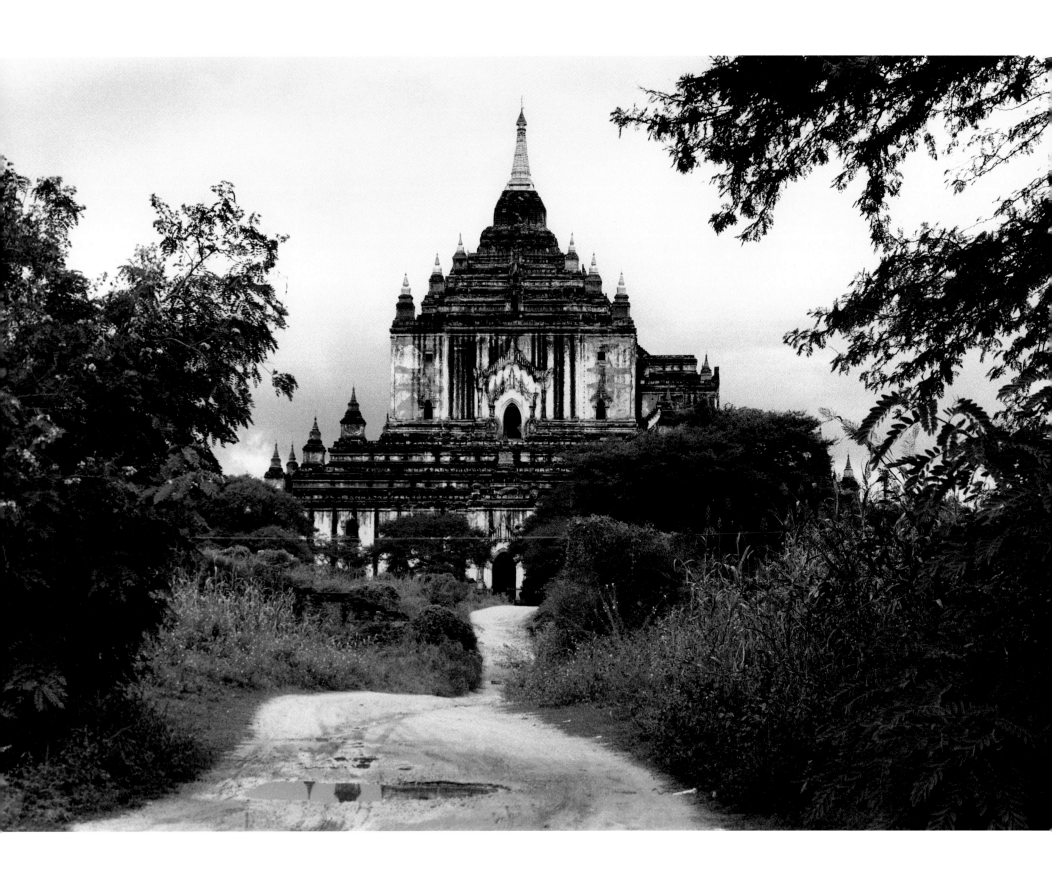

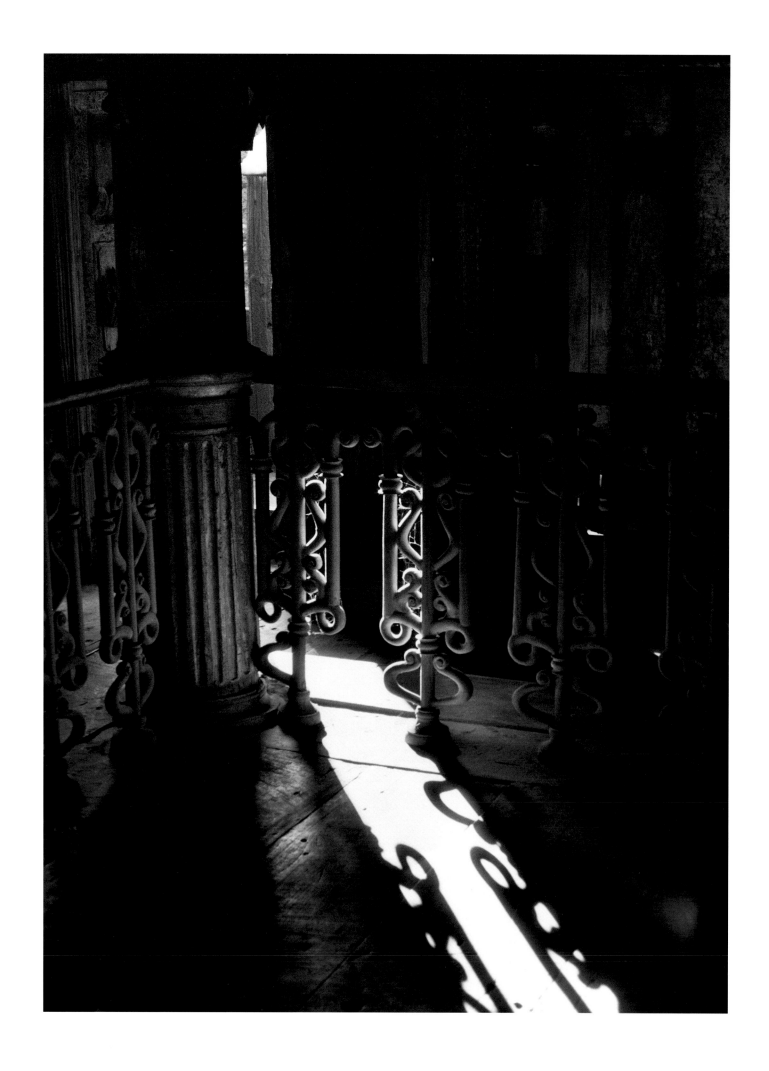

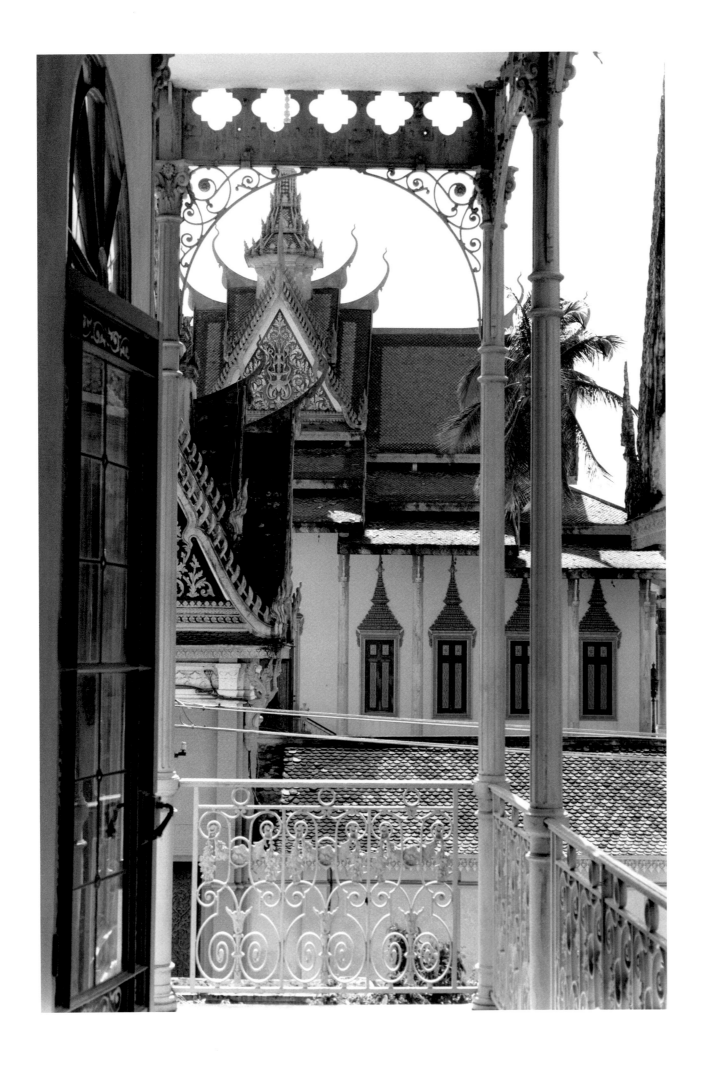

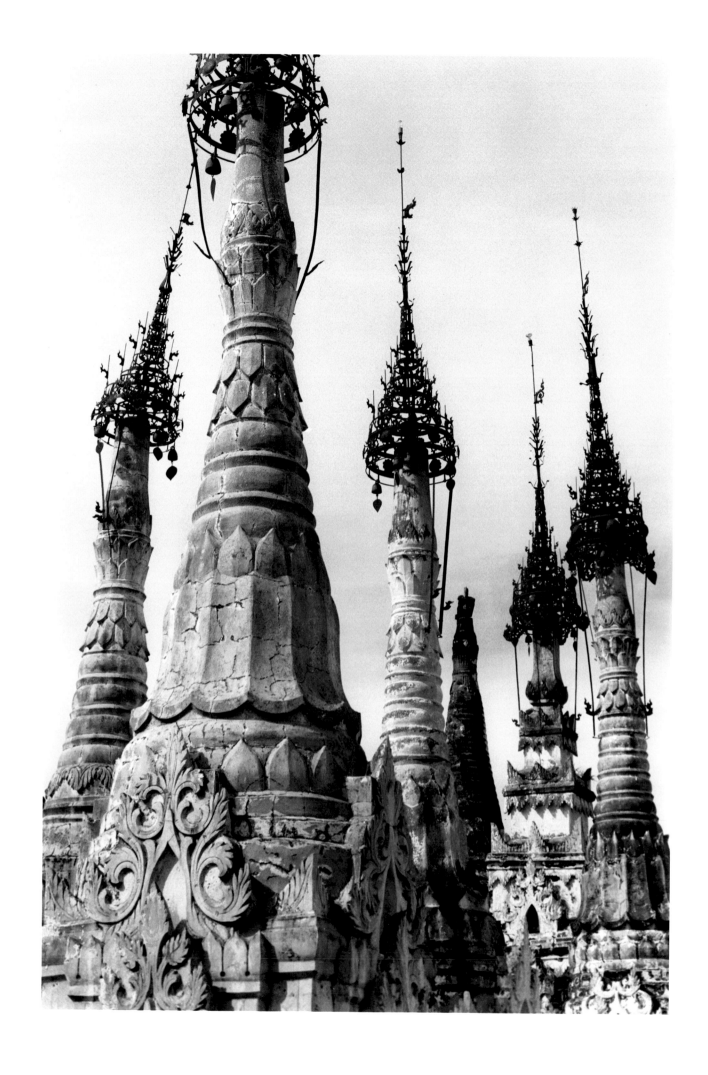

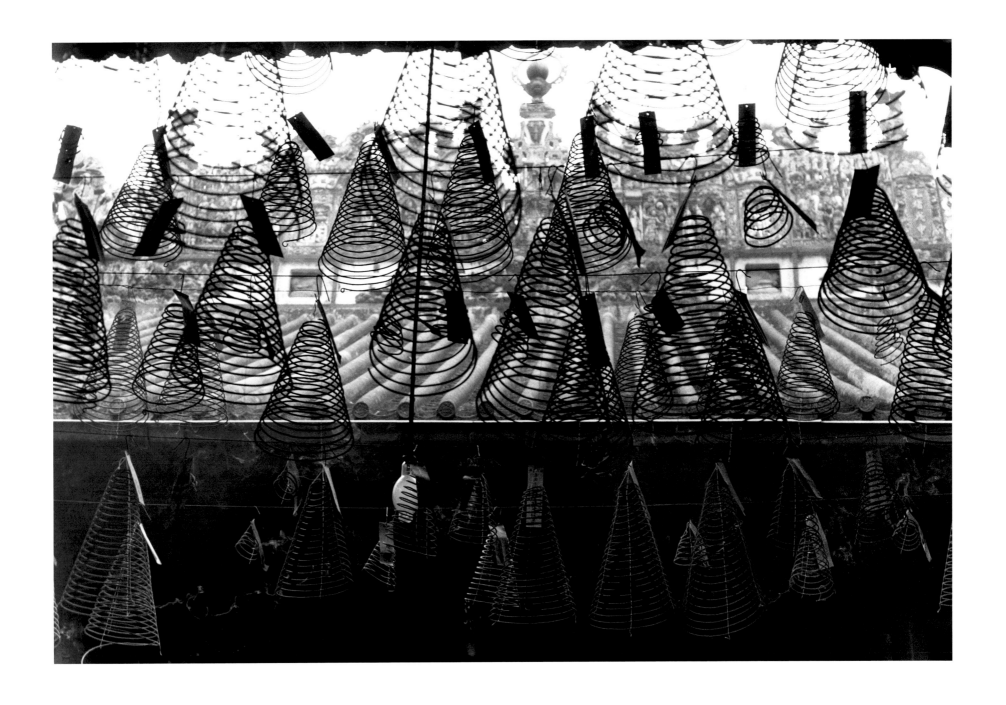

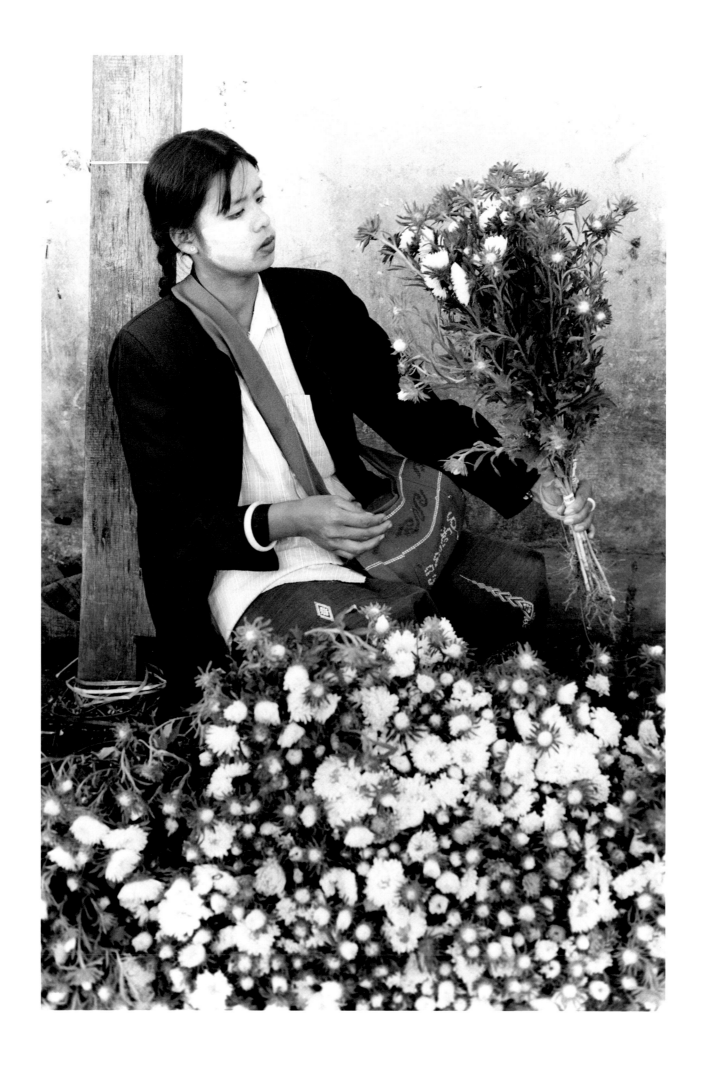

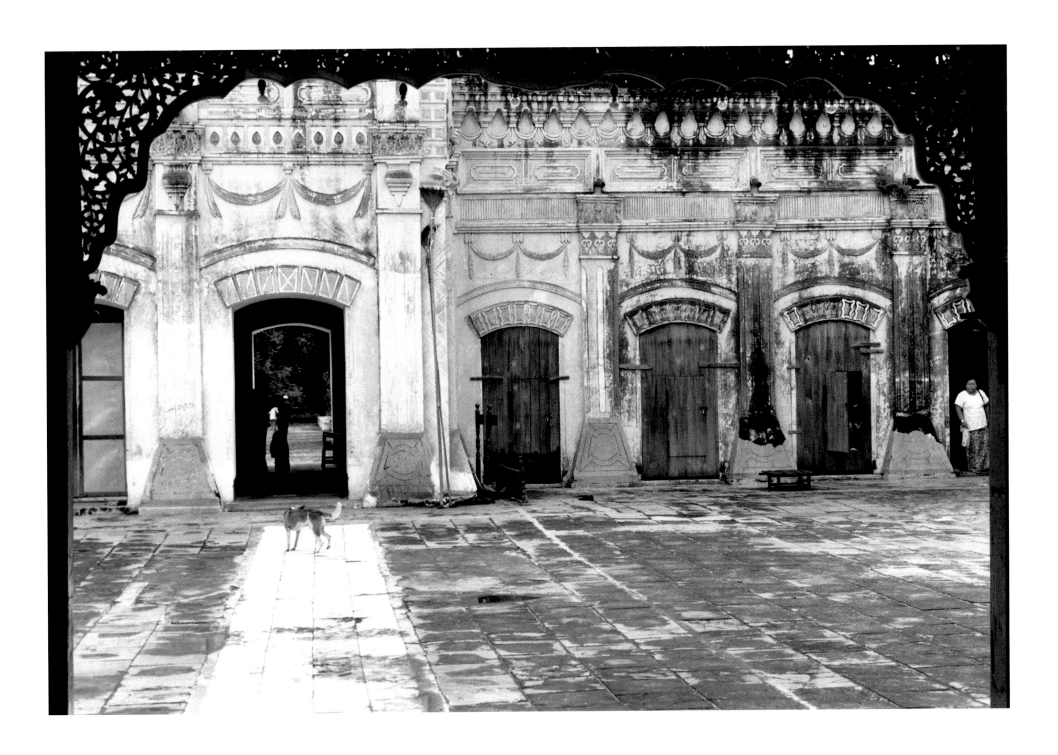

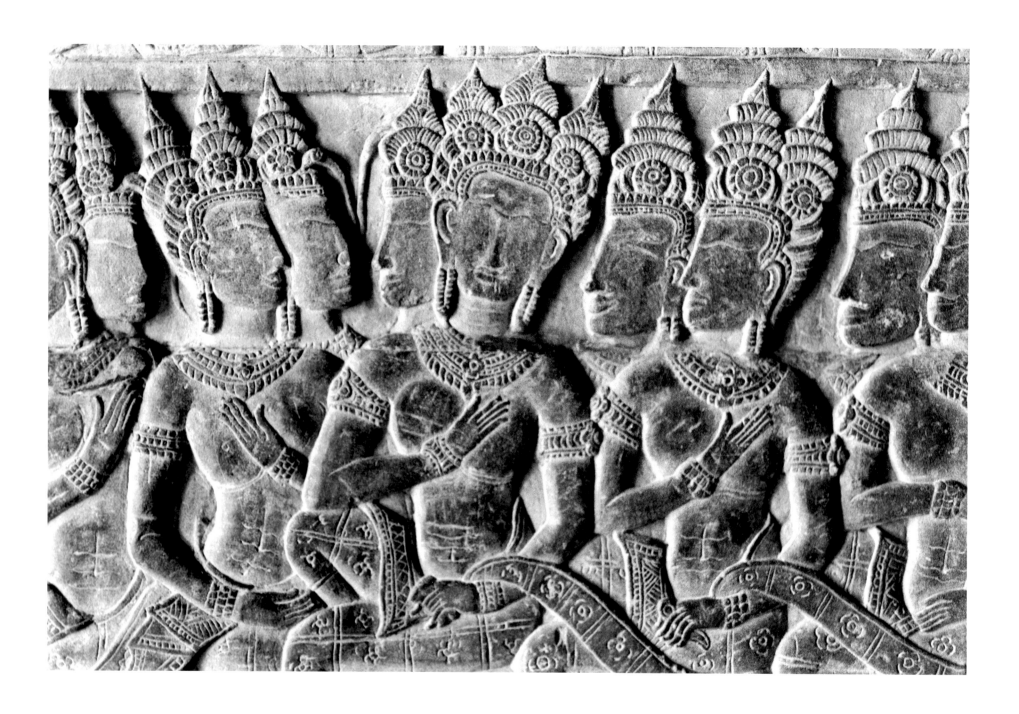

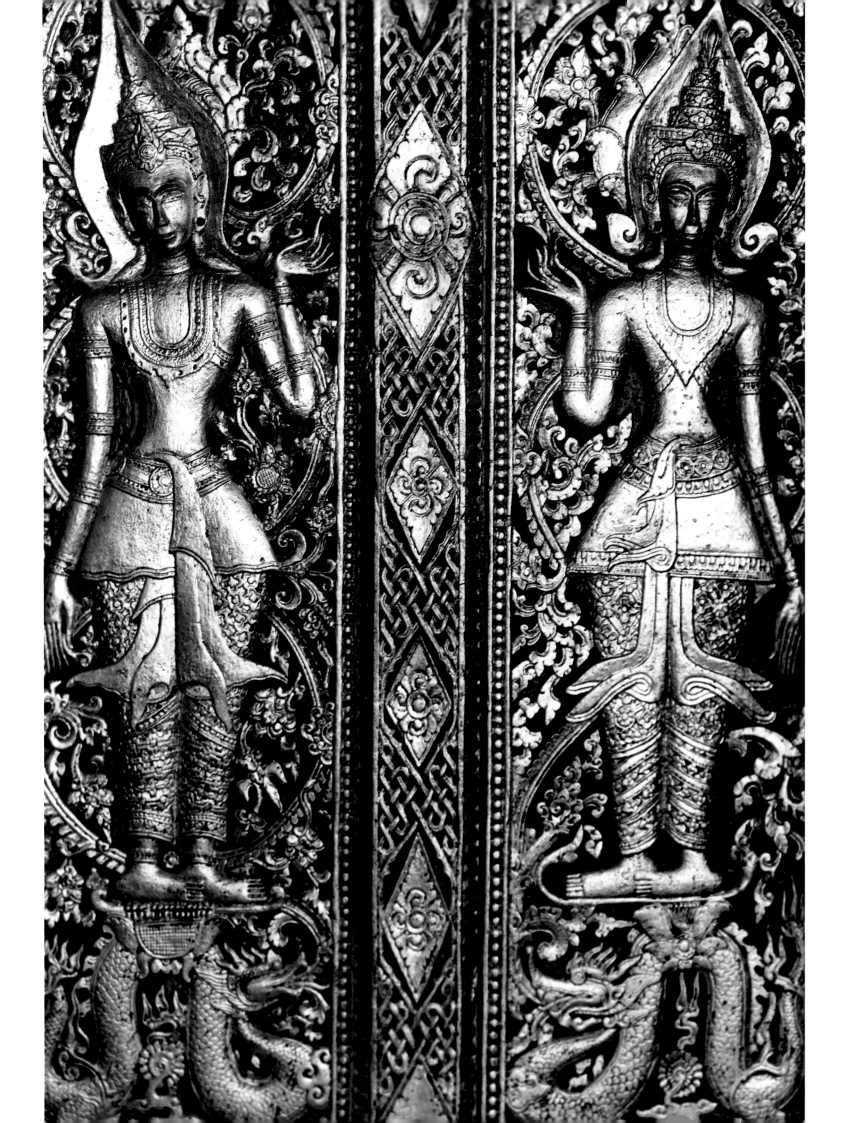

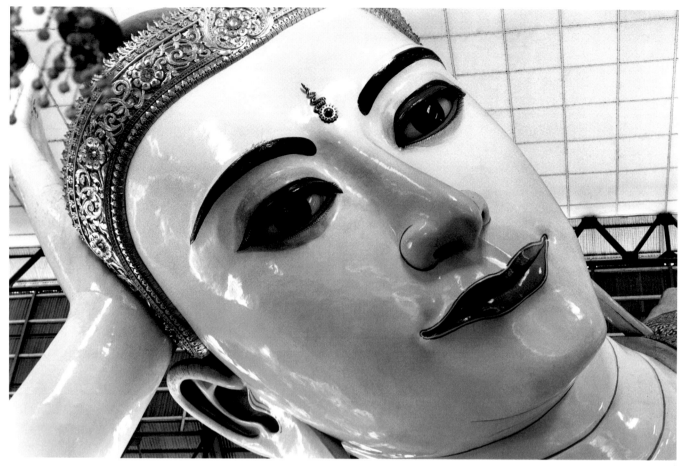
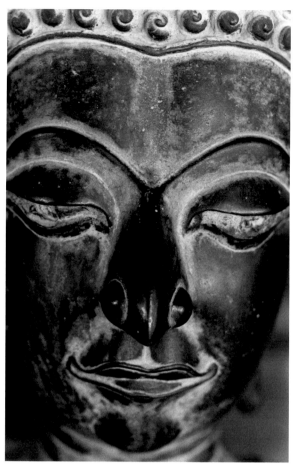
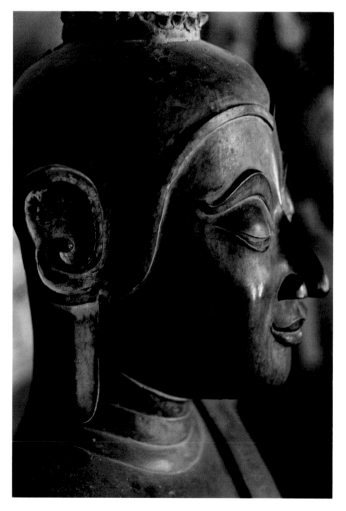
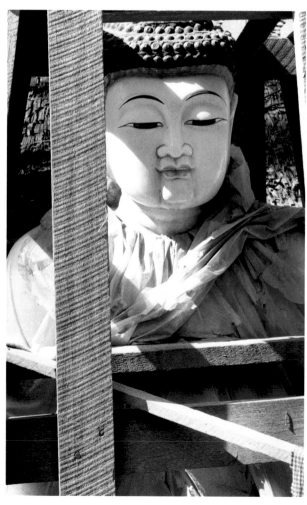
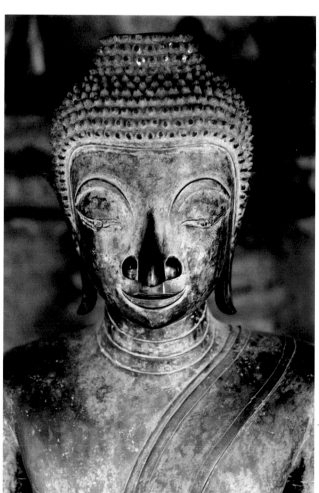

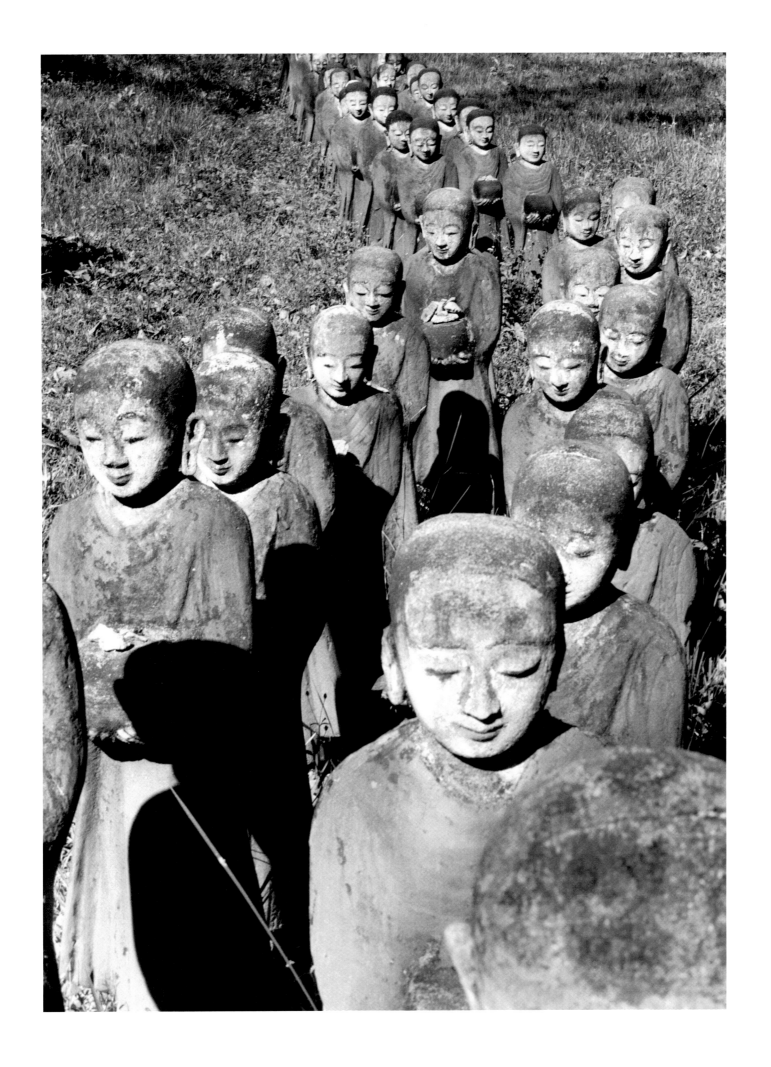

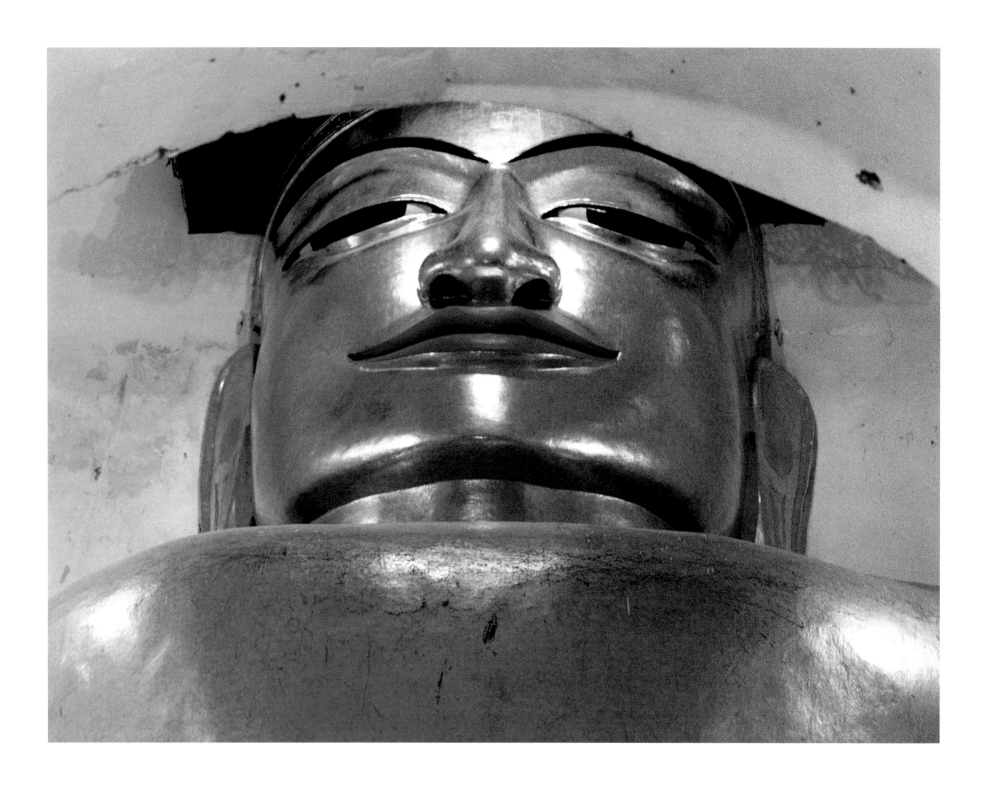

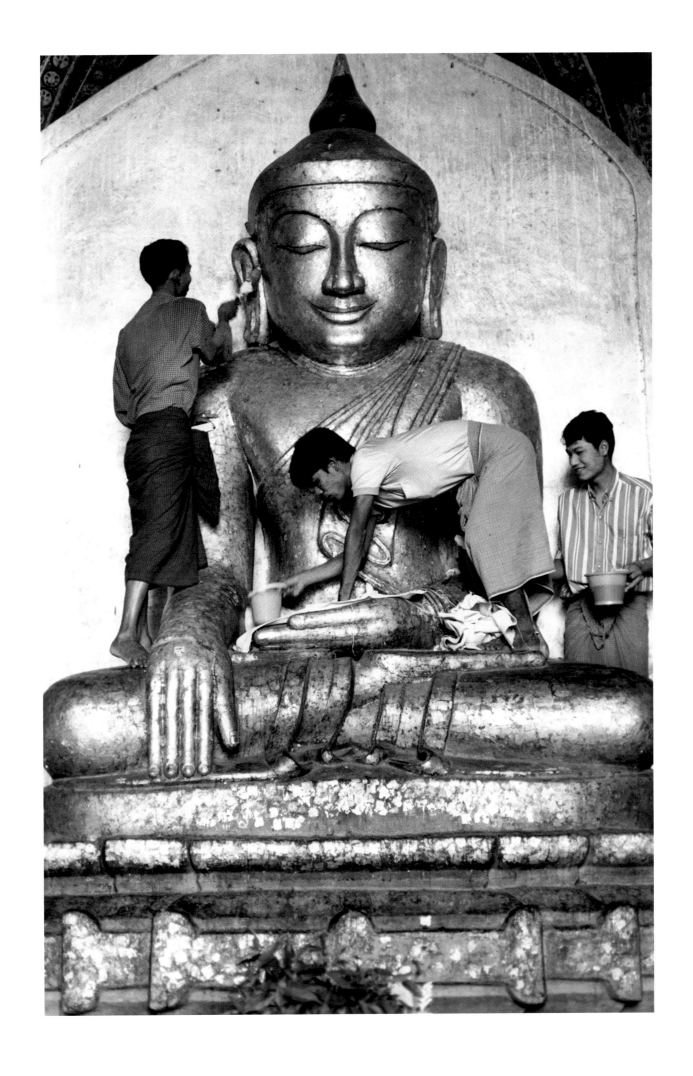

142

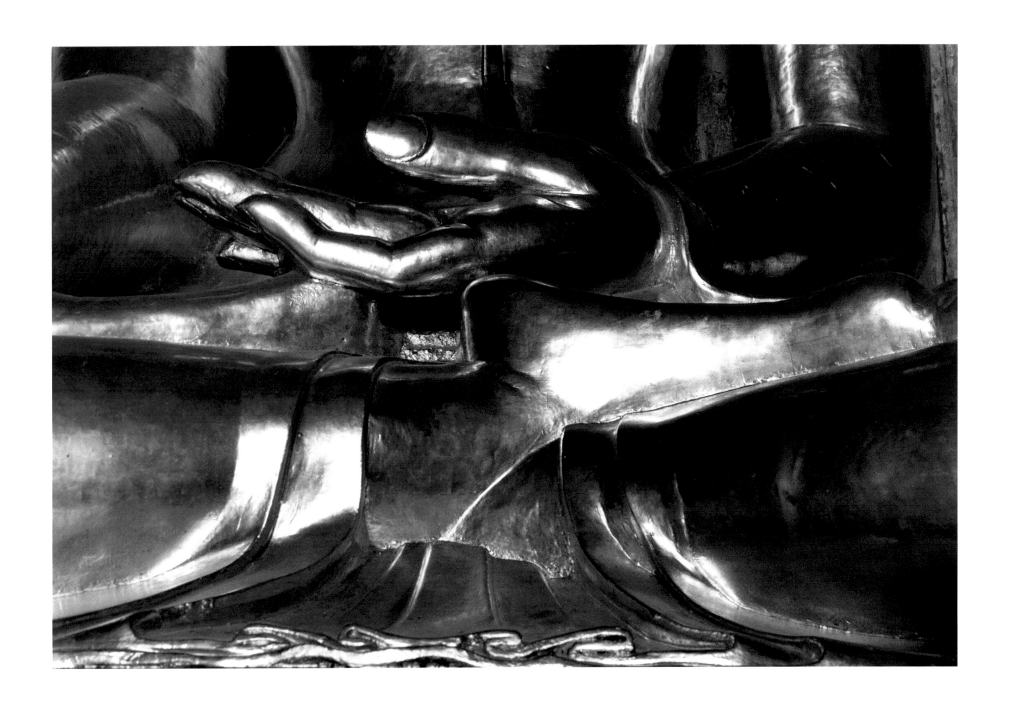

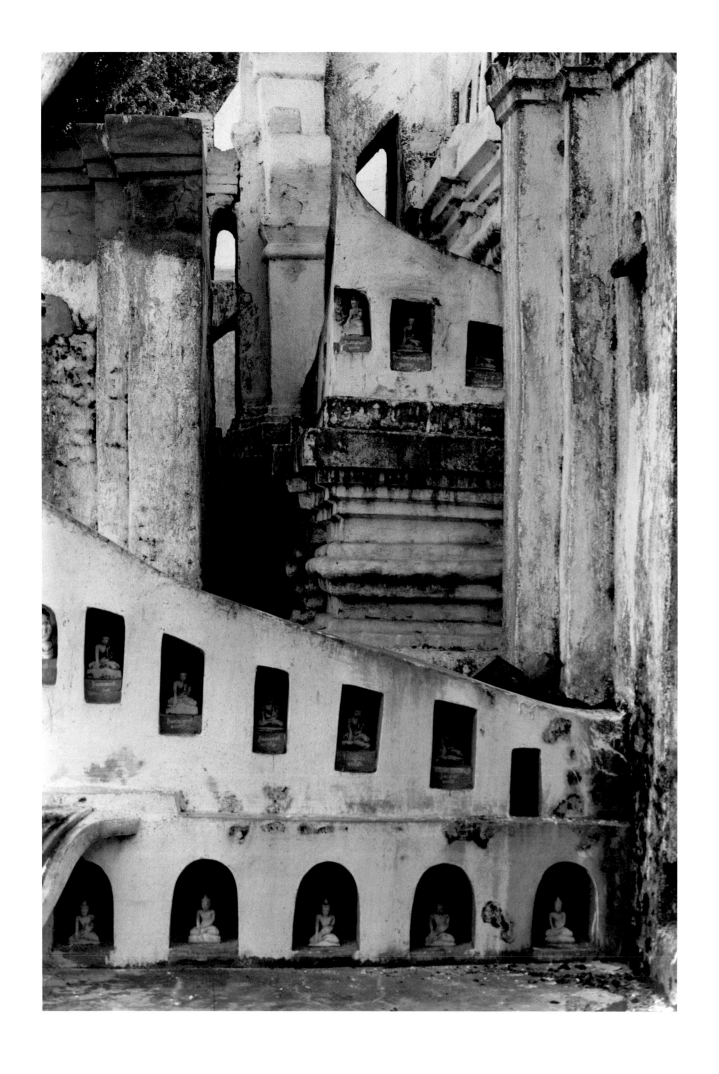

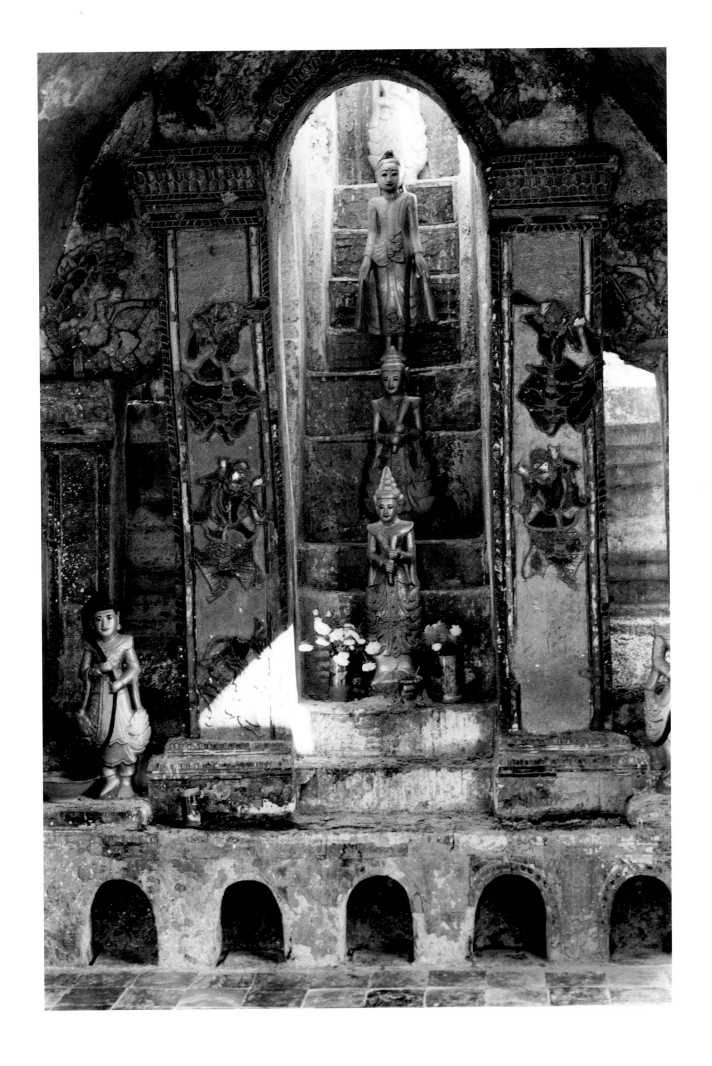

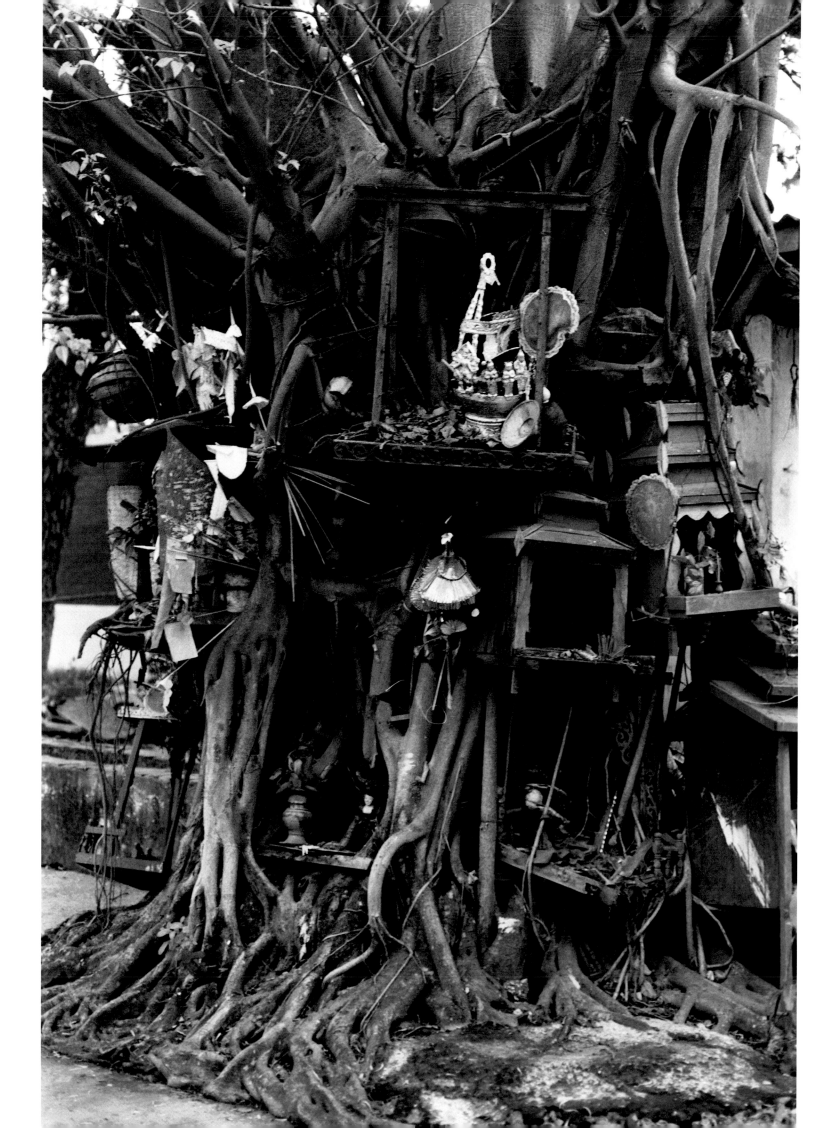

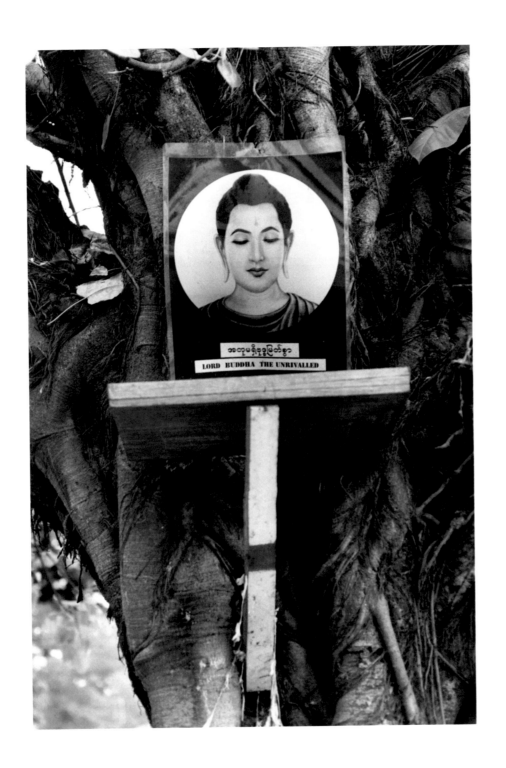

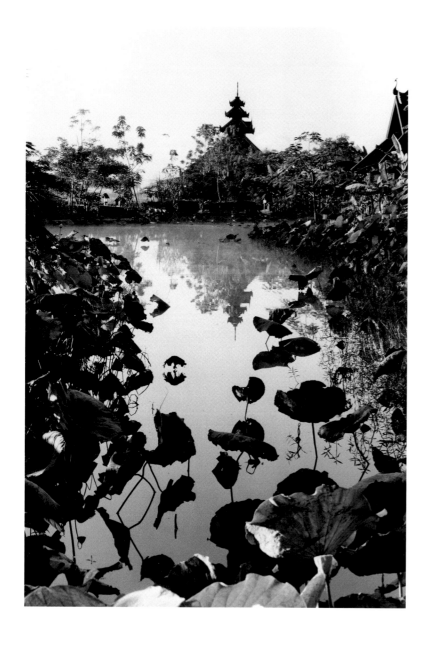

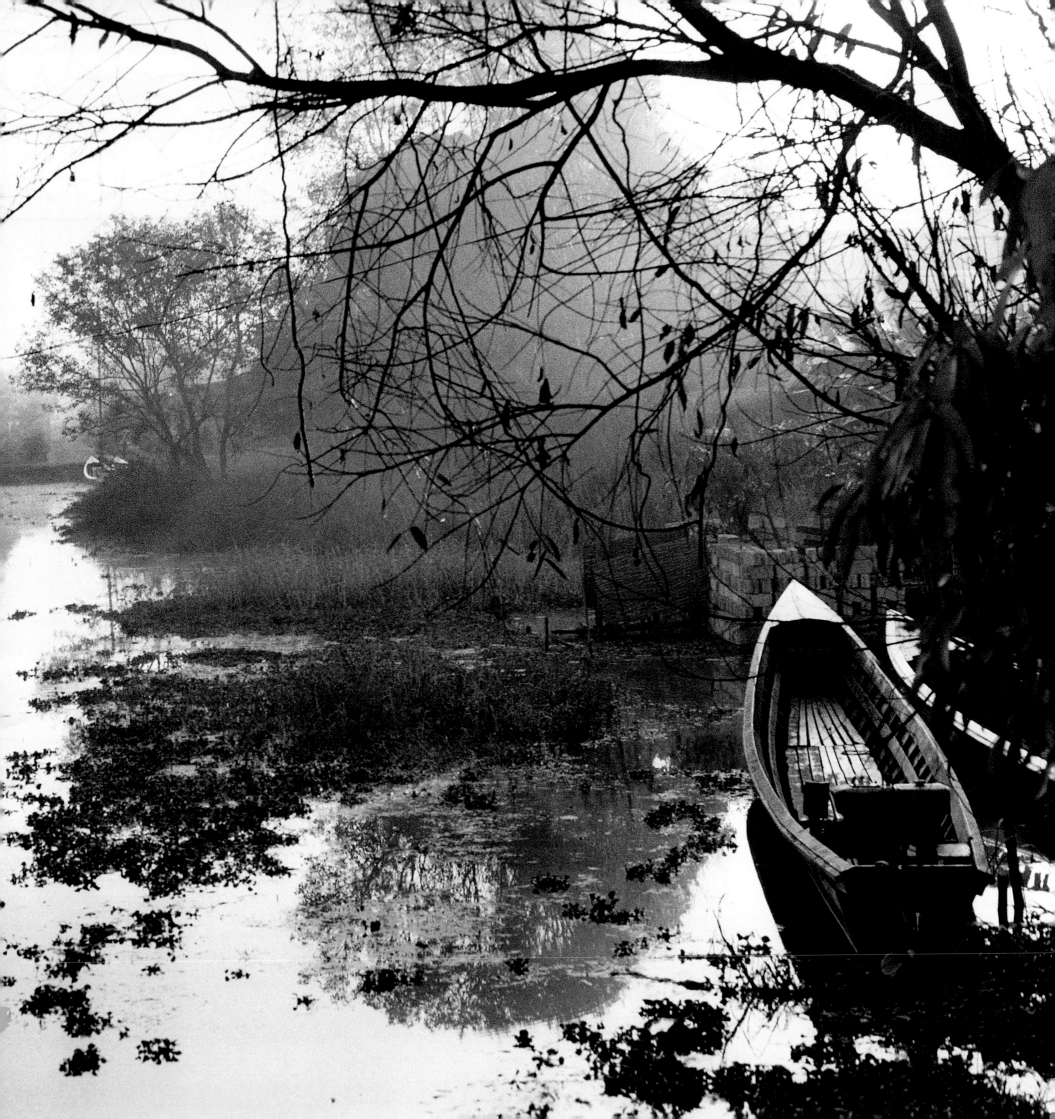

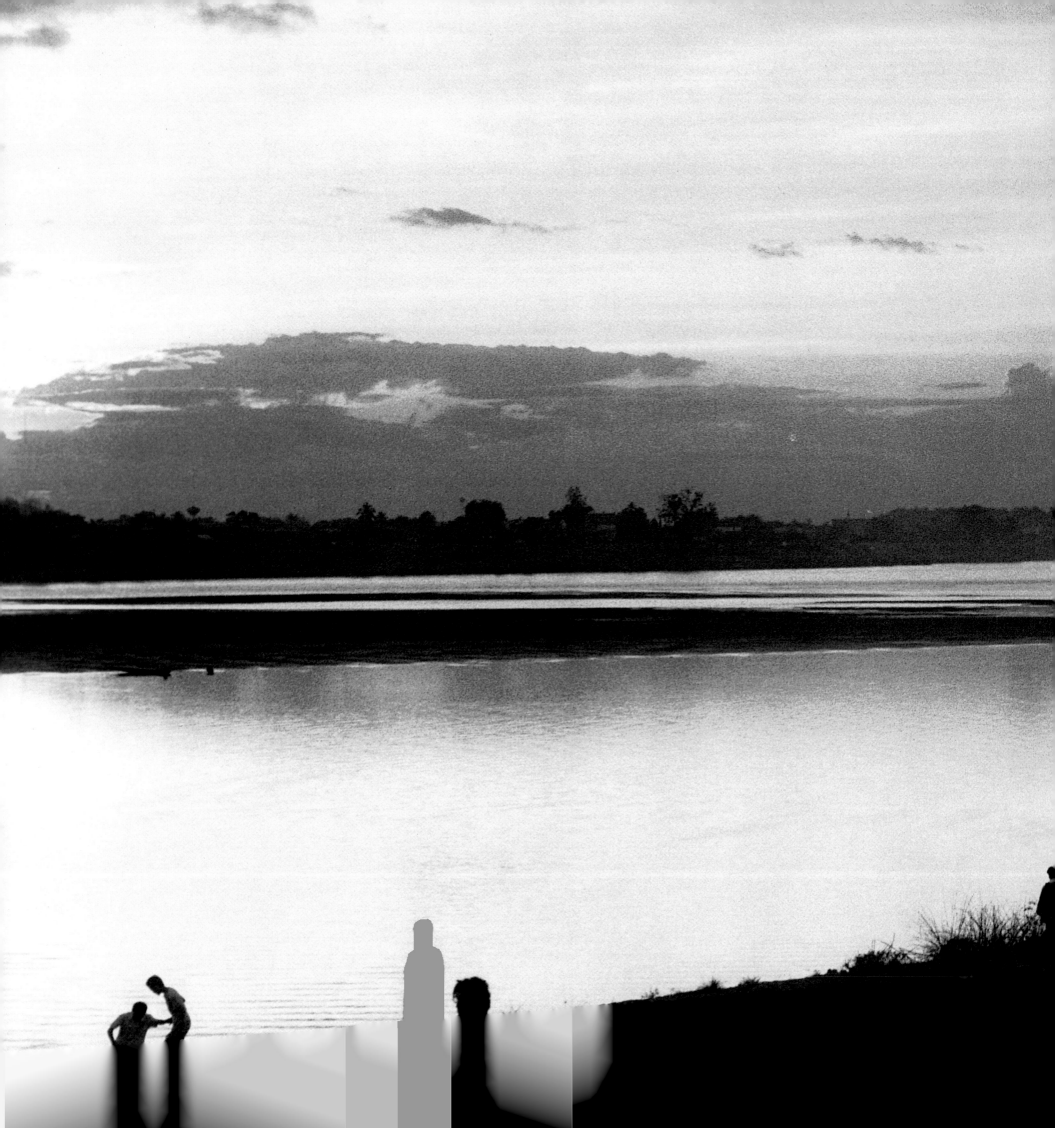

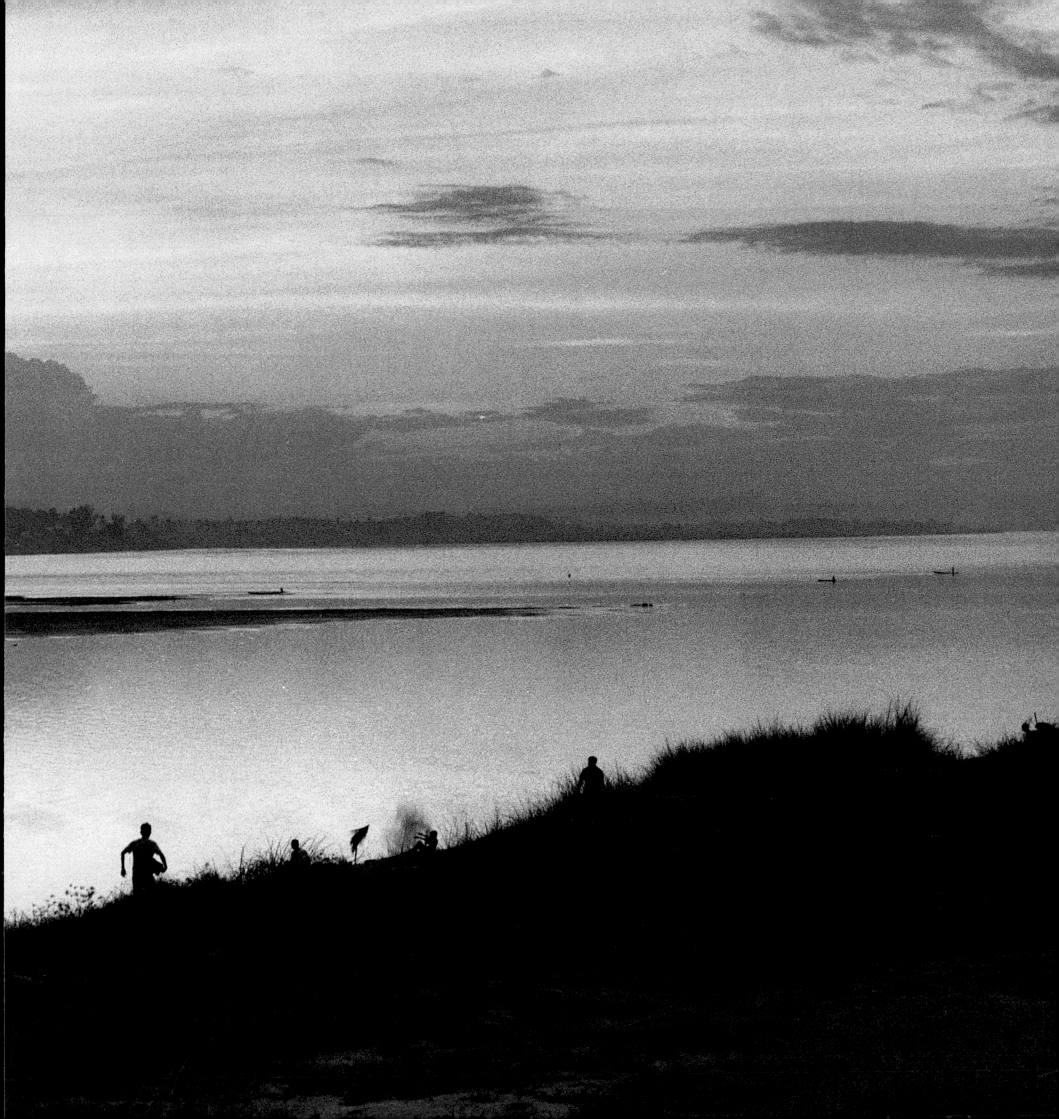

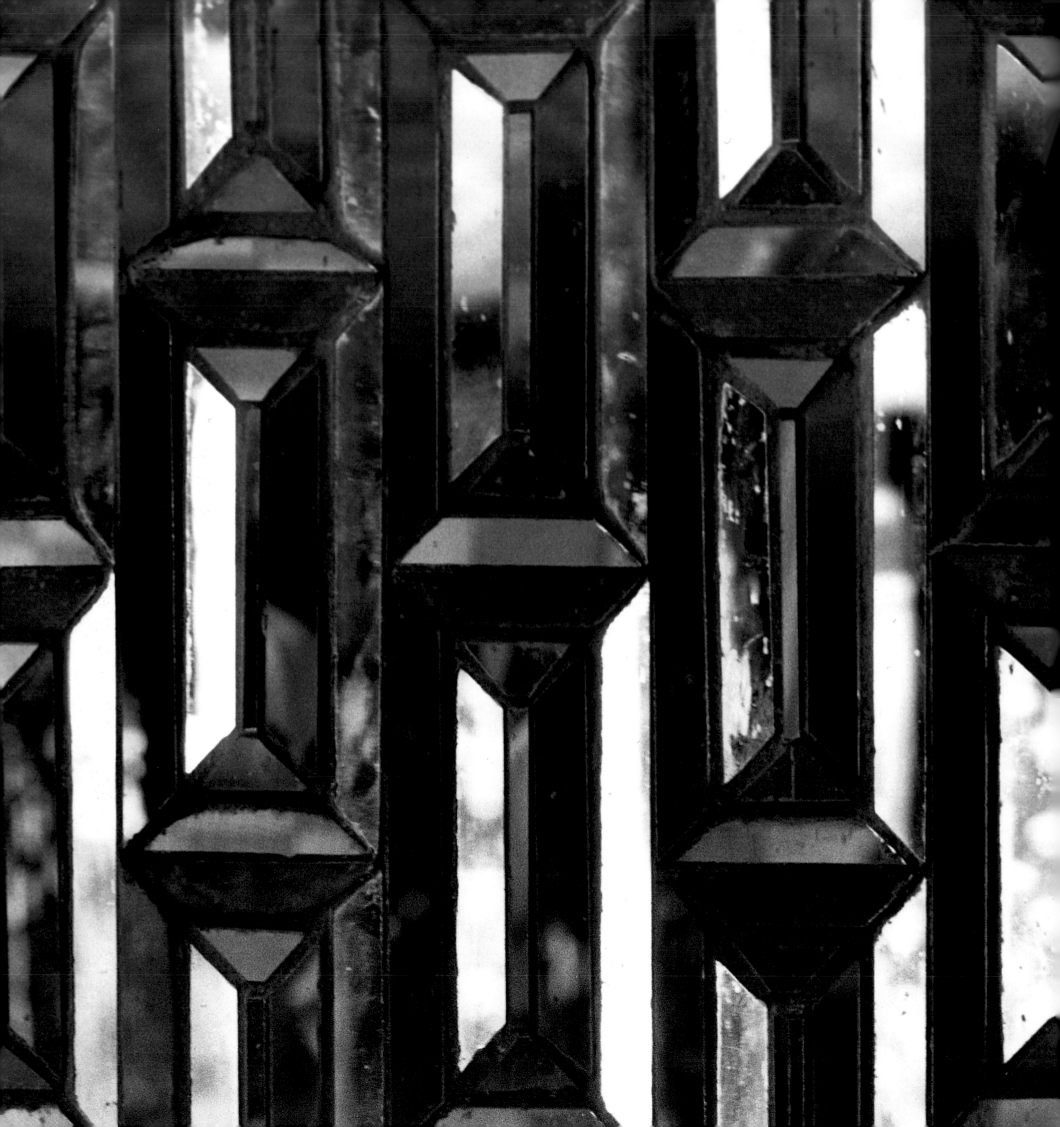

ANDREA BALDECK

Whether as musician, physician, or photographer, Andrea Baldeck has braided a career with strands of art, science, and wanderlust. Born in a rural village in western New York, she began photographing with a box camera at age eight, imaging herself a *Life* photographer canoeing through the jungle to meet Albert Schweitzer. This interest and dream pervaded years of musical study at Vassar, medical studies at the University of Pennsylvania, and practice as an internist and anesthesiologist. On medical trips to Haiti and Grenada, camera and stethoscope occupied the same bag.

Though she exchanged operating room for darkroom in the early 1990s to work as a fine-art photographer in black and white, her curiosity and passion for detail and an ordered vision has continued to help her, this time in an exploration of portraiture, still lifes, and urban and rural landscapes. Among this work, which has been widely exhibited, are the images of artists such as Rudi Staffel and women wearing the jewelry of Breon O'Casey; the studies of proud Haitians that became *The Heart of Haiti* (1996); an embrace of the world's almost hidden details that became *Talismanic* (1998); an intimate involvement in the life of the city of Venice that became *Venice a Personal View* (1999); and, now, this flooding through the rivers of southeast Asia that has become *Touching the Mekong* (2003).

Baldeck's work is always in process, looking for new rhythms and tonalities in the lights and shadows of the natural world: in a show called *Closely Observed* that has been at the Morris Arboretum in Philadelphia and will travel to Cleveland and Washington; in a new collection, called *Walls/Windows/Doors*, a study of the visual effects of apertures and barriers through which the artist and the scientist seek passage; and in an ongoing series entitled *The Poet*. The latter is an exploration of how artist and work reflect each other, often prismatically, as in the "glass palace" mosaic on the facing page.

Baldeck wanders through the streets of Venice or the ancient temples of Angkor; she treks up the Himalayas and to the top of Kilimanjaro and across the Atlas Mountains and the hills of Tuscany; but she has also revealed the wonders that lurk beneath the pine trees in a backyard or within an opening bud. She explores and hears the tonalities of the not yet seen and in her darkroom operations produces the prints that fill these books, exhibitions, and collections.

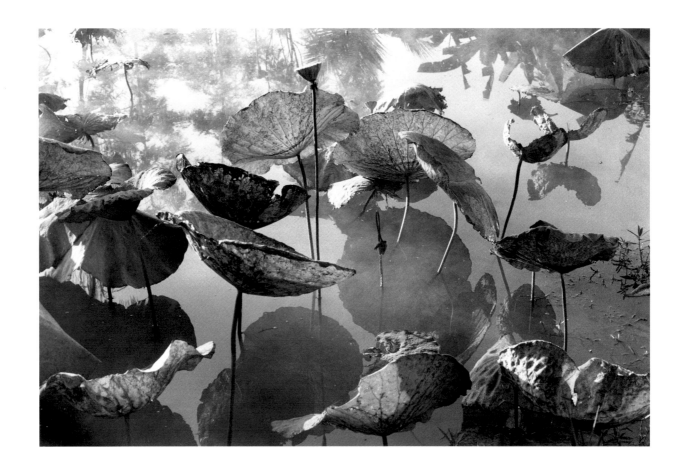

Design and production of this book
were managed by
Veronica Miller & Associates
Haverford, Pennsylvania.
Cartography by Nancy Anderson-Keil, GIS Map Design
Akron, Ohio.
The book was printed by Becotte & Company
Philadelphia, Pennsylvania
and was bound by
Roswell Bookbinding
Phoenix, Arizona.

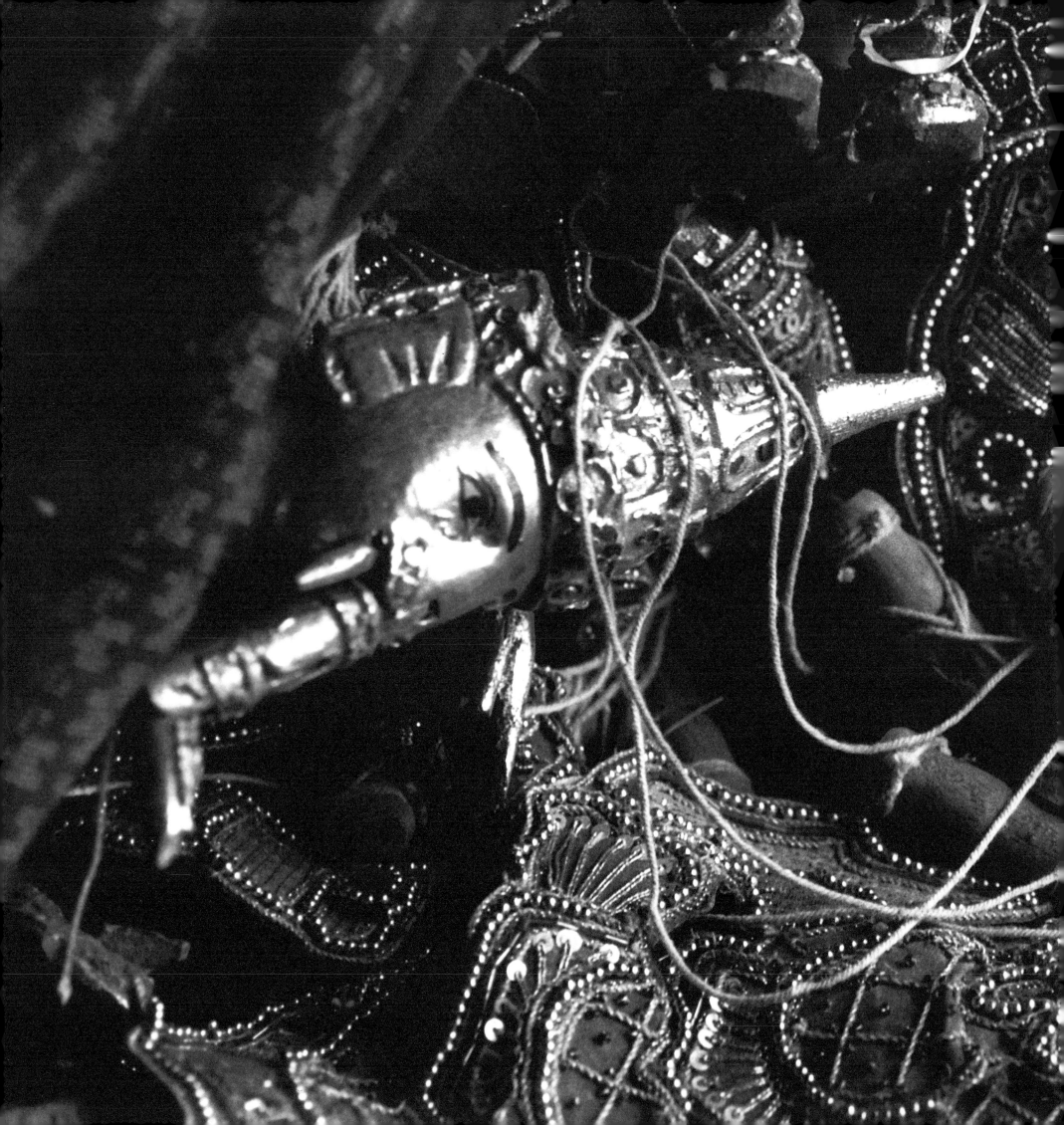